PHOTO-
OFFSET
OFFSET
OFFSET
OFFSET
OFFSET
OFFSET

PHOTO-
OFFSET
OFFSET
OFFSET
OFFSET
OFFSET

Irvin T. Lathrop, M.S., PhD.
Professor of Industrial Arts, California State University Long Beach

Robert J. Kunst
Associate Professor, California State University Long Beach

 American Technical Society CHICAGO, ILL. 60637

Preface

PHOTO-OFFSET is a basic book in American Technical Society's Graphic Arts Series. It is designed to be used as a first course in offset printing.

The design of this book is unique in several ways. PHOTO-OFFSET differs from competing books in that it presents *systems* rather than particular machines. While other texts spend much time describing specific presses, PHOTO-OFFSET explains feeder systems, dampening systems, inking systems, and paper delivery systems—a simpler and more generic approach. This book may be used with any offset press.

PHOTO-OFFSET also covers in detail one of the most neglected aspects of lithography—photography. The book clearly explains the photographic process from simple basics to color separation. Two full-color sections and numerous illustrations are used to achieve this purpose.

The authors concentrate on involving the reader in step-by-step procedures. PHOTO-OFFSET, through a variety of creative learning experiences, is designed to be instructive and easy to use.

Photo Credits

Beloit Corp. (page 1)

Consolidated Papers, Inc. (page 136)

E. I. Du Pont De Nemours & Co. (page 124)

W. T. Jaycox (pages 16, 46)

Mead Publishing Papers (page 151)

Marilyn Mergele (page 102)

Mergenthaler Linotype Co. (page 30)

Rand McNally & Co. (pages 13, 82, 152)

Sun Chemical Co. (page 170)

Typographic Sales, Inc. (page 58)

Production

Edited and Coordinated by *Patricia L. Reband*
Designed and Produced by *Wm. T. Jaycox Associates*
 Production Coordinator: *Georgia Jaycox*
 Production Artists: *Gayle Henson*
 Greg Surufka

Composition work furnished by *Typographic Sales Inc.* using
 Linotron 606. Text is set 11/13 Helvetica; Captions
 10/11 Helvetica Italic.

Printing and Binding By *Kingsport Press,* an Arcata National
Company.
 Printing by Offset Lithograph on 77″ presses,
 both two color and four color.

Contents

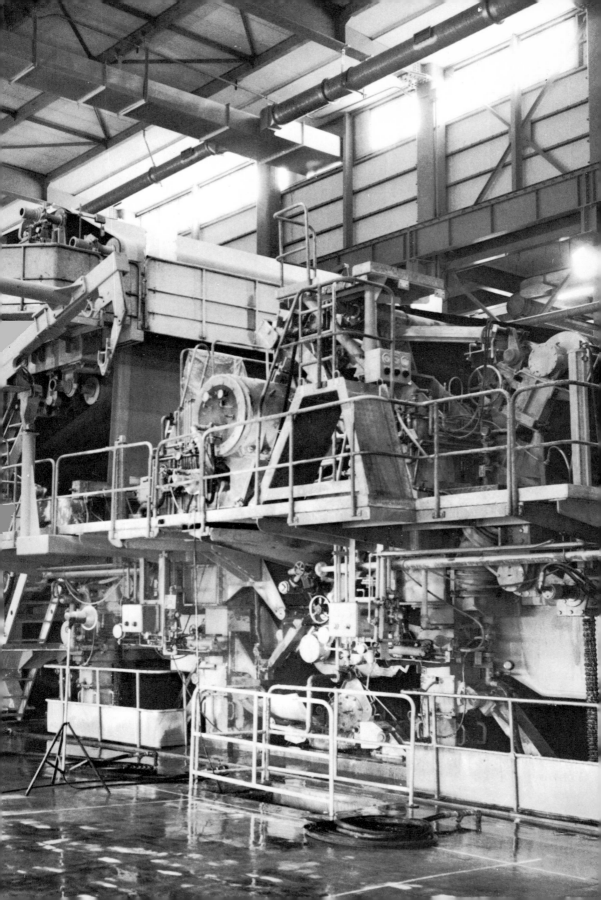

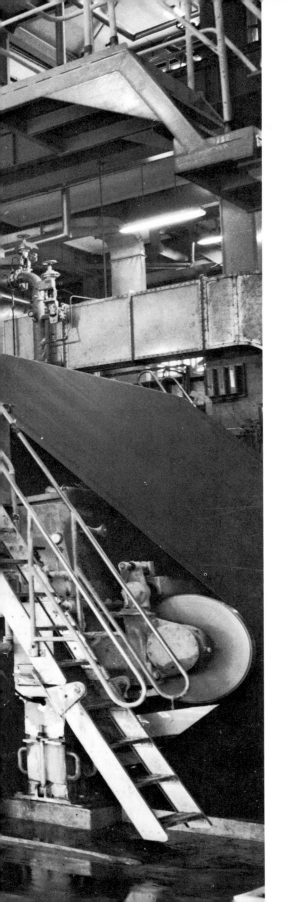

Chapter 1

introduction

offset printing process

Printing is all around us. It is part of our lives twenty-four hours a day. Try to imagine our civilization without printing. For example, think about the first couple hours of your typical day.

When the alarm rings, you look at the clock to see the time. The face of the clock is printed. You stretch and slide out from between printed sheets and go to the bathroom. There you are surrounded by printed materials: toothpaste tube, counter top, various bottles, containers, paper products, shower curtain, soap wrappers, towels, and possibly the wallpaper. Even your toothbrush and comb have printing on them.

The pajamas you take off and the clothes you put on may have been printed. When you go to the kitchen for breakfast you are again surrounded by printing. Cereal boxes, egg cartons, orange juice containers, milk cartons, sugar packages, and even the dishes have been printed. Virtually every food product found in the kitchen is packaged or wrapped in printed materials. Some, including fresh oranges, may even have printed surfaces. Even the woodgrain on the kitchen cabinets and the pattern in the carpet may have been printed.

As you leave for school with your printed books, papers, and lunch bag, you may pick up the morning paper which was printed just a few hours earlier. You may get on a bus that has printed advertising displayed. Your car may have a printed instrument panel. On the way to school you will pass printed street signs, advertising billboards, store signs, traffic signs, and a multitude of other printed materials. Throughout the rest of the day, you will encounter all kinds of printed material, Figure 1-1. There will hardly be a moment that you cannot reach out and touch something printed.

Figure 1-1. *Examples of material that has been printed.*

All of these products may be printed by one of several printing methods. One of the four major processes is called *offset lithography.* In general, the offset printing process is basically the same no matter what is being printed. To give

you an idea of how an offset job proceeds to the finished product, let's watch a chapter of this book being printed.

OFFSET PRINTING PROCESS

After the manuscript for this chapter was written and the drawings and photographs were made, the entire copy was sent to the publisher. For this book, the publisher is the American Technical Society of Chicago, Illinois.

In Chicago, a *copy editor* reads the copy, making additions or corrections where necessary. After the copy is read and corrected it is given to a *graphic designer.* The designer decides such details as type style and size, placement of photographs and drawings, and any other aspects of general format. Actually the designer draws a "blueprint" of the book in much the same way that an architect plans the layout of a house.

The graphic designer then gives the text part of the chapter to a compositor. The compositor sets the letters, words, and sentences in the proper type style and size with the amount of spacing the designer has specified.

After the type is set, the chapter is given to the *paste-up department.* Here all the

type, drawings, and photographs are assembled into pages just as they will appear when the book is printed. At this point, the photographs are not pasted down, but the space they will occupy on the final print is indicated on the paste-up with a special material.

When all the paste-up is complete, the chapter is ready to go into production. Sometimes the production department is in the same building as the editorial department, but often they are not even in the same city. In the case of this book the editorial offices are in Chicago, but the production is done at a book manufacturing plant in another city.

At the book manufacturing plant, the first step toward printing the final book takes place in the *camera department.* Here *camera operators* photograph the paste-up of the pages. The type and drawings, called line copy, Figure 1-2, are photographed with a special cam-

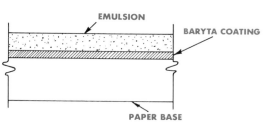

Figure 1-2. *Example of line copy.*

3

era, Figure 1-3, and high contrast film to make a negative of the entire page. Clear windows appear wherever photographs are to be placed in the negative.

While the line copy is being processed, the photographs or continuous tone copy, Figure 1-4, are also being turned into negatives. These pictures are photographed through a *halftone screen,*

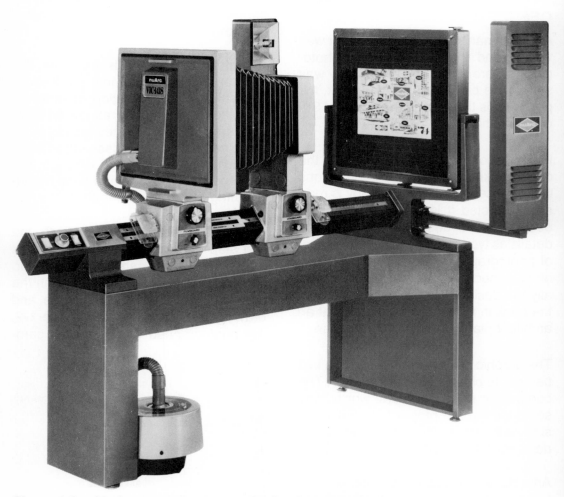

Figure 1-3. *Modern process camera. (nuArc Company, Inc.)*

Figure 1-4. *Example of continuous tone copy. (Marshall LaCour)*

Figure 1-5, which changes the photographs into many small dots. If you look at a printed picture through a magnifying glass, you will see that the shading from light to dark comes from the variation in the size of dots, Figure 1-6.

When both the line negatives and the halftone negatives are finished, they are put together to make the plates for the printing press. The assembly of these negatives is called *stripping* and the

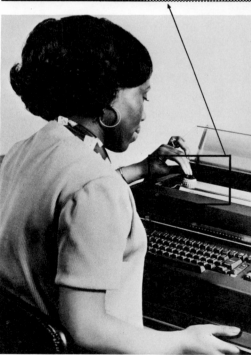

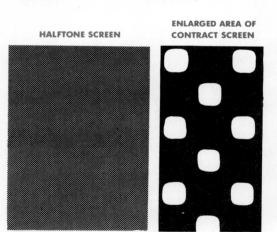

HALFTONE SCREEN

ENLARGED AREA OF
CONTRACT SCREEN

Figure 1-5. *Halftone screen.*

Figure 1-6. *Illustration showing the dots of the halftone screen.*

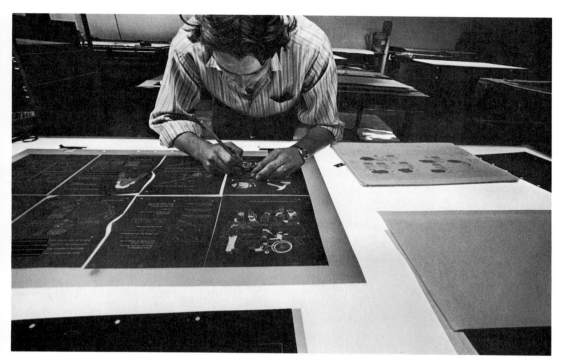

Figure 1-7. *A negative being stripped into a mask called a flat. (Typographic Sales, Inc.)*

person who does this is called a *stripper*. The stripper, Figure 1-7, fastens the negatives to special marking sheets of goldenrod paper cut to the size of the printing plate. Each page of the book is fastened to the goldenrod in such a way that when the book is printed the pages will be in the correct sequence. When these negatives, called flats, are completed for the entire book, they are sent on to the *platemaking* department.

From the flats the platemaker makes plates for each press run. A *plate-burner*, with a vacuum frame which holds the flat and the plate in close contact, makes the plates. When the plate and flat are in contact, the plate is exposed to a bright light, usually an arc or quartz light, Figure 1-8. Because the plate is sensitive to light, the coating changes where the light strikes it through the flat. The platemaker then develops the plate with special chemical

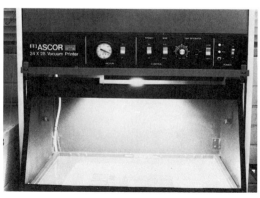

Figure 1-8. *Exposing a plate.*

7

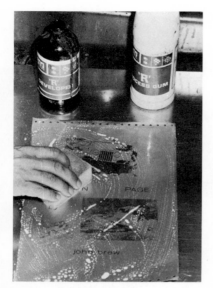

Figure 1-9. *Developed image on an offset plate.*

solutions, Figure 1-9. The plate now contains the image for all the pages that were stripped into the flat. We are ready to print the book.

Two different kinds of printing presses are needed to print this book. Part of the book is printed on a *web* press using continuous rolls of paper. A web press, Figure 1-10, may print one, two or four colors at one time. Portions of this book are printed on a two-color web press.

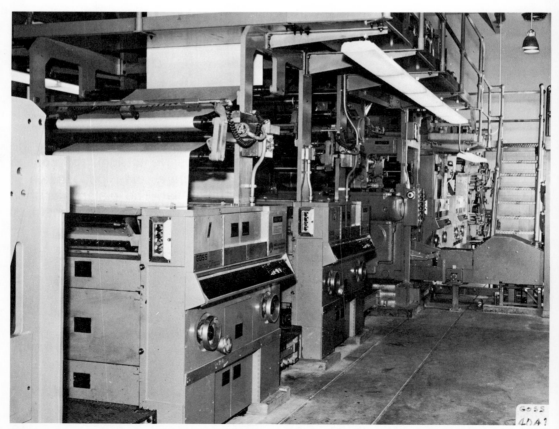

Figure 1-10. *Example of a modern web-fed offset press. (MGD Graphic Systems Group—Rockwell International)*

Other parts of this book are printed on a sheet-fed press, Figure 1-11, which prints flat sheets of paper. Sheet-fed presses may also print one, two or four colors. The four-color sections of this book are printed on four-color sheet-fed presses. These presses can print many thousands of copies per hour from the page plates made by the platemaker.

Even after the pages are printed, the book is not finished. The pages must be folded, placed in order, bound, and covered. These operations are *finishing operations* and are usually done in the *bindery*. Here a machine called a *folder* folds and cuts the pages in sets called

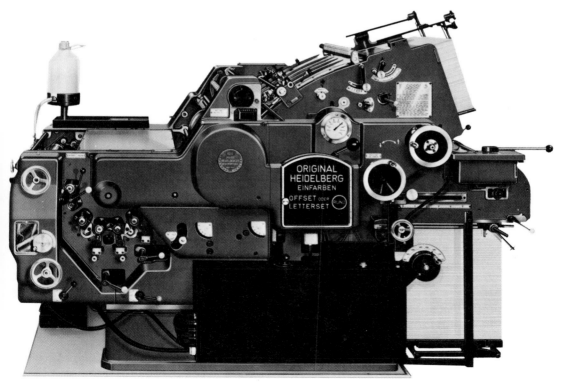

Figure 1-11. *Example of a modern sheet-fed offset press. (Heidelberg Pacific, Inc.)*

Figure 1-12. *Gathering and stacking signatures that have been folded. (Rand Mc-Nally & Co.)*

signatures, Figure 1-12. These signatures are gathered together to form the complete book. A cover is added and the book is finished. Depending on the length of the book and the complexity of the subject, it may take many weeks or months from writing the manuscript to packing and shipping the finished books.

Many people and many crafts are needed to produce a book such as this. In addition to those people involved in the actual production of the book, many others work in industries which manufacture machines or materials used in the printing process. Press manufactur-ers, chemical firms and transportation companies are all important. Two of the most important industries related to printing are paper manufacturing and ink manufacturing.

Paper companies manufacture paper in many kinds and colors. For this book, white book paper in both sheets and rolls is used. The paper begins as logs which are ground into chips and then treated with chemicals and water. Finally pulp fibers emerge to be woven together on a papermaking machine which produces large rolls of paper, Figure 1-13.

Ink, Figure 1-14, the other ingredient essential to printing a book, comes in many kinds and colors. In printing this book, several colors of ink are used.

Inks, like paint, are made from a *vehicle* which carries the color, called *pigment.* A third substance, called a *drier,* is added to speed up the drying.

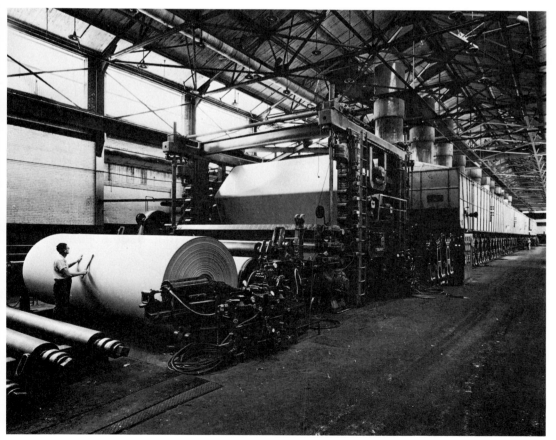

Figure 1-13. *Winding finished paper on rolls. (Crown Zellerbach)*

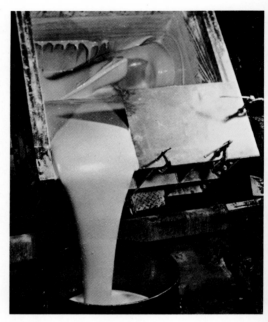

This chapter has been a capsule summary of how the offset process works. In the following chapters of this book you will study each of the steps and processes in more detail.

Figure 1-14. *Ink being poured from a mixer on its way to an ink mill. Ink comes in many kinds, colors, and containers.*

discussion questions

1. List the printed items you used from the time you got up until you left for school.
2. What is the first step in printing a book after the copy has been edited?
3. What is the first step toward printing the actual book?
4. Why are different kinds of presses used to print the book?
5. What happens to the pages of a book after they are printed and before they are shipped to the user?
6. List some crafts other than printing which are necessary to produce a book.

safety in graphic arts

Safety is important in the school shop, at home, and at work. Being safety conscious protects people and saves lives. If people are not concerned about their safety they can be painfully injured or even killed.

Industry, including the graphic arts industry, is very safety conscious. Every three minutes there are over 350 industrial accidents in this country. Many hours of work are lost and some workers are even crippled for life. Many thousands of dollars in wages are lost by workers who are injured. Safety programs are part of every company and each day workers are reminded to develop safe work habits.

As part of your work in graphic arts, you must learn safe work habits. Be sure to observe all the safety rules in the shop. Do not operate any machine unless you have been properly instructed. Remember, whether in the school graphic arts laboratory or in industry, ALWAYS BE CAREFUL.

Here are some general safety rules that should be followed whenever working in the shop:

1. Keep the shop, equipment, and work area clean. Do not leave scraps of paper where they might cause a fire. Pick up tools or other objects which might cause a worker to trip and fall.
2. Wear the right clothes. Loose clothing might catch in equipment and cause injury. Be careful of rings and jewelry. It is best to wear a protective apron when working around presses.
3. Don't horseplay in the shop. Practical jokes often lead to accidents resulting in an injury or damage to a machine.
4. Place all rags in special airtight metal containers. Oily rags can cause fire by spontaneous combustion. Never leave oily rags or rags with ink and solvent in them lying in the open.

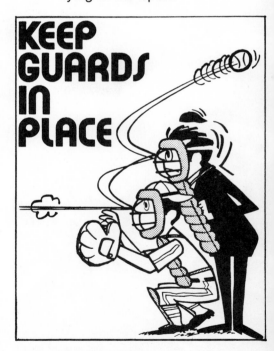

Example of safety poster. Safety posters are a reminder to develop safe work habits.

5. Store all flammable liquids, such as blanket wash, in special safety cans.
6. Wear safety glasses or special safety shields whenever performing any operation where there may be danger to the eyes.

In 1970 Congress passed the Occupational Safety and Health Act. The purpose of this act was to make sure that people have a safe place to work. Standards have been set up which all employers must meet to provide a safe work place. These standards cover all types of safety from safe noise levels to the height of fire extinguishers. OSHA regulations that apply to the graphic arts include safe storage of flammable materials, correct lighting, and adequate ventilation.

OSHA employees make safety checks of work places to make sure they are safe. Even school shops must abide by OSHA regulations.

Rag can. All oily rags should be placed in one of these special rag containers.

Special safety can for storing flammable liquids.

Chapter 2

design
and
layout

All designers follow certain basic ideas in planning and laying out a printed piece. These ideas serve as a starting point and as guides rather than hard and fast rules.

The five basic elements of design are balance, rhythm, contrast, proportion, and unity. Two other factors, color and type style, also affect the design of the printed piece. When you finish this

Figure 2-1. An example of formal balance on the left and informal balance on the right.

chapter, you will better understand how all of these elements fit together to create a well-designed printed job.

BALANCE

Basically there are two methods of achieving balance, Figure 2-1. *Formal balance* has elements of equal weight placed on both sides of an imaginary vertical center line on the page. *Informal balance* gives an *illusion* of equal weights on both sides of an imaginary vertical center line. A design is balanced by use of color or different weights of type, by placement of the elements, or by using other design principles.

Different kinds of balance create different feelings. Formal balance, for example, can give a feeling of permanence, dignity, tradition, strength, security, or order. Generally banks, stockbrokers, universities, governmental agencies, and formal organizations use formal balance in their publications. Informal balance, on the other hand, is used by automobile manufacturers, electronics companies, and other industrial firms that want to emphasize the novelty and originality of their products.

RHYTHM

Rhythm is that element of design that directs the reader's eye in a certain direction over a printed piece, Figure 2-2. Placing the elements vertically leads the eye in a vertical direction; horizontal positioning directs the eye in a horizontal direction. When used properly, rhythm relates the message forcefully and directly. Improperly used, rhythm may move the reader too quickly to the next message.

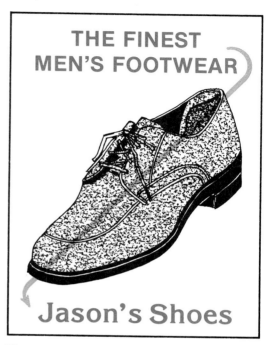

THE FINEST MEN'S FOOTWEAR

Jason's Shoes

Figure 2-2. *Rhythm moves your eye over the printed page.*

CONTRAST

Contrast creates interest in the printed piece by providing variety in the design. The designer adds contrast by changing colors, shapes, weights, sizes, and similar factors in the layout, Figure 2-3.

Figure 2-3. *Contrast provides interest by changing shape, size, color, etc.*

Contrast may also be achieved by varying the type style. The designer may emphasize a word or phrase in several ways, Figure 2-4. Underscoring, changing the type weight, size or face, using capital or small capital letters, adding color, reversing the type, using tints, or bracketing the words are some of the variations possible.

Change the size of the type.
Use CAPITAL letters.
Use SMALL CAPITAL letters.
Use *italic* type.
Add a different type face.
Underline one or more words.
Use symbols ◆ to direct the eye.
Alter type position.
Box the word.
Emphasize by adding color
Use reverse type.
Add screen tints.

Figure 2-4. *Words can be emphasized in many ways.*

PROPORTION

How the parts of a page relate to one another and to the whole is called proportion. All our lives we have been exposed to materials printed in good proportion. Since the time of the ancient Greeks, the 3 to 5 ratio, sometimes called the "Golden Rectangle," has been used in design throughout the world because of its pleasing propor-

tions. Generally, printed pages are longer in one dimension than the other, Figure 2-5. Greeting cards, for example,

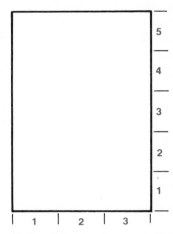

Figure 2-5. *Standard proportion for a printed page.*

come in standard sizes of 3 × 5, 4 × 6, or 5 × 7 inches. Book pages, stationery, and advertising flyers are commonly 5 × 7, 8 × 10, or 8½ × 11 inches. A square shape (equal in height and width) is seldom used for printed materials because it is static and uninteresting.

Proportion also includes the placement of elements in relation to the center of the page. Normally the reader's eyes first focus on the *visual center* of the page, a point approximately one third from the top of the page. The designer can use this fact to present important material first, Figure 2-6, and then direct the reader to other places on the page.

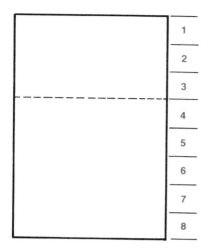

Figure 2-6. *The line where the reader's eyes first come to rest.*

UNITY

Unity holds the design together through the use of similar shapes, Figure 2-7, similar type styles, Figure 2-8, or similar

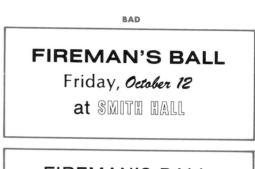

BAD

FIREMAN'S BALL
Friday, *October 12*
at SMITH HALL

FIREMAN'S BALL
Friday, October 12
at Smith Hall

GOOD

Figure 2-8. *Using type as a unifying factor in design.*

BAD

GOOD

Figure 2-7. *Using the same basic shapes as a unifying factor.*

Figure 2-9. *Using color as a unifying factor in design.*

colors, Figure 2-9. All elements should look as if they belong together.

COLOR

Color usually adds interest to a printed piece and makes a design more attractive. It also presents some new problems for the designer. Some colors look good together; others appear to clash or create a disturbing feeling. Colors can also create moods. For example, red, orange, and yellow seem to be warm and exciting, while green and blue are considered cool and calming. A good designer will use these principles to advantage.

A color wheel, Figure 2-10, is a very useful tool for the designer. It provides a ready guide to selecting colors that go well together and to specifying a given color to the printer. There are three pigment primary colors that, in theory, can produce every color possible. These pigment primaries are *cyan,* a blue green color; *magenta,* a light red; and *yellow,* Figure 2-11. Although some people call cyan blue and refer to magenta as red, cyan and magenta are not true blue and red.

When equal amounts of two of these primaries are mixed, a *secondary* color results. Magenta mixed with cyan will produce a dark blue color. Cyan and yellow together will result in green. Magenta and yellow will produce red, Figure 2-12.

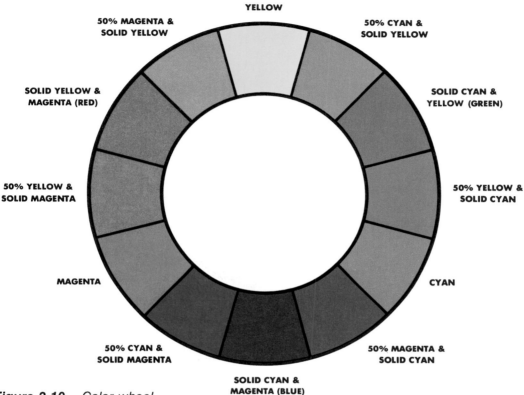

Figure 2-10. *Color wheel.*

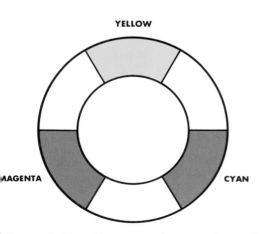

Figure 2-11. *Pigment primary colors of the color wheel.*

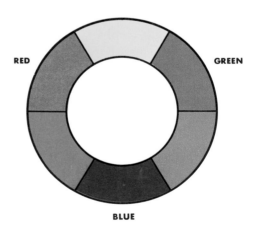

Figure 2-12. *Secondary pigment primary colors made by mixing two of the adjacent primaries.*

Intermediate colors fall between the secondary colors and the primaries. For example, orange falls between red and yellow on the color wheel. Its position on the color wheel indicates that there is more yellow than magenta in orange.

Two other color terms that the beginner must understand are *tint* and *shade.* If white is added to a color, a tint of that color results. If black is added to a color, a shade of that color is produced. See Figure 2-13.

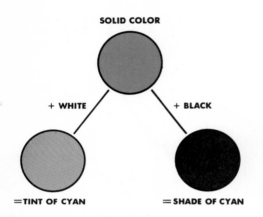

SOLID COLOR

+ WHITE + BLACK

=TINT OF CYAN = SHADE OF CYAN

Figure 2-13. *A tint and a shade of a solid color.*

One of four basic color combinations may be used in a good design: mono-chromatic, analagous, complimentary, or triadic. Monochromatic, meaning "one color," uses a single color with shades or tints of that color. For instance, cyan, a shade of cyan, and a tint of cyan go very well together, as shown in Figure 2-14. This is a monochromatic color scheme.

An analogous color scheme uses two colors that are adjacent on the color wheel. A design using orange and yellow would be analogous. So would an illustration with magenta and violet, Figure 2-15.

Figure 2-14. *Example of a monochromatic color scheme.*

Figure 2-15. *Example of an analogous color scheme.*

Figure 2-16. *Example of a complementary color scheme.*

Figure 2-17. *Example of a triadic color scheme.*

Complementary colors are those directly opposite on the color wheel. These colors may be used together in a design without causing any problems. An example of this would be the use of blue and yellow, Figure 2-16.

A triadic color scheme uses any three colors that are equally distant on the color wheel. For example, the primaries of cyan, magenta, and yellow go very well together, Figure 2-17.

Black and white, of course, go well with any of the color schemes.

TYPE

The printed word is the heart of the message you want to communicate. The type style or the design of the letters you choose helps communicate that message, Figure 2-18. Type can be classified in six main styles: roman, square serif, sans serif, script, text, and occasional or specialty types.

$$\mathfrak{LOVE} \quad \text{LOVE}$$
$$\text{LOVE} \quad \textbf{LOVE}$$
$$\textbf{LOVE} \quad \mathcal{LOVE}$$
$$\text{LOVE} \quad \mathit{Love}$$

Figure 2-18. *The style of type can change the meaning of the message. (Typographic Sales, Inc.)*

Roman Type

Roman type is probably the most commonly used style of type in the world. It is characterized by short, light lines, called serifs, at the ends of the main

strokes of the letters, Figure 2-19. Stone engravers in the Roman Empire first used these strokes to indicate the ends of letters and the ends of ascenders and descenders.

BAUER BODONI BOLD a
MELIOR 1234567890 a
AMERICANA BOLD 1

Figure 2-19. *An example of Roman type. (Typographic Sales, Inc.)*

Variations in serifs have resulted in three styles of roman type: old style, modern, and traditional. Old style has uniform letter strokes and rounded serifs. Modern roman uses heavier strokes, some hairline strokes, and straight serifs. The transitional roman combines features of the old and modern. It has long, but slightly rounded serifs, and letter strokes that are more uniform in thickness than the modern style.

Roman type, Figure 2-19, is one of the easiest typefaces to read. It is a familiar face used in books, magazines, and newspapers, and imparts a feeling of tradition and order.

Square Serif Type
Square serif type is a geometrical style of type, Figure 2-20. The *O's* are perfectly round and the letters uniform in weight with serifs the same weight and shape as the main strokes of the letter. It is a very legible type, easy to read at great distances. For this reason square serif type is widely used in outdoor advertising and for large headlines to capture the reader's attention. Square serif type gives a feeling of boldness and strength.

SERIFA 1234567890 a
STYMIE EXTRA Bold
LYONS EGYPTIAN ABCD

Figure 2-20. *An example of square serif type. (Typographic Sales, Inc.)*

Sans Serif Type
Sans is a French word meaning *without.* So literally, sans serif means without serif. The letters are uniform in structure and weight and without ornamentation, Figure 2-21. Since sans serif letters resemble hand printing, the drafting industry uses this type style for plans and structural drawings. It is an innovative and clean looking face, and can be used when quantities of type are to be set without looking cluttered. Because of this, sans serif type is often used in advertising. More and more textbook and newspaper publishers are adopting the sans serif style as well.

FUTURA LIGHT 12345
SPARTAN BOLD 123456
HELVETICA 1234567
Gil Sans Italic 123 abcdefgh

Figure 2-21. *An example of sans serif type. (Typographic Sales, Inc.)*

Script Type

Script type resembles handwriting, Figure 2-22. The letters have no serifs but vary in weight, almost touching each other in the line of type. Script type is used mainly for announcements and invitations, and sometimes for formal stationery. It gives a personal, handwritten appearance.

Park Avenue ABCDEF a

Medici Script ABCD abcd

Snell Roundhand Script abc

Venture Script abcdefghijkl

Figure 2-22. *An example of script type. (Typographic Sales, Inc.)*

Text Type

The first type cast as movable type by Gutenberg was text type. It was designed to imitate the hand lettering of the scribes and monks in medieval Europe. Text type, Figure 2-23, is a heavy face sometimes referred to as black letter or Old English. It is generally used in formal announcements, wedding invitations, church literature, and religious greeting cards. It gives a feeling of antiquity and reverence.

Engravers Old English
ABCDEFGHIJK

Cloister Black
ABCDEFGHIJKLM

Figure 2-23. *An example of text type. (Typographic Sales, Inc.)*

Occasional Type

Occasional or special type includes typefaces that do not fit into other categories, Figure 2-24. It is made up for a special reason or to impart a special feeling. A manufacturer, for example, may own through trademark and copyright, certain type styles designed for special products. The distinctive typeface advertises a product and interests the buying public.

WINDSOR OUTLINE

STENCIL 123456

BABY ARBUCKLE ABC 123

BROADWAY 12

Figure 2-24. *Examples of occasional type. (Typographic Sales, Inc.)*

LAYOUT PRINCIPLES

A layout is to the printer what a blueprint is to a contractor. It describes in detail what is to be done to complete the printed job. There are three types of layouts: thumbnail, rough, and comprehensive.

A thumbnail layout, Figure 2-25, is the first step in designing a printed piece. It is a rough, quick sketch generally not drawn to scale. It presents the designer's first ideas. The thumbnail layout shows type as simple pencil lines. Photos or drawings appear as rough sketches. The thumbnail is for trying out different placement of type, pictures and lines, or anything that might help the final printed product. This is the time to quickly jot down ideas, good or bad. Weak ideas can be eliminated later.

Figure 2-25. *Typical thumbnail sketches.*

The rough layout is the next step in design. From the many thumbnails, the designer chooses one or more of the best designs. The design is then more carefully refined and drawn to scale to determine if it will be right for the job, Figure 2-26. From the best rough layout, the designer goes on to prepare a comprehensive layout.

Figure 2-26. *The selected thumbnail sketch is refined into a rough.*

A comprehensive layout, Figure 2-27, is the final step in designing a printed job. The designer, using drafting instruments prepares a comprehensive layout as close as possible to the final printed product. The comprehensive is the final blueprint for the job. It must be exact in size and very accurate. It is usually prepared on the same paper that will be used for the final printing or on white cardboard.

Figure 2-27. *The rough is further refined into a comprehensive.*

Finally the designer protects the comprehensive layout with a tissue overlay taped to the top of the layout. On this overlay, the designer gives instructions for the printer, such as:

1. Type style and size;
2. Weight and color of paper;
3. Size, style and spacing of each block of type;
4. Ink colors;
5. Specific instructions for photos, drawings, and illustrations;
6. Number of finished copies and other information to aid the printer in finishing the job.

COPY FITTING

When the comprehensive is complete, the designer must determine how much copy will be needed to fill the given spaces. Here is a simplified way to find out how much type is needed for a block of type two inches wide and four inches deep:

1. Select a typeface and size from a type specimen book.
2. Measure the width needed (two inches) along the alphabet sample and count the number of characters within the measured width.
3. Next insert a sheet of paper into your typewriter. Starting from the left margin, tap the space bar once for each character counted in step 2. Set the right hand margin. Your average line width is now set.
4. Now determine the number of lines needed. Multiply the column depth (4 inches in our sample) by 72 points (the number of points per inch). Divide the depth (288 points in our case) by the sizes of the type selected (10 points for example). This gives us 28.8 lines. Only 28 lines may be set; 29 lines would be longer than the 4 inches allowed.
5. If you want spacing or leading between the lines of type for better appearance or greater readability, add the leading to the type size. For instance, for two points of leading with 10 point type, divide the column depth by 12. In the sample above this would be 288 points divided by 12 or 24 lines to fill the four inch column.

When typing your sample for the typesetter, there are a few things to keep in mind. Use lowercase (small) letters rather than capital letters because typeset material will contain more lowercase letters than capitals per inch. Keep the lines about the same average width; some may be a little longer and some a little shorter. Always double space to allow for corrections and changes.

Other more complex methods of copyfitting are possible. In some cases the designer may begin with the given copy and have to calculate how much space the copy will fill when typeset. The designer may even have to estimate the size of a book to be made from a given manuscript. This may require advanced computations and the use of special tables.

The next step in preparing the printed job is the setting of type and the assembly of all the elements into a mechanical or paste-up.

discussion questions

1. What are the five basic elements of design?
2. How does each element of design contribute to a well-designed printing job?
3. Explain the difference between serif typefaces and sans serif typefaces.
4. List the three kinds of layouts and explain when each is used.
5. What is copy fitting and why is it important in layout and design?

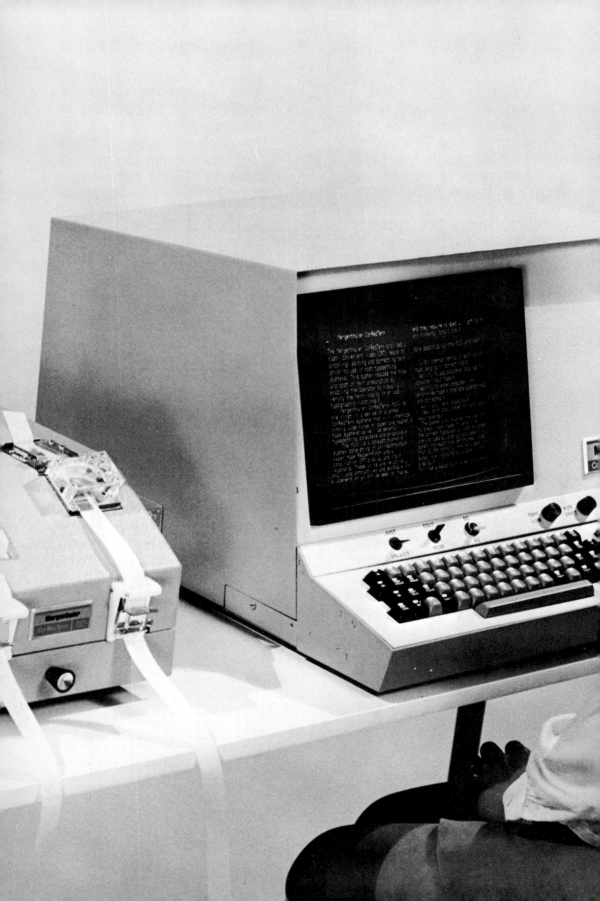

Chapter 3

image generation for lithography

hot type
cold type

Image generation or typesetting is setting type characters to make up words, sentences and paragraphs for books, magazines, newspapers, and other printed pieces. In this chapter you will learn about methods of setting type from the oldest style, hot type, to the more modern, photo composition. After reading this chapter, you will have a basic understanding of how to set characters into words, sentences, and paragraphs by various typesetting methods.

The two basic methods of producing type are hot type composition, using cast metal, and cold type composition, which includes direct impression and photosetting. Hot type includes all cast metal type whether set by hand or machine. Cold type refers to all other methods of setting type by a direct impression, such as typewriter type, hand-assembled alphabets, and photo processes. In recent years, typesetting has probably changed more than any other aspect of offset lithography. Hundreds of changes have taken place in typesetting.

HOT TYPE
Hand Composition

Just as Gutenberg did when he printed his Bible in 1450, the hot type compositor still places hot type (cast metal) characters into a hand-held composing stick, Figure 3-1. Words are composed from individual metal characters assembled into lines. When the line is almost filled, spaces are added so all lines will be uniform in width. This is called justifying the line. Justification improves

Figure 3-1. *Hand-held composing stick.*

readability by creating equal margins on both sides of the type. The compositor may also add metal strips, called leads or slugs, of varying thicknesses between the lines to set to a certain depth and improve appearance.

The compositor repeats this process line by line and page by page. Hand composition is at every step a slow process and is economical only for small or special printing jobs.

After the job is printed, the characters must be returned to their individual compartments in the job case. The most commonly used is the California job case, Figure 3-2.

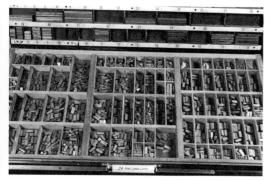

Figure 3-2. *California job case.*

Hand set type is rarely used for offset lithography. When it is, the operator inks the type and prints a reproduction proof (repro) on a proof press, Figure 3-3. The proof is pulled (printed) on a sheet of opaque, coated paper or on translucent or transparent plastic film. Special materials have been developed for making reproduction proofs. The operator must take care to make an accurate reproduction of high quality.

Figure 3-3. *Reproduction proof press. (Vandercook)*

Machine Composition

Type can be cast ready for proofing on any one of four different makes of machines. Linotype and Intertype machines are called line casting machines because they produce full lines of type.

Monotype casting machines set single characters in correct sequence. Ludlow machines also cast lines of type, but the molds are set by hand.

Line Casting Machines. Linotype and Intertype machines cast individual lines of type to a predetermined length, Figure 3-4. The operator works at a keyboard similar to that of a typewriter, Figure 3-5. As each key is depressed, a small mold or matrix drops from a storage case, called the magazine, and falls into an assembly elevator. A separate matrix or mold is required for each size and style of type.

Figure 3-4. *Slug from a linotype.*

LINECASTING MACHINE

CASTER KEYBOARD MAGAZINE

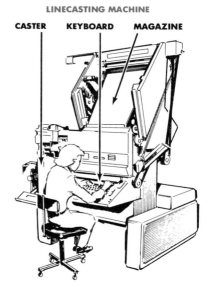

Figure 3-5. *A line casting machine.*

As each word is assembled, the operator inserts a space band. The space band will automatically justify the finished line of type, Figure 3-6. When the assembly elevator is full of matrices and space bands, the operator moves it up and the line automatically moves into casting position. There the line is pressed against a disc and molten metal is forced against the matrices forming a line of type. After it is cast, the line of type, now called a slug, is ejected from the mold, and the matrices and space bands are returned to their storage area for reuse.

Figure 3-7. *A teletypewriter to punch paper tape. (Mergenthaler Linotype Co.)*

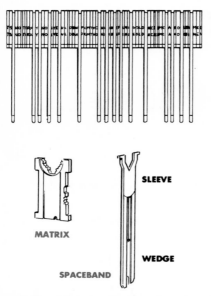

MATRIX

SLEEVE

WEDGE

SPACEBAND

Figure 3-6. *Mats and space bands ready to be cast.*

the machine. Normally several typists are needed to keep one tape-controlled line casting machine operating at full capacity.

Teletypesetting can also be done by telephone as in the case of Associated Press and United Press lines. The terminal teletype machine receives the coded signals and delivers perforated tape directly to the line caster without an operator being present.

Monotype. Unlike line casting machines, the Monotype casts each character separately. A Monotype machine is made of two distinct units, a tape perforator and a type caster, Figure 3-8. As the operator types the copy, a perforated tape is made which will be used to

Some line casting machines are semiautomatic. They produce a perforated teletypesetting (TTS) tape produced by an operator working at a special keyboard, Figure 3-7. The paper tape, about an inch wide, is then fed into a special unit on the line caster. The machine sets type from the coded perforations. This method of typesetting is limited only by the casting speed of

MONOTYPE SYSTEM

KEYBOARD

TYPECASTER

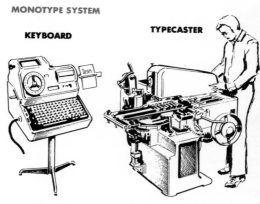

Figure 3-8. *A Monotype system.*

direct the type caster. This tape is much wider than the usual teletypesetting tape, resembling instead a paper roll used on a player piano, Figure 3-9. As the operator types, a counting mechanism registers the width of each character. At the end of the line, a bell rings to signal the operator to press space keys to fill out the line. When the job is complete, the operator feeds the roll into the type caster to cast the letters and spaces.

positor assembles the matrices (type molds) by hand in a special composing stick, Figure 3-10. The casting mechanism automatically casts the type. As with Intertype and Linotype, the Ludlow makes a new slug for each line, providing an unlimited supply of type.

Figure 3-10. *Ludlow composing stick.*

The Ludlow is used primarily to set large sizes of type for headlines and ads. Printers seldom use the Ludlow for jobs with large amounts of text type because it is a slow machine. However, it is capable of setting the special large type that other hot metal machines cannot handle.

COLD TYPE

Cold type generally includes such typesetting methods as hand mechanical, preprint, strike on, and photomechanical typesetting.

Hand Mechanical Cold Type

Hand mechanical type can take many forms. The most direct is simply head

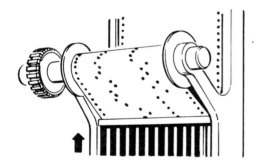

Figure 3-9. *Monotype paper roll.*

Monotype has an advantage when setting certain types of copy such as complicated forms and charts, or mathematical and scientific material where special symbols are needed. Corrections can easily be made by hand instead of by machine.

Ludlow. Ludlow typesetting uses both hand work and machine work. The com-

Figure 3-11. *Speedball tips and letters. (Hunt Manufacturing Co.)*

lettering. When done by a skilled calligrapher, beautiful and sophisticated lettering results. Many special lettering pens, Figure 3-11, and devices, guides, and templates are available to help the hand letterer produce work of very high quality.

Preprint Cold Type

The preprint method of composition with cold types uses clip art, art type or dry transfer type. Clip art is commercially prepared and available in sheets or books. Art type and dry transfer type, Figure 3-12, are available in different forms. Usually individual letters are printed on a plastic sheet with a pressure-sensitive adhesive behind the

characters. To set this type, the operator lines up the letters and presses them down so they adhere to the mechanical or layout.

Sometimes the letters come printed on paper sheets. Then the characters are simply cut off, assembled in a stick, and pasted down on the mechanical. Preprint composition is used mostly for headlines and large display type. It is not normally used for body type.

Strike-on Cold Type

The third method of cold typesetting, strike-on or impact typesetting, uses special typewriters called impact composers, Figure 3-13. Standard typewrit-

Figure 3-12. *The method of applying dry transfer letters.*

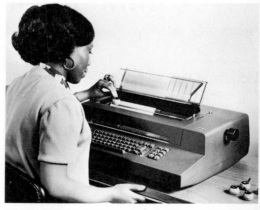

Figure 3-13. *A typical impact composing machine. (IBM Office Products Division)*

This is an example of strike-on composition with a carbon ribbon, 200% magnification.

This is an example of strike-on composition with a cloth ribbon, 200% magnification.

Figure 3-14. *The difference between regular and carbon ribbons can be easily seen when the type is enlarged.*

ers are not often used for commercial printing because all letters on the typewriter take up the same width. An *i*, for example, takes up the same amount of space as a *w*. A strike-on composer, however, allows much less space for an *i* than for a *w*. This is called proportional spacing and results in a more pleasing appearance. In addition, an impact composing machine uses a carbon ribbon which produces sharp, black letters, Figure 3-14.

The printing industry uses several machines for direct impression composi-

tion, among them the Varityper, Figure 3-15, the Justowriter, Figure 3-16, and the IBM Selectric Composer, Figure 3-17. The typefaces on these machines are designed to add space proportionately to justify the type.

The Varityper, Figure 3-15, carries two fonts (type styles) on the front wheel so it can mix two styles of type on the same line. It cannot, however, mix different sizes on the same line. To justify type, the operator must type each line twice. The line length is set by adjusting the carriage. As the operator types a line, a

light and dial indicate when the line is within justification range. When the line is typed again, a word-spacing mechanism in the machine adds spacing between words to justify the line.

The Justowriter, Figure 3-16, is a keyboard typesetter that produces a punched paper tape similar to that of automatic line casters. The Justowriter is made up of two units. The first punches a tape with special line endings and justification codes. At the same time it types a copy that can be proofread. The operator then feeds the tape into the second unit which contains two tape readers. The first reader adds or subtracts spacing to justify the printed line. The second reader activates a typesetter which produces finished and justified copy on reproduction paper.

The original IBM Selectric Composer is similar to the Varityper in that it is a single unit and requires two typings for

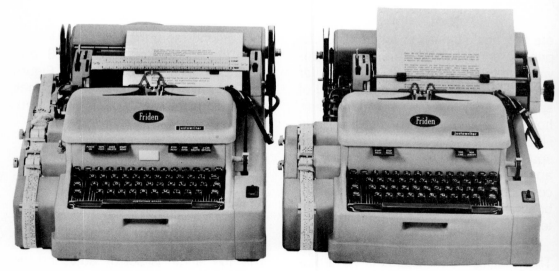

Figure 3-15. Varityper composing machine.

Figure 3-16. Justowriter composer. (Friden)

justification. It carries one single font on a type element, a removable golf-ball shaped piece. Having to replace the type element to change type styles makes mixed composition difficult. As with the Varityper, the operator can change type styles but not sizes within a line.

Figure 3-17. *The IBM MTST system.*

The MTST system, Figure 3-17, forerunner of the new IBM composer, records the typed material on magnetic tape and encodes line length, caps, punctuation, and other factors. The encoded tape is then fed into a special selectric composer that produces final justified copy. If errors appear on the input tape, a second corrected tape can be merged with the first tape to prepare a third tape used to produce the final composition.

The new IBM Selectric Composer is very similar to the original composer with only one major change. The copy does not need to be retyped. The typing is done automatically by the machine, thereby eliminating half of the typing and allowing corrections to be made prior to the machine typing the copy.

This is made possible by a computor-like memory system which is built into the composer.

Photomechanical Cold Type

The fourth type of cold typesetting includes both photolettering and phototypesetting.

Photolettering. Photolettering, sometimes called photodisplay, is primarily the setting of headlines and display text, letter by letter. There are two types of photolettering machines. One exposes photographic paper in direct contact with the film negative matrix. The other exposes the paper by projection as in a photo enlarger. With the projection method, the operator can enlarge or reduce the type as needed.

The first photolettering machine, the Headliner, was developed in the 1940's by the Varityper Company. The Filmotype followed in the 1950's. In both of these machines, the matrix is in direct contact with the photoprint paper.

In recent years, a variety of photolettering machines has appeared on the market offering a wide selection in design, classification, and flexibility. All of these machines use negative film fonts of type characters on strip film, film chips, or laminated slides. Letter selection may be completely manual, semi-automatic,

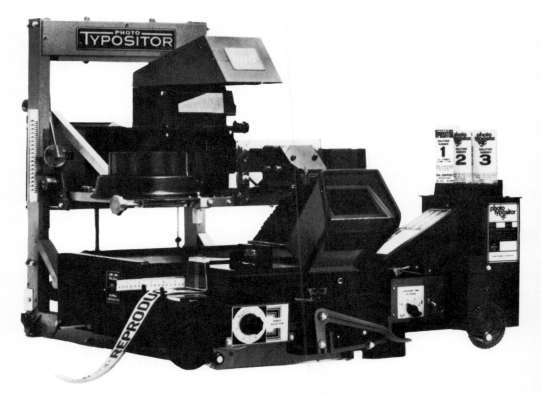

Figure 3-18. *A photolettering machine with internal developing. (Visual Graphics Corp.)*

or fully automatic. Most of these photo-lettering machines have simplified photographic processing systems built in. One of the most advanced and versatile projection photolettering machines is the Photo Typositor, Figure 3-18. It can enlarge and reduce type, slant and curve typefaces, and perform a variety of special effects with a single film strip or matrix. The Compugraphic 7200, Figure 3-19, has a separate processing unit.

Phototypesetting. Phototypesetting, also called text typesetting, is generally set a line at a time. All photographic typesetting requires three elements: a master character image or font, a light source, and a light-sensitive material.

The first practical phototypesetter, the Fotosetter, was sold by Harris Intertype in the 1950's. Since then, several categories (called generations) of photo-typesetters have been developed. Machines in each of these generations are

Figure 3-19. *A photolettering machine which has a separate processing unit. (Compugraphic Corp.)*

still in demand and have a definite place in typesetting.

First generation phototypesetters are adaptations of line casting machines. The Fotosetter is really an intertype that uses modified hot metal matrixes, Figure 3-20. Each matrix contains negative characters through which the exposure is made. It has a keyboard which is almost identical to that of hot metal machines. Characters are exposed at the rate of about five to ten characters per second. These first generation Fotosetters are mechanical and use tungsten light sources.

FIRST GENERATION

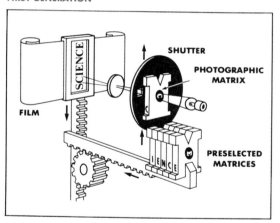

SHUTTER

PHOTOGRAPHIC MATRIX

FILM

PRESELECTED MATRICES

Figure 3-20. Photosetter with matrix. (Eastman Kodak Co.)

To meet the need for more speed and flexibility demanded by a higher volume of work, a second generation of photo-typesetting machines was introduced in the mid-1950's. The Photon 200-B was the first working example. In second generation phototypesetters, the character matrix is mounted in negative form on a disc. As the operator keyboards copy, the machine stores this information in a memory unit. At the operator's

signal, the memory feeds the information into a photo unit. The photo unit then exposes the line of characters through a spinning disc onto the film or paper, Figure 3-21. These electromechanical machines expose ten to twenty characters per second and have great flexibility in the selection of typefaces.

With the introduction of computers, paper tape, and magnetic tape, a higher speed phototypesetter which could use off-line keyboards was introduced in the mid-1960's. A computer is used to feed tape and set type at a rate of about 500 characters per second.

SECOND GENERATION

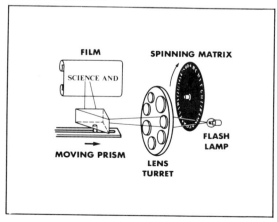

FILM

SPINNING MATRIX

SCIENCE AND

FLASH LAMP

MOVING PRISM

LENS TURRET

Figure 3-21. Photo drawing. (Eastman Kodak Co.)

But even this speed was not enough to keep up with computer output. Through a combination of telephone and electronic data processing technology, electronic manufacturers were able to bring about a third generation machine. This machine, Figure 3-22, uses a cathode ray tube, similar to a television picture tube, to display the image and set a whole page at a time. It sets more than one thousand characters a second directly from magnetic tape.

THIRD GENERATION

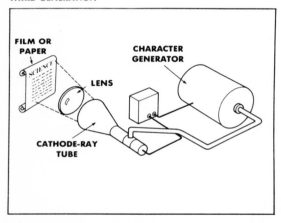

Figure 3-22. *CRT system. (Eastman Kodak Co.)*

A fourth generation phototypesetter, presently being developed, uses a laser to create an intense light beam, Figure 3-23. The operator feeds copy in through magnetic tape, paper tape, or floppy discs. A minicomputer then controls a laser beam as it moves rapidly back and forth across photographic film or paper. Characters are produced dot by dot, in either negative or positive

FOURTH GENERATION

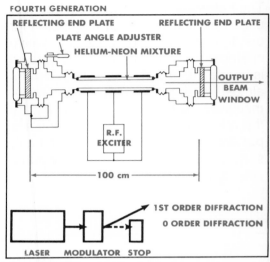

Figure 3-23. *Laser system.*

form on film or on paper. A Lasercomp is shown in Figure 3-24. These machines are generally smaller than other systems and have fewer parts requiring service.

Figure 3-24. *A Lasercomp typesetter. (Monotype International)*

Other Hardware. Other hardware that is used in modern typesetting includes the optical character recognizer (OCR), Figure 3-25. This machine scans a line or a page of typewritten material and automatically makes a record on paper tape for the phototypesetting unit. The OCR eliminates the retyping normally required to produce a tape.

A video display terminal (VDT) Figure 3-26, is a unit that uses a cathode ray tube. The VDT screen shows the keyboarded copy on a screen. Some VDT's show all the various codes on the screen. Other VDT's show the material exactly as it will be typeset, so line up and fit can be checked before typesetting is done.

The VDT allows the operator to see and make changes to the copy. Some large newspapers actually set up full pages on VDT's. Reporters feed stories into the computer with OCR's. The material is then edited, formatted, and corrected

Figure 3-25. *Optical character recognition (OCR) unit.*

Figure 3-26. *A VDT unit.*

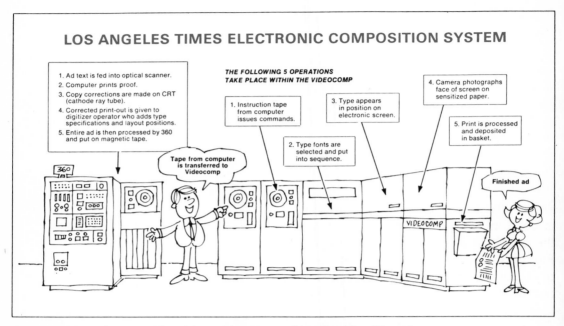

Figure 3-27. Setting ads with a videocomp. (Los Angeles Times)

on a VDT and sent directly to an on-line typesetter. The same operation is used for setting ads, Figure 3-27. Use of the VDT editing unit eliminates the need for rekeyboarding corrected copy and therefore speeds up composition.

Figure 3-28. A floppy disc.

A recently developed aid to phototype-setting is the floppy disc, Figure 3-28. It is a thin, flexible disc, similar in appearance to a phonograph record. It is mounted inside a carrier resembling a record jacket. The floppy disc records and stores electronic data. The main advantage of a floppy disc is almost instant retrieval of information. The operator does not have to run through yards and yards of tape to find an exact spot on the tape. Most new phototype-setters using video display terminals, Figure 3-29, use a floppy disc recording unit.

Phototypesetting is very complex. It is impossible to give specific instruction on how to run all phototypesetters in a book of this type. For further information you should rely on the manufacturer's manual for each piece of equipment.

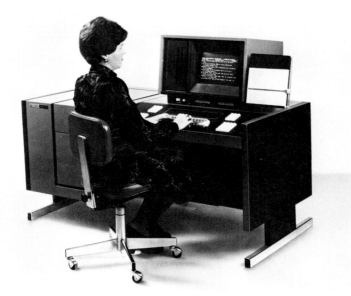

Figure 3-29. *Compugraphic 7500 with VDT. (Compugraphic Corp.)*

discussion questions

1. What are the two basic methods of producing type?
2. What are the advantages of each of the two methods of producing type?
3. List some of the various methods of setting cold type.
4. What is the difference between photolettering and phototypesetting?
5. Describe the operation of a first generation phototypesetter.
6. List some advantages of a video display terminal for phototypesetting.
7. What is the floppy disc and why is it useful in typesetting?
8. Explain what impact typesetting is.
9. What is the main advantage of using an optical character recognizer?

Chapter 4

copy
preparation
for
the
camera

proofreading

fitting copy

line copy

continuous tone copy

paste-up preparation

Once the printed piece is designed, the illustrations chosen, and the type set, all the elements can be put together into a single composite, called a *mechanical*. This process is called *paste-up.* After you have studied this chapter, you will understand how to prepare copy for the process camera and be able to do simple paste-ups.

PROOFREADING

After the type has been set, someone must read the material carefully to make sure there are no typographical errors. This person, called a proofreader, uses standard marks and symbols, Figure 4-1, to mark corrections. The printer then resets corrected portions of copy based on the proofreader's marks.

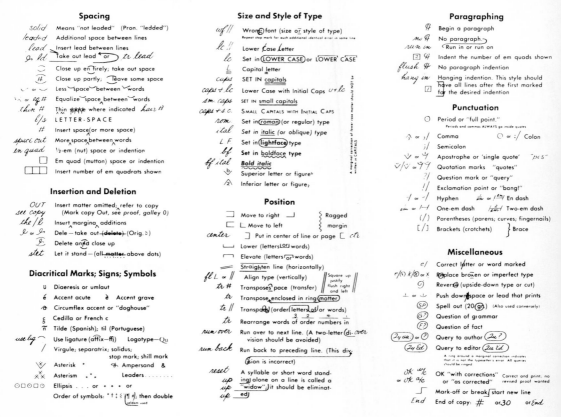

Figure 4-1. *Proofreaders' marks.*

FITTING COPY

Many different elements are combined in a finished mechanical. There may be photographs, drawings, headlines, text type, display type, all needed for the final printed product. Some of these pieces may be the wrong size for the finished piece. We may have to enlarge or reduce some of the copy to fit the space indicated on the comprehensive layout. Enlarging or reducing copy to fit is called *scaling* copy. Various methods of scaling are possible.

The most popular way of changing copy size is by using a proportion scale, Figure 4-2. Identify the wheel marked *original size* and the one marked *reproduction size.* When you line up the original size with the reproduction size wanted, you can read in the window the percentage at which to shoot on the process camera. For example—you have a photograph 9 inches by 12 inches to be fit into a space 4½ inches by 5 inches. Align the 9 on the original size wheel with the 4½ on the reproduction size wheel. The reading in the window is 50%. Then line up the original dimension 12 with 5 on the reproduction wheel. The reading is 42%. Now you must choose one of these sizes.

If the photograph is to fill a given area on the mechanical, you select the largest size because you could not accept an area not being filled. The stripper must decide what part of the photo to trim away. This is called *cropping.*

If, on the other hand, the material you are scaling is type, you cannot crop it. Therefore you would choose the smaller percentage.

The percentage you choose depends on the final use of whatever you enlarge or reduce.

A second way to scale copy is called the diagonal line method, Figure 4-3, a simple method of determining reduction or enlargement. It requires a geometric drawing for each piece of copy to be changed in size.

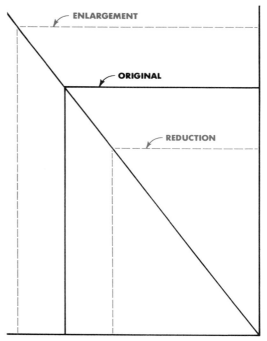

ENLARGEMENT

ORIGINAL

REDUCTION

Figure 4-3. *Diagonal line method of scaling copy.*

Figure 4-2. *Proportional scale for sizing copy.*

A third method of scaling, purely mathematical, uses a formula to find the unknown width and height, Figure 4-4. It is a simple ratio equation.

$$\frac{W}{H} = \frac{w}{h}$$

IN WHICH:
 W = ORIGINAL WIDTH IN INCHES
 w = WIDTH OF ENLARGEMENT OR REDUCTION IN INCHES
 H = ORIGINAL HEIGHT IN INCHES
 h = HEIGHT OF ENLARGEMENT OR REDUCTION IN INCHES

Figure 4-4. *Formula for scaling copy.*

LINE COPY

Line copy includes solid lines and areas with no gradations of tones. Line copy may be pen and ink drawings, graphs, charts, and even type, Figure 4-5.

Guide Numbers for Adjustable Cameras
Below film speed and across from shutter speed, read guide number

Tungsten Film Speed (See film inst. sheet)	10 to 16	20 to 32	40 to 64	80 to 125	160 to 250	320 to 500
Shutter Speed			**Guide Number**			
"X" or "M" Sync. Up to 1/30	95	140	200	280	400	550
1/60	90	130	180	260	360	500
"M" Sync. Only 1/125	75	110	160	220	320	440
1/250	60	85	120	180	240	360
1/500	46	65	95	130	190	260
1/750	34	50	70	100	140	200

For f-stop, divide Guide No. by distance in feet, lamp-to-subject.
(Example: If Guide No. is 160, distance 10 ft., lens setting 160÷10 is f/16.)
Guide for 4"-5" polished reflector; open ½ f-stop for others.

Figure 4-5. *Example of line copy. (Eastman Kodak Co.)*

Good typed matter should be very black and sharp. The type may be set photographically or with a carbon ribbon typewriter or with some other medium that gives a good dark image. Material set on a typewriter with a cloth ribbon is usually not adequate for good line copy.

Line illustrations must be prepared with black ink on white coated paper to give maximum contrast when photographed. Ink pens or ballpoints should have black reproducible ink. Felt tip pens should be avoided because they do not produce good tone values.

Specially prepared chart tape may also be used for doing line work on the mechanical. Adhesive backed tints, screens, and designs are also available and may be applied like rub-on letters. High contrast black dot patterns that contain no grays may also be used.

CONTINUOUS TONE COPY

Continuous tone copy includes grays as well as black and white. It may be a pencil or charcoal drawing, wash drawing, painting, airbrush rendering, or photograph, Figure 4-6. Continuous tone

Figure 4-6.
Example of continuous tone copy.

Figure 4-7. *Setup and materials for paste-up.*

copy is photographed through a screen. This breaks the image into various sizes of dots. When you look at the screened illustration, the dots will blend and appear as shadows and highlights. For the mechanical, it is sufficient to scale these illustrations to size and to allow space for them, Figure 4-7.

PASTE-UP PREPARATION

Be prepared before you begin the paste-up. The tools and materials you will need are:

- Drawing board and T-square

- Clear, plastic triangles, 45° and 30°-60°-90°

- Ruler or scale, marked in both inches and picas

- Cutting tool (such as an X-acto knife) with extra blades
- Scissors
- Light blue non-reproducing pencils for marking guidelines
- Writing and drawing pencils, black pens with various sizes of points, grease pencils
- Rubber cement with applicator or wax machine for waxing proofs
- Clean white or hard gum erasers and, if using rubber cement, a rubber cement pickup
- Masking tape and transparent tape (the kind you can write on)
- Other useful equipment: a compass, french or adjustable curves, opaque brushes, opaque fluid and any special materials needed for a particular mechanical or paste-up.

Procedure

The general procedure for completing an acceptable paste-up includes the following steps:

1. Line up the top edge of a sheet of cold-press illustration board that is approximately three inches wider and three inches longer than the finished page will be. Square the side edge with a triangle.
2. Hold down the illustration board with a T-square while taping down the four corners with masking tape, Figure 4-8. Check again that the sheet is aligned.

Figure 4-8. *Lining up sheet of illustration board for paste-up.*

3. With a light blue non-reproducing pencil draw a thin blue line to define the area of the printed page. With the same pencil outline the position of all the elements to be placed on the page.
4. Trim the reproduction proofs leaving at least a ⅛ inch margin.

Handle the proofs by the edges to keep the copy clean.

5. Place all the pieces on the mechanical but do not paste them down until you are sure of their position. When you are satisfied with the position of all elements, make a blue pencil dot on the illustration board at two corners of each piece. This will allow you to return each piece to that exact position.
6. Apply rubber cement or wax to the back of each piece, and adhere each element. Before pressing down, check the alignment with the T-square. When all elements are correctly placed, burnish them. To burnish, place a clean sheet of bond paper over the finished page and press down with your fingernail, a burnisher, or other smooth tool. The reproduction proof will now adhere firmly to the illustration board.
7. If you used rubber cement, clean around the edges of the repro by rubbing with a rubber cement pickup. If you used wax, carefully remove the excess with your X-acto knife.
8. Sometimes it is necessary to add or correct copy on the paste-up. In this case, it is usually better to paste the new copy right over the old to eliminate shadows when photographing. If the old copy is cut out and new copy is butted in, the valley shadow will usually show on the negative, Figure 4-9.

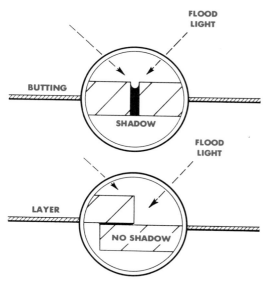

Figure 4-9. Shadow created by cut out insertion of correction.

9. Draw in any additional art work needed on the illustration board, such as rules or drawings not supplied by the typesetter or artist. If your mechanical includes only line art, you have finished, Figure 4-10. If your mechanical includes photographs, proceed to step 10.

Figure 4-10. Finished line paste up.

Figure 4-11.
Window on paste-up showing where photograph will go.

10. If your mechanical includes photographs, indicate the borders of the photograph with black or red artist's tape, or fill the area with rubylith or with an adhesive backed red film, Figure 4-11. When the copy is photographed, the taped areas will appear as transparent windows in the black negative. After the photographs are shot, they can be positioned under these windows and exposed along with the line art. Don't forget that sometimes the photos may have to be reduced or enlarged. The mechanical should show the finished size.

Another method of indicating photos on the paste-up is by drawing a thin, red line. This fine line then appears on the negative as a guide for the stripper to cut away the area with precision tools. The negatives of the illustrations can then be keyed or registered exactly in place under these windows. This process is called *keylining.*

A third method that is sometimes used to mark photos on the paste-up is called *veloxing.* A velox is a screened reproduction of the photo printed on paper. It is shot to the correct size for the paste-up. The velox is then treated as line copy and is positioned, trimmed, and pasted down on the illustration board.

11. Next extend the page borders by inking in two hairline trim marks at each corner of the blue line. Make them at least ⅛ inch from the corner, about ¼ inch long and very fine. The printer uses these marks to line up a paper cutter to trim the printed piece. If this is a one-color job, cover the whole mechanical with tissue and tape along the top edge. If the layout is to be in more than one color, proceed to step 12.

12. Apply or draw registration marks (little crossmarks) about ¼ inch outside the blue page borders, Figure 4-12. These marks are used to align one color to the next when printing on the press. If the registration marks do not coincide, the press and paper must be adjusted. Later the registration marks are trimmed off with the trim marks.

13. For each additional color attach with a strip of tape a piece of frosted acetate film to the mechanical. The acetate should cover the mechanical but be free to be turned all the way back, Figure 4-13.

14. Strip in registration marks on the acetate flap directly over the two on the mechanical below.

REGISTRATION MARKS

Figure 4-12.
Registration marks on paste-up.

Figure 4-13.
Acetate for second color attached to mechanical.

RUBYLITH

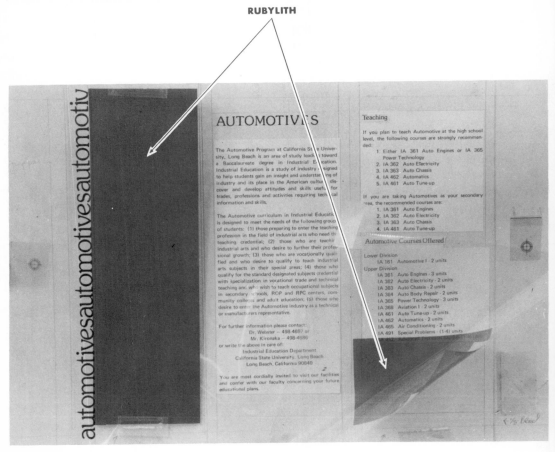

Figure 4-14. *Rubylith on acetate.*

15. Apply all materials that are to be in the second color on this overlay. Sometimes an adhesive backed red material or rubylith is applied to the acetate for the window preparation. This overlap is also used to indicate areas that will have a screen tint. Tints are also indicated with the red material, Figure 4-14.

If a third color is to be applied, lay another acetate sheet over the original and tape it along a second edge.

Margins outside the page dimensions on the acetate sheet and on the mechanical may be used for notes to the camera operator, Figure 4-15.

Figure 4-15. *Notes are placed in margins.*

16. After all the color overlays are in place and the mechanical is complete, cover the mechanical with a protective tissue sheet. This keeps the mechanical clean and allows room for additional notes to the camera operator. Finally clean the layout and touch up any imperfections, Figure 4-16.

Accuracy and cleanliness are the two most important factors in preparing a mechanical. They determine the quality of the finished printed piece.

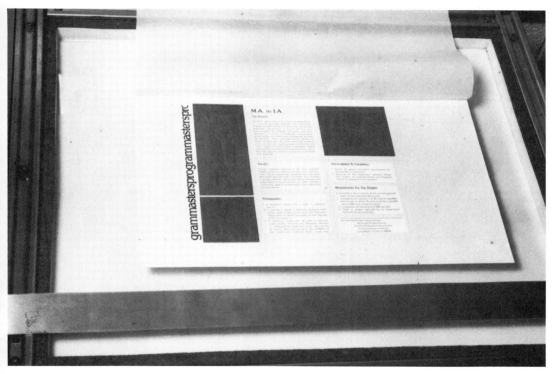

Figure 4-16. *Finished mechanical ready for camera operator.*

discussion questions

1. What is the process of combining type and pictures for camera called?
2. Why is the proofreader's job important?
3. What do we mean by scaling copy?
4. Explain the difference between line copy and continuous tone copy.
5. What are the three ways of indicating the placement of pictures in the final paste-up?
6. What are the two most important factors in preparing a mechanical?

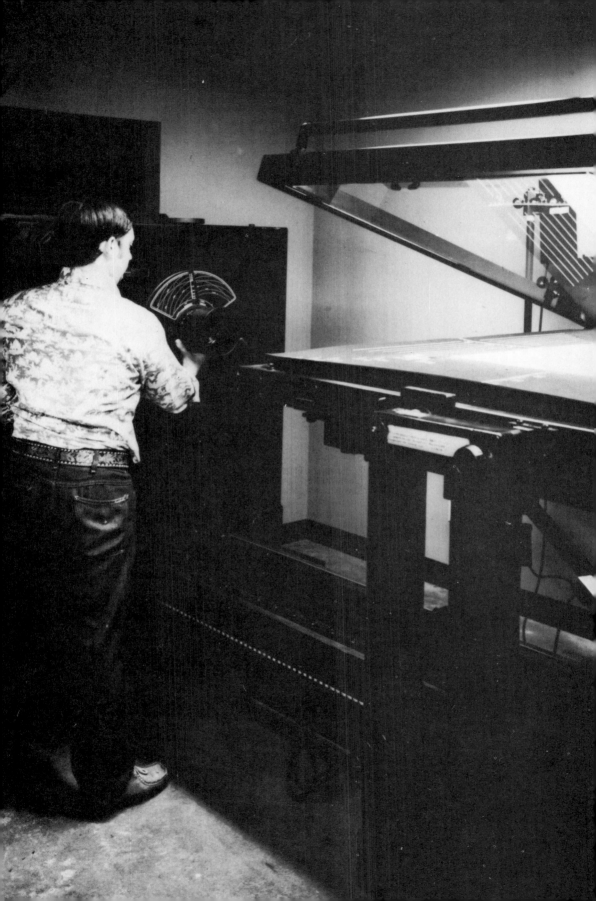

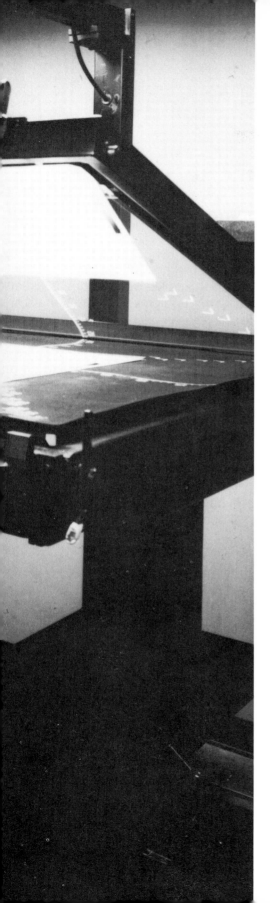

Chapter 5

line
photography

Photography is a way of recording an image. In the graphic arts this recorded image (negative) is used to make a printing plate. We then use the plate on a printing press to make many copies of the original. Graphic arts photography is sometimes called high contrast photography because only black and white areas are recorded on the film. Gray areas on the original become either black or white. Because printing presses cannot print different thicknesses of ink, they must work within these limitations. Therefore we must make photographic negatives that conform to these requirements.

For graphic arts photography a light-tight room, called a darkroom, is essential. Other equipment and materials are necessary as well. When you have completed this unit you will know how to set up a darkroom and how to shoot a line negative suitable for printing on an offset press.

DARKROOM

Almost any small room can serve as a graphic arts darkroom. But the darkroom should:
- be light-tight
- have about 80 square feet of floor space

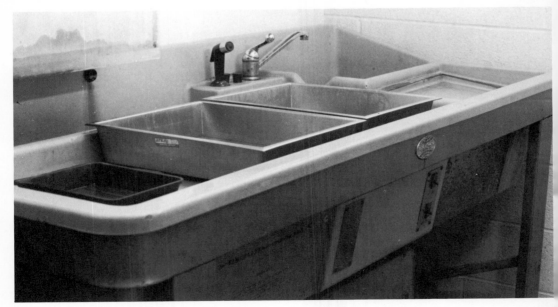

Figure 5-1. *Film processing sink.*

- include a sink, Figure 5-1, with hot and cold running water
- have some work surfaces
- be equipped with red safelights, Figure 5-2, and
- be adequately ventilated.

Many other features can be added to make the darkroom more functional and efficient, including:

- a light trap, which is a darkroom entrance designed to keep out light at all times, Figure 5-3

Figure 5-2. *A typical safelight for graphic arts film. (Aristo Grid Lamp Products, Inc)*

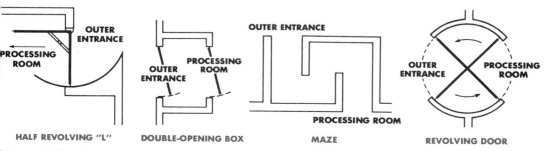

HALF REVOLVING "L" DOUBLE-OPENING BOX MAZE REVOLVING DOOR

Figure 5-3. *Various types of light traps.*

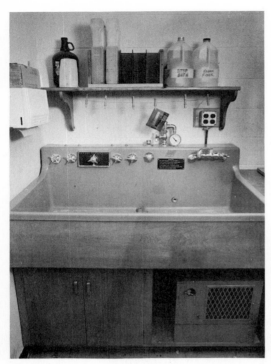

Figure 5-4. *A recirculating temperature controlled sink.*

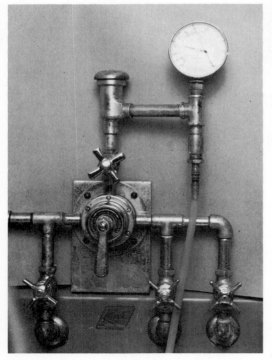

Figure 5-5. *A mixing valve for controlling water temperatures.*

- a temperature controlled sink, Figure 5-4, or a water mixer, as shown in Figure 5-5
- storage shelves and cabinets.

Darkroom Equipment

Trays, Figure 5-6, are used to hold the chemicals for developing and stabilizing. At least three trays are needed. They must be made of stainless steel, plastic, or hard rubber.

Figure 5-6. *Developing trays in a processing sink.*

A thermometer is necessary to check the temperature of developing solutions.

Mixing equipment includes graduated cylinders, beakers, and cups for accurate measurement and funnels for safety and ease in pouring, Figure 5-7. At least four airtight storage containers, one-gallon size or larger, are needed.

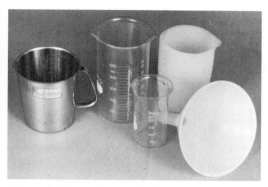

Figure 5-7. *Array of chemical handling containers.*

Timers, Figure 5-8, are used both on the camera (to control the length of exposure) and at the sink (to measure the development time).

PROCESS CAMERA

Process cameras are large cameras used to photograph artwork, type-proofs, photos and paste-ups. They are either vertical, Figure 5-9, or horizontal,

Figure 5-8. *Timer for film developing.*

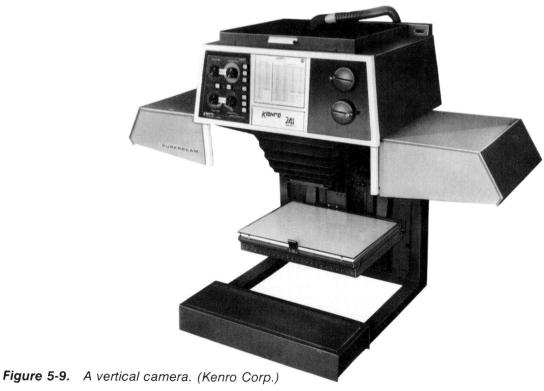

Figure 5-9. *A vertical camera. (Kenro Corp.)*

Figure 5-10. The bed of a vertical camera runs parallel to the wall. It is used where floor space is limited. A horizontal camera moves parallel to the floor. It is more popular and gives quality reproductions at maximum size.

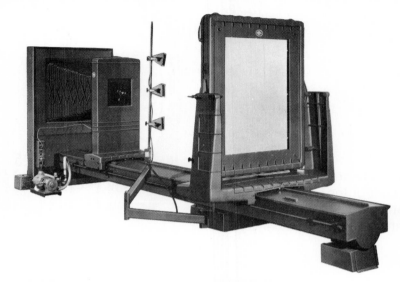

Figure 5-10. *A horizontal camera. (Brown Graphic Products)*

Parts of Process Camera and Their Function (Figure 5-11)

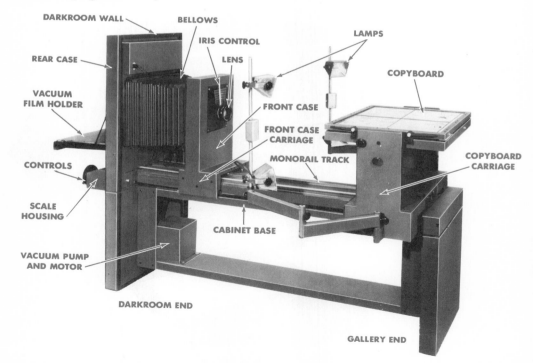

Figure 5-11. *The major parts of the process camera. (Brown Graphic Products)*

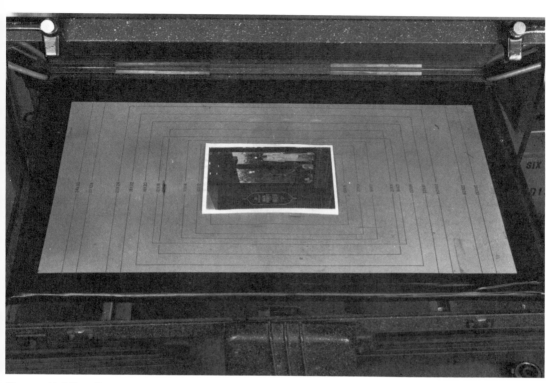

Figure 5-12. *Copy on a camera copyboard.*

Copyboard. The copyboard, Figure 5-12, is a flat gray board with a hinged glass cover to hold the copy to be photographed. Copyboards may have vacuum attachments, padding, transparency openings or backlighting.

Lamps. Bright lighting is necessary for photography in the graphic arts. There are many types of lamps available. See Figure 5-13. They include photoflood, mercury vapor, quartz-iodine, carbon arc, and pulsed xenon. Photofloods give the poorest quality light, while pulsed xenon provide the best light (closest to sunlight). The lights are usually placed to give even illumination on the film plane of the camera. Some lamps are connected to the copyboard so that they can move with it when enlarging or reducing. This allows the light level to remain constant on the copy.

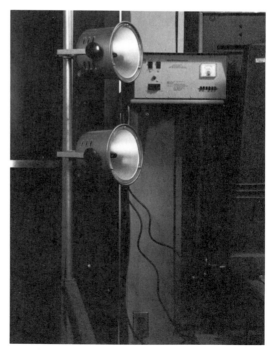

Figure 5-13. *A typical camera lighting system.*

CONVEX LENS NODAL DIAPHRAGM CONCAVE LENS
POINTS

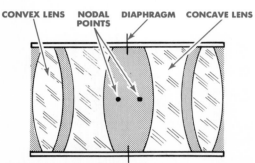

Figure 5-14. *Cross section of a process camera lens.*

Lens. A process lens, Figure 5-14, is made to give best results with flat copy. It is different from a regular camera lens, which is used to photograph three-dimensional subjects. The lens is the most delicate, critical, and expensive part of the process camera.

Lens Diaphragm (f/stop). The most common means of controlling the amount of light entering the camera is an arrangement of metal blades within the lens barrel, Figure 5-15. As the lens

RING OPERATED

Figure 5-15. *The lens diaphragm.*

collar is rotated, the blades open or close, allowing more or less light to strike the film plane. The f/stops have been numbered so that each successively smaller number doubles the aperture size and doubles the light admitted. For example, a setting of f/16 will admit twice the amount of light as a setting of f/22, Figure 5-16.

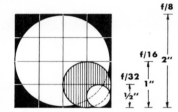

Figure 5-16. *Relative f/stop sizes.*

Camera Back. The camera back usually has two parts, Figure 5-17:

- film holder
- ground glass.

The film holder holds the film flat during exposure. This is usually done by suction created with a vacuum pump. The ground glass is used to view, focus, and adjust the image before the film is exposed.

Size and Focusing Controls. Process cameras are usually equipped with tapes, screws, scales, and other devices to help the camera operator position the lens and the copyboard when changing copy sizes, Figure 5-18.

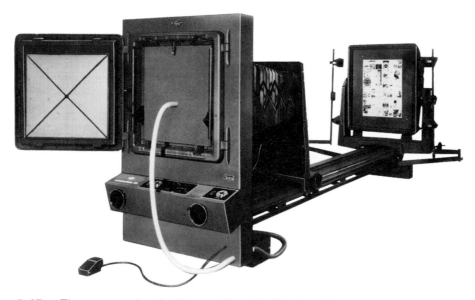

Figure 5-17. *The camera back. (Brown Graphic Products)*

Figure 5-18. *Sizing scales on a process camera.*

Film is the most important part of the photographic process. It is extremely delicate and should be treated with care. Film is made up of several layers, each important in making a good quality negative. The layers on a sheet of graphic arts film, from top to bottom, are shown in Figure 5-19.

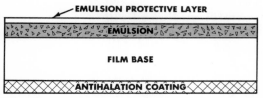

Figure 5-19. *Cross section of film.*

The protective coating is a tough, clear layer designed to protect the emulsion from scratches.

The emulsion is the critical, light-sensitive layer. It is made up of very small crystals of silver salts suspended in gelatin. When exposed to light, this layer changes chemically and records the image that can be seen after it is processed.

The base material can be paper, glass, acetate, polystyrene, or polyester. It is usually 0.003 to 0.008 inch thick and is transparent or translucent after being processed. The most popular base is polyester because of its dimensional stability (does not shrink or expand).

The antihalation layer contains a dye (usually red) that absorbs light rays that pass through the base material during exposure. Without such a backing, light rays may be bounced back to the emulsion, resulting in a secondary exposure. See Figure 5-20. The antihalation backing also helps prevent the film from curling when the emulsion has absorbed moisture.

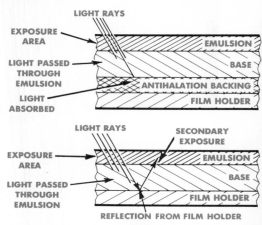

Figure 5-20. *Antihalation coating absorbing light.*

The emulsion side of the film is a lighter color than the antihalation side. Another way to identify the emulsion side is by the direction of curl. Usually the film will curl towards the emulsion side of the film.

Orthochromatic is the most common film used in graphic arts. This film is sensitive to 2/3 of white light; it will be exposed by blue and green. It is insensitive to (will not be exposed by) red, the other 1/3 of white light. This means the film can be handled under red safelights without danger of exposure. It also means that the film treats red copy as if it were black.

Film Handling

When handling film, you should always:

1. Open film boxes only under correct safelight conditions (usually 1A red for orthochromatic film).
2. Avoid sliding film over other sheets of film. To do so may cause scratches and sparks of static electricity, which will expose the emulsion.
3. Handle film only by the edges of corners to prevent chemical changes to the film. This is especially true if your hands are damp.
4. Place film only on clean surfaces and then with the emulsion side up. Leave the film in its box until it is ready to be used.
5. Store film in a vertical position, Figure 5-21, where the temperature is 68° to 75° F (20° to 24° C) and humidity is low.

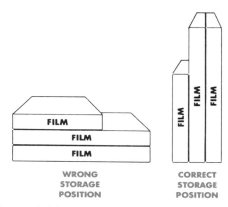

Figure 5-21. *Storage position of film.*

LINE PHOTOGRAPHY

The simplest form of camera work in the graphic arts is line photography. Line copy consists of solid and clear areas with no intermediate shades of gray, Figure 5-22. The copy is simply black on a white background, for example, lines of type. The resulting negative will have a black background with the type or solid areas and lines appearing clear. There should be no gray areas on the negative.

Figure 5-22.
Typical line copy.

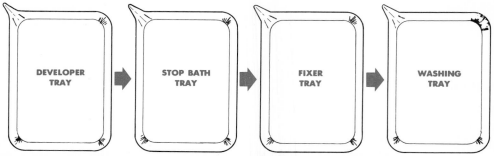

Figure 5-23. *The arrangement of chemicals in the processing sink.*

Making a Line Negative

The three major steps in making a line negative are setting up the darkroom, preparing the camera, and exposing and developing the film.

Setting up the darkroom:

1. Turn on the white lights and clean up any dust, dirt, or spilled chemicals.
2. At the sink, set the water temperature at 68° F (20° C). Set up a wash tray or wash compartment in the sink.
3. Place three trays, Figure 5-23, in the sink, developer tray at the left.
4. Prepare the developer by mixing equal amounts of Part A and Part B, Figure 5-24. Parts A and B are mixed either from liquid concentrate or from powder.

Follow the manufacturer's directions for mixing the solutions. Pour about an inch of the developer into the first tray. The leftover developer cannot be stored for future use.

5. Pour between one half and one inch of stop bath into the second tray. Mix the acid stop bath by pouring eight ounces (237 ml) of 28% glacial acetic acid into one gallon (3.8 liters) of water, Figure 5-25. NOTE: *Always add acid to water.* Many manufacturers make an *indicator* stop bath which is yellow when mixed with water. When the solution is exhausted, it will turn reddish purple, at which time it should be discarded.

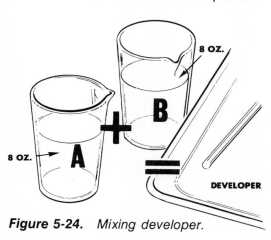

Figure 5-24. *Mixing developer.*

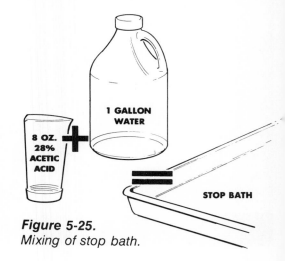

Figure 5-25.
Mixing of stop bath.

6. Pour about an inch of fixer into the third tray. Fixer comes in liquid or powder form. Mix according to the manufacturer's directions.

7. Store all chemicals in tightly stoppered, clearly labeled bottles or storage tanks, Figure 5-26.

The second step in making a line negative is preparing the process camera:

1. Clean the copyboard glass if necessary. Place the original copy in the center of the copyboard, Figure 5-27. On some cameras the copy must be placed upside down so that the image on the ground glass appears right side up.

Figure 5-26.
Chemicals should be labeled and stored in air-tight containers.

Figure 5-27.
Copy with gray scale placed on copyboard for exposing.

2. Place a sensitivity guide, Figure 5-28, on the copy, making sure you do not cover part of the image. The sensitivity guide provides a reference for processing later. It helps insure negatives of consistent quality.

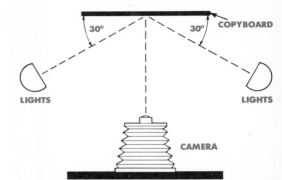

Figure 5-29. *Proper position for camera lights.*

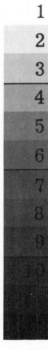

Figure 5-28. *Sensitivity guide. (Stouffer Graphic Arts Equipment)*

3. Close the copyboard cover and position the copyboard for photographing.
4. Adjust the camera lights to an angle of 30° to the copyboard, Figure 5-29. A 30° angle gives more uniform lighting than the 45° angle used by some camera operators. Aim four lights (two on each side) toward the four corners of the copyboard. This gives more even light than aiming all four lights toward the center of the copyboard.

5. Adjust the *f*/stop. Resolution is the ability of the camera to copy very fine, close lines without blurring them together. For the best resolution, set the lens stop two complete stops smaller than wide open, Figure 5-30. For example, if the lens is rated at *f*/10, set the stop at *f*/22.

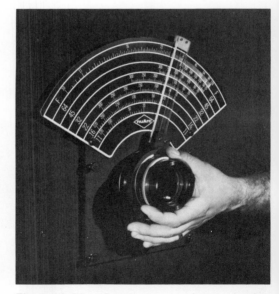

Figure 5-30. *Set the proper f/stop. (nuArc Company, Inc.)*

6. Adjust the camera copyboard and the bellows extension. Switch on the camera and check the image on the ground

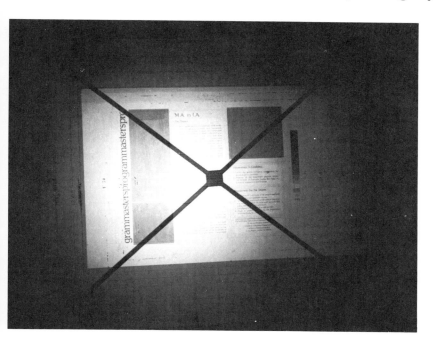

Figure 5-31.
*Checking
the image on
the ground glass.*

glass to make sure the size is correct and the image is in focus, Figure 5-31.

7. Set the camera timer, Figure 5-32, for the recommended line exposure time.

8. Turn off white lights and turn on red safelights.

9. Position a piece of the correct size of ortholith film so that it will receive all of the projected image, Figure 5-33. Turn on the vacuum pump if the camera has one. Check to see that the light-sensitive or emulsion side (light color) of the film faces the copy when the back of the camera is closed. Close the camera back.

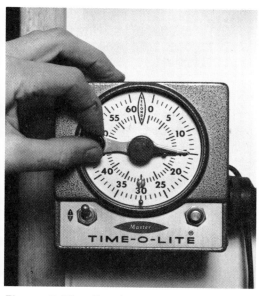

Figure 5-32. *Set the camera timer for the correct exposure.*

Figure 5-33. *Placing film on the camera back.*

developer by smoothly lifting alternate sides of the tray, Figure 5-35. Most camera operators develop a uniform pattern of agitation so they can repeat their results on future negatives.

10. Turn on the timer to expose the sheet of film.
11. When the exposure is complete, open the camera back and remove the film. (Turn off the vacuum pump if there is one.)

The last step in making a line negative is the processing of the exposed film. The latent image on the film cannot be seen, but the structure of the emulsion has changed where it was struck with white light reflected from the copy. Developing makes the latent image visible. The procedure for development is:

1. Pull the exposed film, emulsion side down, through the developer. Then quickly turn the film over and immerse it, emulsion side up, Figure 5-34. Agitate the

Figure 5-35. *Agitating the film in the developer.*

Do not agitate in one direction only. To do so may cause the developer to become exhausted in one area while not used in another.

After several negatives, the developer solution becomes exhausted. One gallon (3.8 liters) of developer will develop about thirty sheets of 8 × 10″ film. As the developer becomes weaker, you should increase the time to compensate. Approximate time in new developer is two minutes and forty-five seconds.

When the sensitivity guide develops to a solid step four, Figure 5-36, remove the negative

Figure 5-34. *Immersing the exposed film in the developer.*

Figure 5-36. *A comparison of the exposed gray scale in the developer and after fixing.*

Density of Copy	Size of Copy		
	10-40%	40-120%	120-400%
EXTRA HEAVY COPY Black Bold type Etching Proofs Photo Proofs	4 Black	5 Black	6 Black
NORMAL COPY Good black type proofs with fine serfs Pen and Ink Drawings Printed Forms	3 Black	4 Black	5 Black
LIGHT COPY Grey Copy Ordinary Typewritten Sheets Printed Forms Light Lines Good Pencil Drawings	2 Black	3 Black	4 Black
EXTRA LIGHT COPY Extra Fine Lines * Pencil Drawings Extra light grey copy.	1-2 Black	2 Black	3 Black

*Difficult fine line copy and fine line reductions can usually be improved by fine line development, or still development (not agitated) in regular developer (refer to the manufacturers instructions).

Figure 5-37. *Chart for determining proper developing steps for problem copy. (Stouffer Graphic Arts Equipment)*

immediately. Step four is the guide for average line copy shot at 40% to 120% size. See Figure 5-37 for other sizes and variations of copy.

2. Handle wet film only by the edges to avoid fingerprints or other damage to the negative. Allow the film to drain for a few seconds before you transfer it to the stop bath. Immerse the negative in the stop bath the same way you immersed it in the developer. Agitate the film in the stop bath about ten seconds.

3. Remove the film from the stop bath and let it drain for a few seconds. Place the negative in the fixer. Agitate frequently for two to four minutes. A general rule for fixing film is to leave it in the fixer for twice the time it takes to clear (lose its milky color). After the film has been in the fixer for one minute, the white lights can be turned on.

4. Remove the negative from the fixer and let it drain a few seconds. Place the negative in the wash tray, Figure 5-38, and wash for at least ten minutes. Usually a longer time is recommended to prevent chemical spots and discoloration.

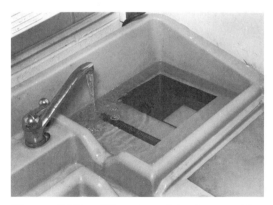

Figure 5-38. *Film placed in the washing sink.*

5. After washing, gently squeegee or wipe off excess water. Hang the negative by one corner in a dust-free place to dry.

Evaluating the Line Negative

Just having an image on the line negative is not enough. The image must be a faithful reproduction of the copy. For good quality negatives:

- The black areas should be so black that light cannot be seen through them.
- There should be few, if any, pinholes (small clear openings) in the solid black areas.

- The transparent areas should be clean and clear.
- The edges of the image should be as sharp as those of the original copy.
- The line widths and the shapes of small image areas should be the same as those of the original copy, Figure 5-39.

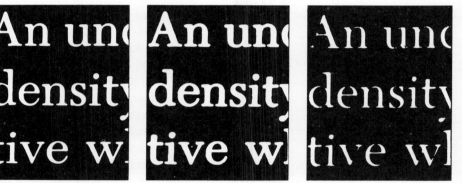

CORRECT EXPOSURE	UNDEREXPOSURE	OVEREXPOSURE
This segment was exposed correctly. The negative areas are either clearly transparent or densely opaque. Edges are sharp, and detail proportions are true to the original.	This segment was underexposed. Although transparent areas are clear, the dark areas have low density. A positive made from a negative of this type shows thickening of all detail.	This segment was overexposed. Although dense areas are opaque, density appears in some areas which should be clear. A positive made from a negative of this type shows loss of fine detail.

Figure 5-39. *A comparison of correct exposure, under-exposure and over-exposure. (Eastman Kodak Co.)*

CONTACTING

Contact printing with a contact frame is widely used in industry. Usually the contact frame and light source, Figure 5-40, are set up inside a darkroom. However, if you use materials not very sensitive to light, you could set up a contacting area outside a darkroom.

Figure 5-40. *Light source for contact printing frame.*

Basically a contact printing frame is a vacuum frame that holds two pieces of film in tight contact and a light source which exposes the film, Figure 5-41.

One of the most common uses for contact printing is to make an exact duplicate of a developed negative. Several negatives may be made to produce the image several times on one plate. Or a duplicate may be made to save the original if the negative needs to be cut or otherwise altered. Contacting is also used to combine many small negatives into one large negative.

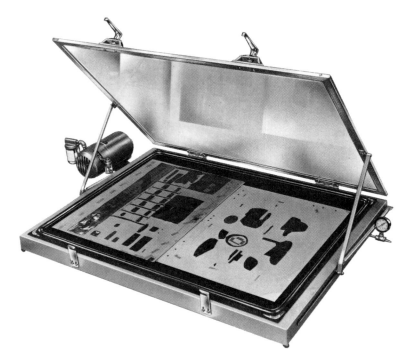

Figure 5-41. *Contact printing frame. (nuArc Company, Inc.)*

Contact printing may also be used to form a "flop" or lateral reverse negative when an image must face another way. For instance, a photograph that shows someone looking off the printed page would lead the reader's eye away from the printed copy. The easiest way to correct this would be to flop or turn over the negative so that the subject photographed is looking back into the page. What was originally a "right-reading negative" then becomes a wrong-reading negative. A wrong-reading negative is simply a mirror image of the original. Type, for example, appears to be backwards, as it would be seen when a page of type is held up to a mirror. When viewed through the base side of the film, a right-reading negative looks like the original. See Figure 5-42.

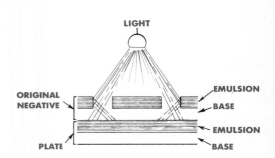

Figure 5-43. *Example of spreading that occurs when copying negatives with both emulsions up.*

Another reason for using right-reading negatives is that the emulsion is placed down on the goldenrod sheet. In this position the emulsion is less likely to be scratched by the stripper.

To make a right-reading contact negative, place the unexposed emulsion side up (base down). Place the developed film on top, also emulsion side up, Figure 5-44. For a wrong-reading negative, place the unexposed film and the exposed and developed film emulsion to emulsion as shown in Figure 5-44.

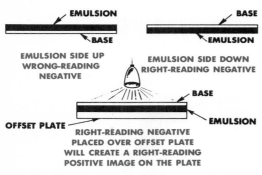

Figure 5-42. *The difference between right-reading and wrong-reading negatives depends on the emulsion side of the film.*

Right-reading negatives are most often used by the printing industry. It is important when exposing a printing plate to have the emulsion on the film facing the emulsion of the plate. Any space between the emulsions could cause the light to undercut or change the size of the image. The result would be a distorted image, Figure 5-43, unacceptable to the customer.

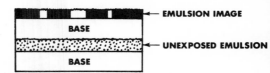

DIAGRAM SHOWING THE PROPER PLACEMENT OF THE FILM NEGATIVE AGAINST THE EMULSION OF A FRESH SHEET OF FILM TO MAKE A CONTACT EXPOSURE WITH DUPLICATING FILM

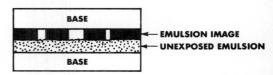

DIAGRAM SHOWING THE PLACEMENT OF THE FILM AGAINST THE EMULSION SIDE OF A NEW SHEET FOR A LATERAL REVERSE WITH DUPLICATING FILM

Figure 5-44. *Proper placement of films for lateral reverse duplicate negative.*

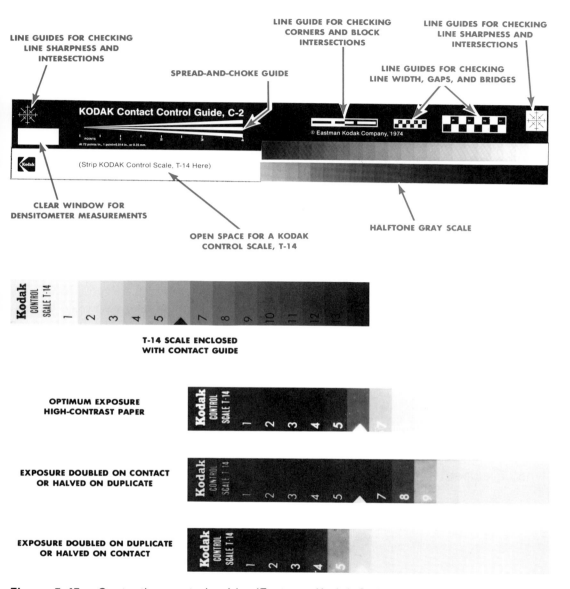

Figure 5-45. *Contacting control guide. (Eastman Kodak Co.)*

Guides are available for determining the correct exposure when contacting. One of the most popular is Kodak's Contact Control Guide C-2, Figure 5-45. With this guide you can tell whether all of the elements will be produced as in the original copy.

Several papers and films are available for contact printing. Duplicating film, for

example, contains a built-in density which is destroyed when exposed to light. It produces a negative from a negative or a positive from a positive. This eliminates the extra step involved in making a positive from a negative and then contacting the positive to get another negative. The less steps taken, the more minor variations you can avoid. Duplicating film is especially use-

ful when you need several negatives or positives of a given image. Standard emulsions are also available when you need a negative from a positive or a positive from a negative.

Contact printing has several advantages. First, it frees the process camera for other uses. Second, contact printing uses a point light source. This means there is no lens used. Whenever an image is focused through a lens, some distortion or change takes place. So contacting eliminates this problem. A contact frame produces very exact duplicates and is easier to use than a camera.

Contacting is also useful for making customers' proofs. Some proofing materials require low level light or a vacuum frame with a point light source. Photographic stabilization processing paper is an example. This paper comes in various types. Some can be fed through a small processor camera, Figure 5-46. Others are developed in lith type developer.

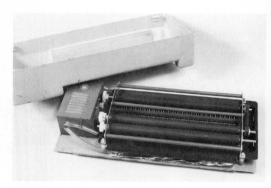

Figure 5-46. *A stabilization processor.*

Many other proofing materials require a high-level light source. Brownline paper, for example, contains no silver compounds, and therefore requires a very high-level light similar to a plate burner. Other proofing papers are the Peerless Room Light Paper, 3-M Color Key, and other colored, and black and white, proofing materials. They all require a control guide to determine the correct exposure. Directions for exposing and developing these proofing materials are usually packed along with the proofing materials, Figure 5-47.

discussion questions

1. What are the basic requirements for a graphic arts darkroom?
2. What are the differences between horizontal and vertical cameras? Which is best?
3. What are the major parts of a process camera?
4. Explain the relationship of f/stops on a process camera.
5. Describe the chemistry needed for developing lithographic film.
6. Describe the requirements for a good line negative.
7. Why is contacting used in the graphic arts?
8. List some proofing materials and give their advantages and disadvantages.

PROCESSING INSTRUCTIONS

3M BRAND "COLOR-KEY"
CONTACT IMAGING MATERIALS
negative transparent

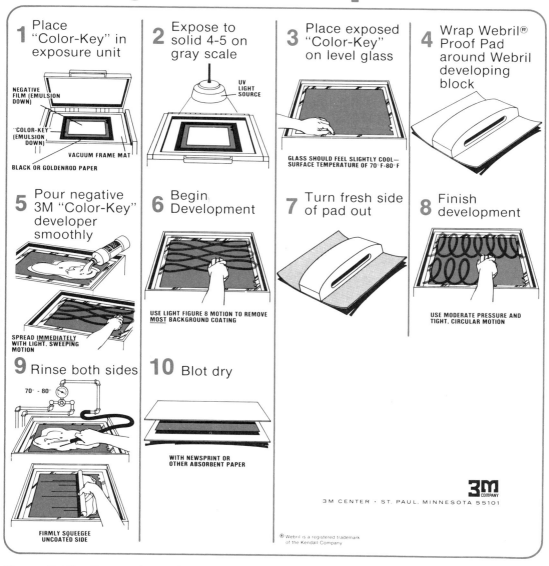

1 Place "Color-Key" in exposure unit

NEGATIVE FILM (EMULSION DOWN)

"COLOR-KEY" (EMULSION DOWN)

VACUUM FRAME MAT

BLACK OR GOLDENROD PAPER

2 Expose to solid 4-5 on gray scale

UV LIGHT SOURCE

3 Place exposed "Color-Key" on level glass

GLASS SHOULD FEEL SLIGHTLY COOL— SURFACE TEMPERATURE OF 70° F-80° F

4 Wrap Webril® Proof Pad around Webril developing block

5 Pour negative 3M "Color-Key" developer smoothly

SPREAD IMMEDIATELY WITH LIGHT, SWEEPING MOTION

6 Begin Development

USE LIGHT FIGURE 8 MOTION TO REMOVE MOST BACKGROUND COATING

7 Turn fresh side of pad out

8 Finish development

USE MODERATE PRESSURE AND TIGHT, CIRCULAR MOTION

9 Rinse both sides

70° - 80°

FIRMLY SQUEEGEE UNCOATED SIDE

10 Blot dry

WITH NEWSPRINT OR OTHER ABSORBENT PAPER

3M COMPANY

3M CENTER · ST. PAUL, MINNESOTA 55101

® Webril is a registered trademark of the Kendall Company

Figure 5-47. Processing color key material. (3M Co.)

Chapter 6

halftone
photography

The process of halftone photography makes it possible for a printer to reproduce copy that has a range of different tones. By the end of this chapter you should understand the basics of halftone photography, be able to calibrate a halftone screen, and shoot a halftone negative.

Because of the nature of printing, it is impossible to lay down varying thicknesses, or densities, of ink on paper. So the eye must be tricked in to seeing various shades of gray. This is done by printing small dots of ink of various sizes. The eye views the combination of white paper and dots of ink as various tones of gray, Figure 6-1.

A halftone screen is needed to break down copy in order to reproduce it as a continuous tone illustration. Three types of screens are used in most halftone work. They are the glass screen, the magenta contact screen and the gray contact screen.

Before halftone screens, an engraver cut or etched by hand an illustration in a metal plate. This hand-engraved plate was the only way newspapers and magazines could include pictures. The engraver created the patterns as he went along. The halftone screen, however, makes geometrically regular patterns, Figure 6-2.

Figure 6-1. *A continuous tone print is made up of shades of gray blending into each other. A halftone is made of dots which gives the illusion of grays blending together.*

Figure 6-2. *A halftone is made of geometrically regular patterns while an engraving is made of irregular patterns made up while being engraved.*

Halftone screens come in various rulings. The screen number indicates the number of dots per inch. The quality and the precision of halftone photography increases as the number of dots per inch increases.

COMMON SCREEN RULINGS

The number of dots is counted along a one-inch 45° line. This number represents the ruling or lines per inch. The more dots per inch, the finer the screen. Some commonly used screens include:

A 65-LINE SCREEN
1" = 65 LINES

A 33-LINE SCREEN
1" = 33 LINES

Figure 6-3. *Screen rulings are counted along a one-inch line at a 45° angle.*

65, 85	Newspaper letter press
100, 120,133	Newspaper offset
120,133, 150	Magazine and commercial letterpress
133, 150	Magazine and commercial offset
133	The halftones in this book
150 to 400	Gravure

HOW A GLASS HALFTONE SCREEN WORKS

A widely accepted theory on how the glass halftone screen actually works is called the pinhole principle. The screen is placed just in front of the film. During exposure, light reflected from the copy is projected through the transparent openings in the screen. Each opening acts as a pinhole lens. Dots proportionate to the amount of light reflected from the copy are produced on the film. Screen distance, lens opening, and exposure time all determine the quality of reproduction and are critical factors in this type of halftone photography.

HOW A CONTACT SCREEN WORKS

Contact screens are made of a clear, stable, base material such as polyester plastic. The screen has a pattern of vignetted dots. Vignetted dots are completely clear in the center and become darker around the edges. In gray contact screens these dots are made of silver particles. In magenta screens the dots are made of a dye. The vignetted dots break light into a corresponding pattern of dots on lithographic film or paper. Where the reflected light is more intense, a larger dot is formed. The final image then consists of a pattern with varying sizes of dots, Figure 6-4.

Most halftones today are made with contact screens. Compared to glass screens, contact screens:
- are easier and faster to use
- have better resolution
- need not consider screen distance or screen positioning mechanism
- can be used with any camera that has a vacuum back to produce halftones

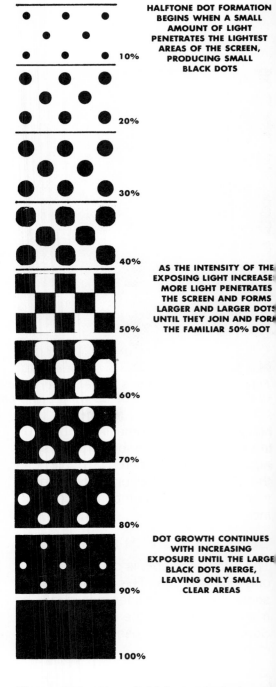

HALFTONE DOT FORMATION BEGINS WHEN A SMALL AMOUNT OF LIGHT PENETRATES THE LIGHTEST AREAS OF THE SCREEN, PRODUCING SMALL BLACK DOTS

AS THE INTENSITY OF THE EXPOSING LIGHT INCREASES MORE LIGHT PENETRATES THE SCREEN AND FORMS LARGER AND LARGER DOTS UNTIL THEY JOIN AND FORM THE FAMILIAR 50% DOT

DOT GROWTH CONTINUES WITH INCREASING EXPOSURE UNTIL THE LARGE BLACK DOTS MERGE, LEAVING ONLY SMALL CLEAR AREAS

Figure 6-4. *How light is controlled and strikes film through a halftone screen.*

- provide relatively simple and reproducible contrast control
- are initially inexpensive.

Contact screens also have some disadvantages:

- They are easily scratched, stained, or kinked, and become dirty.
- Density ranges vary from screen to screen and from manufacturer to manufacturer.
- The density range can change with cleaning or aging.

CARE OF THE CONTACT SCREEN

Because the contact screen is so fragile, it is important to protect the screen from dirt, dust, finger marks, scratches and other damage. Follow these precautions when using a contact screen:

- Store the screen flat in its box.
- Dust the screen only when necessary with a clean, dry photo-chamois that has never been wet. Do not use any type of brush because brushes will scratch the screen.
- Handle the screen by the edges only.
- Clean the screen only when necessary with a lint-free pad barely moistened with film cleaner. Dry immediately with a fresh lint-free pad.
- If the screen is spotted with water soluble substances which cannot be removed with film cleaner, immerse the screen in a tray of distilled water and wipe lightly with a cotton pad. If possible, use a rinse to prevent water spotting. Do not leave the screen in the distilled water too long because the water will remove some of the dye, changing the screen's density. Hang the screen in a dust-free place to dry.

DENSITOMETRY

An understanding of basic densitometry is very useful in determining halftone exposures and tone control on light-sensitive emulsions. Basically density is the measurement of the blackness of a developed photosensitive material. Three items are used to describe the degree of blackness:

- transmittance
- opacity
- density

These three terms express the same idea in different ways.

Transmittance is the ability of a transparent or translucent material to pass light. It is expressed in a fraction:

$$T \text{ (Transmittance)} = \frac{\text{Transmitted light}}{\text{Incident light}}$$

Incident light means the amount of light projected. So, using this formula, if 100

units of light are projected at a piece of developed film and only 10 units passed through, the transmittance is 10/100 or 0.10. See Figure 6-5.

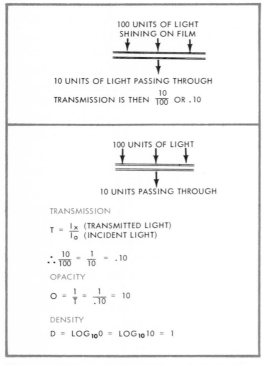

100 UNITS OF LIGHT
SHINING ON FILM

10 UNITS OF LIGHT PASSING THROUGH

TRANSMISSION IS THEN $\frac{10}{100}$ OR .10

100 UNITS OF LIGHT

10 UNITS PASSING THROUGH

TRANSMISSION

$T = \frac{I_x}{I_o}$ (TRANSMITTED LIGHT)
(INCIDENT LIGHT)

$\therefore \frac{10}{100} = \frac{1}{10} = .10$

OPACITY

$O = \frac{1}{T} = \frac{1}{.10} = 10$

DENSITY

$D = LOG_{10}O = LOG_{10}10 = 1$

Figure 6-5. *Transmittance, opacity, and density formulas.*

Opacity, on the other hand, measures the amount of light held back (absorbed) by the developed film. To determine the opacity we use the formula:

$$\text{Opacity} = \frac{1}{\text{Transmittance}}$$

If we use transmittance from the example above, 1 divided by 0.10 equals 10. The opacity is 10. Opacities sometimes

reach very large numbers. In fact, opacities above 100,000 are very common. For convenience in calculations, the light absorbing properties of film are usually expressed as densities.

Density is opacity expressed as a logarithm. Logarithms are usually found in available tables and need not be calculated. The formula for finding density is:

$$\text{Density} = Log_{10} \times \text{Opacity}$$

Using our first example again, log_{10} times 10 equals 1, which is the density, Figure 6-5.

Logarithms are not necessarily whole numbers. Most densities are given in decimals. An added advantage of using logarithms is that a uniform progression of numbers results (0.10, 0.20, 0.30, etc.) as the density differs from step to step.

Although densities are expressed in very small numbers, they cover the whole range of tonal variations from white to black. A 0.20 or 0.30 density difference is a great difference. For example, a density of 2.00 is ten times greater than a density of 1.00, and a density of 3.00 is 100 times the density of 1.00.

Densitometers

Densitometer is an instrument to measure density. There are two types of densitometers: visual comparators and electronic types.

The visual comparator, Figure 6-6, depends on the operator matching two densities in much the same way the ear can match two pitches or tones. Fatigue and eyestrain can affect the accuracy of the reading. Another problem is that the eye cannot distinguish tone differences past a density of 2.00. A visual comparator is only as reliable as the operator.

An electronic densitometer, Figure 6-7, is much more accurate and is more commonly used in industry. A photocell in the densitometer measures the amount of light that passes through the film and electronically displays the reading. A transmission densitometer, Figure 6-8, measures the density of developed emulsion on transparent or translucent material.

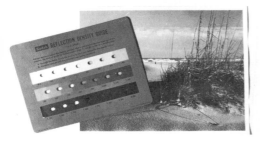

Figure 6-6. *Visual densitometer.*

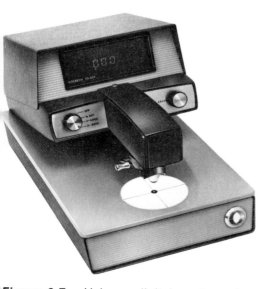

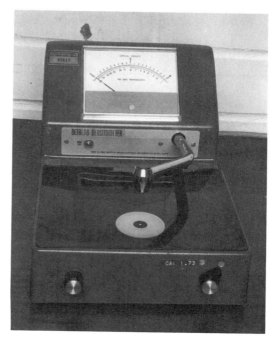

DENSITOMETER SCALE

PHOTOCELL

FILM TO BE READ

LIGHT

HOW A TRANSMISSION DENSITOMETER WORKS

Figure 6-7. *Using a digital readout electronic densitometer is a very accurate way of determining photographic densities. (Brown Ferguson, Macbeth Division)*

Figure 6-8. *A transmission densitometer determines the amount of light passing through a sheet of film.*

Some densitometers, reflective types, can measure the light reflected from an opaque object. They are used to measure the density of an exposed and developed emulsion on a sheet of paper or of the ink on a printed sheet of paper. This densitometer can also help determine the density range of photographic copy that is to be made into a halftone, Figure 6-9. This densitometer is also used in the pressroom to standardize the thickness and purity of ink on a printed sheet, most critical in four-color process work.

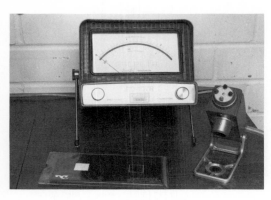

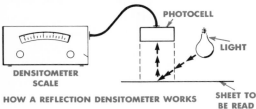

Figure 6-9. *A reflection densitometer determines the amount of light reflected from a sheet of paper.*

CHOICE OF HALFTONE END POINTS

The choice of halftone end points (the sizes of highlight and shadow dots) depends on the printing capability of your press. This is determined by printing a long range halftone scale on your press using the ink and stock that will be used for the job. By comparing the original halftone scale with the printed one, you can then determine which halftone values will be easily and accurately held on the printed sheet. Some factors that affect the dot reproduction from negative to plate, then to press, and finally to paper are:

- accuracy of camera controls
- processing reproductibility
- printing method
- mechanical condition of press
- press adjustments
- ink quality
- printing paper.

Some typical dot requirements for various printing methods are:

- High quality offset 3% to 97%
- Duplicator offset 10% to 90%
- Letterpress with powderless etch 15% to 95%
- Conventional photoengraving 30% to 95%
- DuPont Dycril 5% to 95%

Besides checking the upper and lower limits of dot formation, you should also

check the position of the midtone (50%) dot. The midtone should have a density around 0.65 on the original.

Shadow Dots

Dark areas (shadows) of a photograph reflect very little light. This small amount of light can penetrate the contact screen only where the dye density is the lightest. The film in turn will be lightly exposed and only tiny black pinpoint dots will appear when the film is processed. These are called shadow dots, Figure 6-10.

Midtone Dots

As the intensity of reflected light increases (as in the gray areas) more light

penetrates the dye density, forming increasingly larger dots. The dots will usually join to form the familiar fifty percent dot or checkerboard pattern called the midtone dot area, as shown in Figure 6-10.

Highlight Dots

As even more light is reflected from the white areas of the photograph, more of the dye density of the screen is penetrated and the very black area of the negative is formed with only very small clear areas remaining. These are the highlight dots, Figure 6-10.

CALIBRATING FOR HALFTONE EXPOSURES

Each halftone screen is different just as cameras and operators are different. Finding out what your screen, camera and operator can do in combination is called calibration. Before you can determine halftone exposures, you need to know:

- the screen range—usually called basic density range (BDR)
- basic exposure time—including f/stop, percentage of original, exposure needed to achieve desired highlight dot, and density of copy area where this dot was found on the negative
- basic flash exposure—the amount of yellow light exposure needed to produce the desired shadow dot.

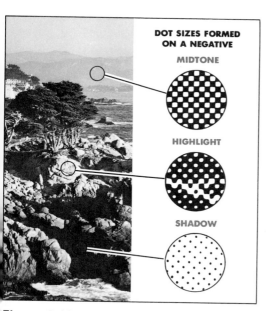

DOT SIZES FORMED
ON A NEGATIVE

MIDTONE

HIGHLIGHT

SHADOW

Figure 6-10. A comparison of how shadow, midtone and highlight dots are formed on a sheet of film.

5. Cover the sheet of film with the desired contact screen, Figure 6-12. Close the camera back.

A step-by-step procedure for calibrating is to:

1. Place a calibrated gray scale on the camera copyboard, as shown in Figure 6-11.
2. Set the camera for size (50 to 100 percent).
3. Set f/stop (f/16 for halftones).
4. Place sheet of orthochromatic lith type film on camera vacuum back. Start the vacuum pump.

Figure 6-12. *The halftone screen is put over the ortho film prior to giving the test exposure.*

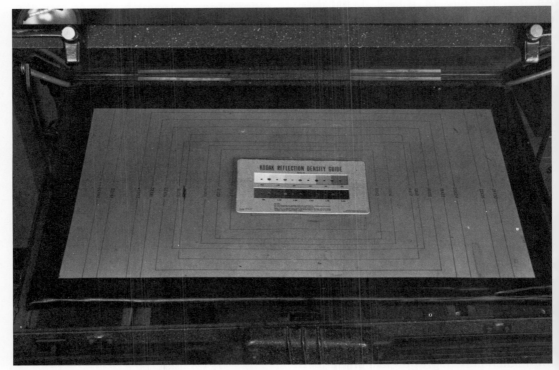

Figure 6-11. *A calibrated gray scale about to be used to calibrate a halftone screen.*

6. Expose for four to five times the normal line exposure.
7. Process in lith developer for two minutes and forty-five seconds. Use fresh, new developer.
8. Put a new strip of film on the vacuum back and cover it with the same contact screen. Switch on the vacuum back but DO NOT CLOSE THE CAMERA BACK.
9. Cover the film with black paper leaving about one inch uncovered, Figure 6-13. Expose for two to five seconds with the yellow flashing light.

Figure 6-13. With the camera back open and the halftone screen over the ortho film, a step off is made to determine the basic flash exposure.

10. Move the paper back another inch and expose again. Repeat this process for about ten steps

or until you run out of film. Count the steps as you go along.
11. Process the strip as you did in Step 7.
12. Locate the desired highlight dot and shadow dot on the processed density guide. Note their densities, Figure 6-14.

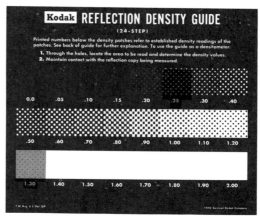

Figure 6-14. The negative of the calibrated gray scale. The 10% dot falls at 1.30 and the 90% dot falls at .25. (Eastman Kodak Co.)

13. Subtract the desired highlight density (darkest on the negative) from the desired shadow density (lightest on the negative). This is the basic density range (BDR) for the screen used in conjunction with the camera and your developing technique.

Figure 6-15. *The negative of the flash test shows that the 10% dot falls at the fourth step which had 20 seconds of exposure.*

14. Find the desired shadow dot on the step-off, Figure 6-15, and determine the exposure time for that step. This is the *Basic Flash Exposure.*

15. Write down the density step where the desired highlight dot fell, the amount of time you exposed the gray scale, the percentage setting of the camera, and the *f*/stop used. All this information makes up the *Basic Main Exposure.*

CALCULATING HALFTONE EXPOSURES

Once you have calibrated the camera you are ready to shoot a halftone. You now know:

- basic density range (BDR)
- basic flash exposure (in seconds)
- basic main exposure including

 —*f*/stop used
 —percentage setting when calibrating

—length of exposure
—density where the desired highlight dot fell.

Basic density range and basic flash exposure determine the flash exposure. Basic main exposure determines the main exposure.

The graphic arts exposure computer, Figure 6-16, is one of the most important tools available to the graphic arts photographer. The computer consists of two parts, a chart and a set of revolving wheels. The chart is used to determine the flash exposure for the photo; the wheels are used to determine the main exposure.

For practice in using an exposure computer, let's run through the following example beginning with calibration through the shooting of the halftone. Assume the highlight dot to be 90% and the shadow dot to be 10%. These are the most common dot end points for small offset presses.

GRAPHIC ARTS EXPOSURE COMPUTER

Flash Exposure Table — Basic Flash Exposure in Seconds*	Flash Exposure Times in Seconds for Excess Density Range								
	0	0.1	0.2	0.3	0.4	0.5	0.6	0.8	1.0
16	0	3½	6	8	9½	11	12	13½	14½
18	0	4	7½	9	11	12	13½	15	16
20	0	4	7½	10	12	13½	15	17	18
22	0	4½	8½	11	13	15	16½	18½	20
24	0	5	9	12	14½	16	18	20	22
26	0	5½	10	13	15½	17½	19½	22	23½
28	0	6	10½	14	17	19	21	23½	25
30	0	6½	11	15	18	20½	22½	25	27
35	0	7	13	18	21	24	26	29	32
40	0	8	15	20	24	27	30	34	36
45	0	10	17	23	27	31	34	38	41
50	0	11	19	25	30	34	38	42	45
55	0	12	20	27	33	37	41	46	50
60	0	13	22	30	36	41	45	50	55
70	0	15	26	35	42	48	53	59	63
80	0	17	30	40	48	54	60	67	72

*Flashing-lamp arrangements which give basic flash exposures of less than 16 seconds are not recommended unless accurate timing devices are used, in which case this table can be expanded easily. For example, the times for 14 seconds' basic flash would be ½ those in the 28-second row; the times for 10 seconds' basic flash, ½ those in the 20-second row, etc.

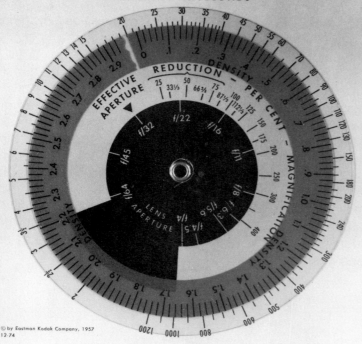

This side of the computer is primarily for determining exposures for making halftone negatives with Kodak contact screens and KODALITH AUTOSCREEN Ortho Film 2563 (ESTAR Base). Other uses include calculating exposure times for color-separation negatives, photographic enlargements, and contact printing.

Before using this computer, it must be calibrated for your individual exposure conditions as described in the instruction booklet. Because the making of a halftone is a critical operation, the operator must provide consistent processing conditions when calibrating and using this computer.

The other side of the computer is a device for quickly finding exposures of enlarged or reduced images when the same-size exposure is known. This is applicable to linework, continuous-tone copying, and halftone negative-making.

T. M. Reg. U.S. Pat. Off.
Printed in the United States of America

Figure 6-16. *The graphic arts exposure computor has two parts. The upper section (chart) is used to determine the flash exposure while the lower section (wheel) is used to determine the main exposure.*

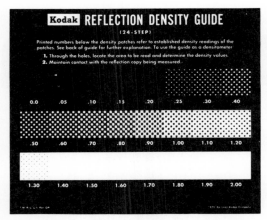

Figure 6-17. *The test negative of the density guide. (Eastman Kodak Co.)*

Figure 6-19. *A photograph and its highlight and shadow densities. When they are subtracted from each other they give us a copy density range. The screen range or BDR is subtracted from the copy density range giving us the excess density. (Photo by Gary Moats)*

1. See Figure 6-17. This is a test negative that was exposed for 50 seconds, f/16, 100%. Note that the desired highlight dot falls at .25, and the desired shadow dot falls at 1.30. From this information we get the BDR of 1.05 (shadow minus highlight) and the basic main of f/16, 50 sec, .25 highlight density.

2. Figure 6-18 is the exposed and developed test strip. It was stepped off ten times at 5-second intervals. Note that the 10% dot falls at step 4 or an exposure of 20 seconds.

3. Read the densities on the photograph you want to make into a halftone. In this example, Figure 6-19, the highlight density is .15 and the shadow density is 2.00.

Subtract the highlight density from the shadow density giving a range of 1.85. This is your copy density range or CDR.

4. The next step is to subtract the BDR from the CDR to determine the excess density. This is the part of the photograph density that the screen cannot handle with the main exposure. In this case, the excess is .80 (1.85-1.05).

Figure 6-18. *Step-off test negative.*

5. Next check the top of the exposure computer, Figure 6-20. Find the excess and read down until you line up with your basic flash exposure of 20 seconds. There you will find 17 seconds, which is the flash exposure for your photograph.

6. To determine the main exposure for your photograph, set up the exposure wheel of the computer with your basic main exposure data: f/stop (f/16) opposite the percentage (100%) and the highlight density (.25) where the desired 10% dot was found on the negative (Figure 6-17) opposite the exposure time (50 seconds). See Figure 6-21.

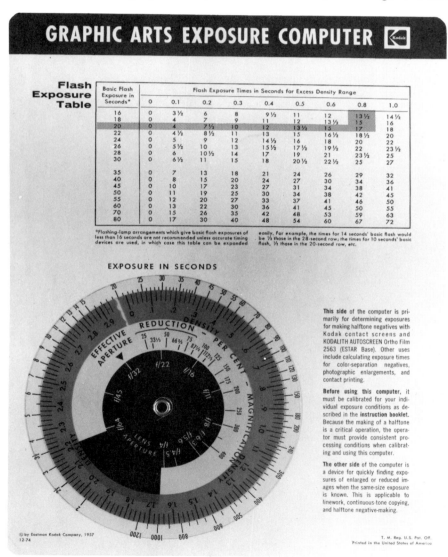

GRAPHIC ARTS EXPOSURE COMPUTER [Kodak]

Flash Exposure Table

Basic Flash Exposure in Seconds*	Flash Exposure Times in Seconds for Excess Density Range								
	0	0.1	0.2	0.3	0.4	0.5	0.6	0.8	1.0
16	0	3 ½	6	8	9 ½	11	12	13 ½	14 ½
18	0	4	7	9	11	12	13 ½	15	16
20	0	4	7 ½	10	12	13 ½	15	17	18
22	0	4 ½	8 ½	11	13	15	16 ½	18 ½	20
24	0	5	9	12	14 ½	16	18	20	22
26	0	5 ½	10	13	15 ½	17 ½	19 ½	22	23 ½
28	0	6	10 ½	14	17	19	21	23 ½	25
30	0	6 ½	11	15	18	20 ½	22 ½	25	27
35	0	7	13	18	21	24	26	29	32
40	0	8	15	20	24	27	30	34	36
45	0	10	17	23	27	31	34	38	41
50	0	11	19	25	30	34	38	42	45
55	0	12	20	27	33	37	41	46	50
60	0	13	22	30	36	41	45	50	55
70	0	15	26	35	42	48	53	59	63
80	0	17	30	40	48	54	60	67	72

*Flashing-lamp arrangements which give basic flash exposures of less than 16 seconds are not recommended unless accurate timing devices are used, in which case this table can be expanded easily. For example, the times for 14 seconds' basic flash would be ½ those in the 28-second row; the times for 10 seconds' basic flash, ½ those in the 20-second row, etc.

EXPOSURE IN SECONDS

This side of the computer is primarily for determining exposures for making halftone negatives with Kodak contact screens and KODALITH AUTOSCREEN Ortho Film 2563 (ESTAR Base). Other uses include calculating exposure times for color-separation negatives, photographic enlargements, and contact printing.

Before using this computer, it must be calibrated for your individual exposure conditions as described in the instruction booklet. Because the making of a halftone is a critical operation, the operator must provide consistent processing conditions when calibrating and using this computer.

The other side of the computer is a device for quickly finding exposures of enlarged or reduced images when the same-size exposure is known. This is applicable to linework, continuous-tone copying, and halftone negative-making.

© by Eastman Kodak Company, 1957
12-74

T. M. Reg. U.S. Pat. Off.
Printed in the United States of America

Figure 6-20. *To determine the flash exposure read across the basic flash exposure until you are opposite the excess density of the photograph.*

7. Holding the two wheels to-
 gether, rotate them until the f/
 stop (f/16) is opposite the de-

sired size. In this case it was
determined to be 50%. See Fig-
ure 6-22.

Figure 6-21. *Set the exposure wheel using the information determined from the calibrated gray scale.*

Figure 6-22. *Hold the two wheels together and rotate to the desired size.*

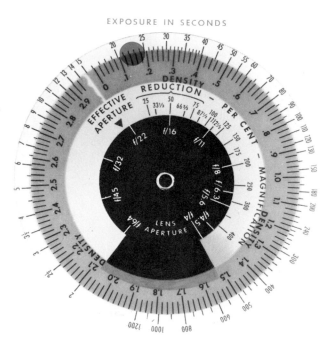

Figure 6-23. *Read opposite the photograph's highlight exposure to determine the photograph's main exposure.*

8. Read opposite the photograph's highlight density (.15) for your photograph's main exposure of 22 to 23 seconds. See Figure 6-23.

9. So, to shoot this photograph you would need to give a main exposure of 23 seconds and a flash exposure of 17 seconds.

BUMPING

When the basic density range (BDR) of a photograph is greater than the copy density range (CDR), the halftone requires a bump exposure with no screen. A bump exposure decreases the small, clear highlight areas, thus increasing the percentage of blackness in the highlights. It also increases slightly the size

**NO
FLASH EXPOSURE**

10% BUMP

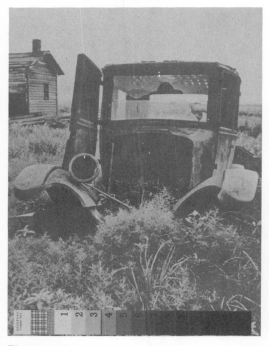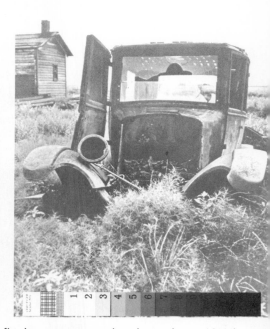

Figure 6-24. *A flat photograph shot without a flash exposure and reshot using a 10% bump. Notice how the gray scale is shortened on the bumped print. (Gary Moats)*

of the midtone dot while causing no change in the shadow dots. See Figure 6-24 for an example of a bumped photograph. To bump a photograph:

1. Calculate the main exposure with the exposure computer.

2. Determine the amount of screen compression, Figure 6-25, and read the percent of main exposure.

Minus Density	% of Main
−.05	2%
−.10	3%
−.15	4%
−.20	5%
−.25	6%
−.30	7%

Figure 6-25. *A bump exposure chart indicating the amount of flash required by various degrees of minus density.*

3. Multiply the calculated main exposure by the percent of main to give the bump exposure.
4. Decrease the main exposure by approximately twice the bump exposure.
5. Place the copy on the copyboard and prepare the camera for normal halftone shooting.
6. Place a sheet of film on the camera back and close it.
7. Expose the film, using the calculated bump exposure. (The halftone contact screen is not over the film.)

8. Open the camera back (with vacuum on) and position the halftone screen over the film. Close the camera back, and give the main exposure.
9. Remove the film and develop it normally, Figure 6-25.

A bump exposure shortens the BDR while a flash exposure lengthens the BDR. So a flash exposure is not normally given when a bump exposure is used. One cancels the effect of the other.

discussion questions

1. Explain how a contact halftone screen works.
2. What special precautions should be taken when using a contact screen?
3. How are transmission, opacity, and density related?
4. What is meant by halftone end points?
6. Describe what the Basic Density Range of a screen is.
7. What information is contained in a basic main exposure?
8. Describe how to calculate a photograph's main exposure.
9. Explain how to calculate a photograph's flash exposure.
10. What is the main purpose of a flash exposure?

Chapter 7

special photographic techniques

screen prints

photo silhouette

posterization

special effect screens

duotones

color separation

Special photographic techniques are limited only by the imagination and ability of the designer and photographer. This chapter covers some of the more popular and common techniques. Use your imagination to combine, vary and adapt these techniques to your own needs. Basically these special effects depend on special film, equipment, or photographic techniques.

SCREEN PRINTS

Screen prints, sometimes called veloxes or stats, are used on a mechanical for simplified paste-up and stripping. One method of making screen prints uses a diffusion processor, a special paper-base negative, and a paper receiver sheet, Figure 7-1. This photomechanical transfer (PMT) process is calibrated the same as a halftone negative. Figure 7-2 lists some of the problems that may occur in making screen prints and their causes.

Another method of making a screen print uses a continuous-tone negative in an enlarger. The procedure is:

1. Place a continuous tone negative in an enlarger, emulsion side down.
2. Focus to the desired size.
3. Place a sheet of ortho high-contrast paper on the enlarger easel, emulsion side up. If pos-

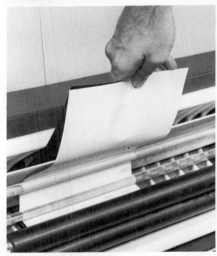

Figure 7-1. Procedure for making a PMT.

Symptom	Cause
No dots in large highlight areas	Main exposure too long. Highlights show no detail or separation of adjacent highlight tones. Reproduction appears too contrasty in highlights.
Dots too large in highlight areas	Main exposure too short. Highlights are muddy, and reproduction shows poor contrast.
Large, solid-black shadow areas	Flash exposure too short. Shadow detail nonexistent; shadow contrast too high.
Shadow dots too large	Flash exposure too long. Shadows appear gray with too little contrast.

Figure 7-2. Potential problems with PMTs. (Eastman Kodak Co.)

sible the easel should be a vacuum easel.

4. Place a long-range "High BDR" halftone screen over the paper, emulsion to emulsion. If the easel is equipped with a vacuum, Figure 7-3, turn it on. If not, cover the screen with a piece of clear glass.

5. Make the main exposure through the continuous tone negative.

6. With the screen still in place and without moving the screen or paper, make a flash exposure.

7. Process the screen print.

To determine main and flash exposures, you must step-off a print with negative, paper and screen in position. A step-off is made by covering the photo paper with an opaque card, moving the

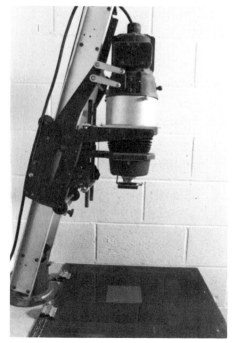

Figure 7-3. Enlarger setup for screened print.

MAIN EXPOSURES					
25 M 0 F	20 M 0 F	15 M 0 F	10 M 0 F	5 M 0 F	
25 M 4 F	20 M 4 F	15 M 4 F	10 M 4 F	5 M 4 F	FLASH EXPOSURES
25 M 8 F	20 M 8 F	15 M 8 F	10 M 8 F	5 M 8 F	
25 M 12 F	20 M 12 F	15 M 12 F	10 M 12 F	5 M 12 F	

Figure 7-4. *Example of stepping off on enlarger.*

card after each exposure, Figure 7-4. Follow this procedure:

1. Give the main exposures in a step-off from left to right of five, ten, fifteen, twenty, and twenty-five seconds. Each area will be about one fifth of the final print.
2. Flash from bottom to top using step-offs of about zero, four, eight, and twelve seconds.

Remove the paper and process it. Your final print should appear similar to Figure 7-4. Some problems you may encounter and their causes are shown in Figure 7-5.

Another way to make a screen print from a continuous tone negative is to use a point light source and vacuum frame. To do this:

1. Use a pin register system to avoid shifting. Punch a piece of high-contrast ortho paper or film and place it on the vacuum frame, emulsion side up. (You

Symptom	Cause
No dots in large highlight areas	Flash exposure too short. In lithography, a few very small areas without dots in the lightest tone are acceptable.
Dots too large in highlight areas	Flash exposure too long. This condition produces a dark, muddy appearance in the reproduction.
Large, solid-black shadow areas	Main exposure too long. This condition is indicated in the developer by the fact that the image appears too soon (in less than 5 seconds).
Shadows have no solid areas at all, or the clear dots in the shadow areas are too large.	Main exposure too short. This condition is indicated in the developer by the fact that the image takes too long to appear (more than 15 seconds).

Figure 7-5. *Enlarger problems and cures. (Eastman Kodak Co.)*

may use tape instead of the pin register system.)

2. Cover with a halftone screen, emulsion side down. Pin or tape the screen also.
3. Place a continuous tone negative on top of the screen, emulsion side down. Turn on the vacuum and give a main exposure.
4. Turn off the vacuum and remove only the continuous tone negative.
5. Turn on vacuum and give a flash exposure.
6. Turn off vacuum and process the paper or film.

Calibration for this method is essentially the same as for a process camera. Use a transparent step wedge (gray scale) to calibrate for main exposure and determine the flash exposure using a standard flash step-off. Determine the main exposure and the flash with the exposure computer.

You may also use a special camera or a camera processor, Figure 7-6, to make screen prints. Such units provide screen prints from continuous tone copy. Standard graphic arts film is used, but for special effects, exposing or processing is changed.

Figure 7-6. *Example of a stat camera. (Itek Corp.)*

PHOTO SILHOUETTE

An easy and popular special effect is the photo silhouette, Figure 7-7. However, because it loses detail, this technique is not suited for all types of continuous tone photography. To make a photo silhouette:

1. Place a continuous tone copy on the camera copyboard.
2. Put film on the camera back and expose it as you would line copy.
3. Process normally until the desired effect is achieved.

Usually no calibration is necessary for a photo silhouette because the effect desired may vary from photo to photo. Exposure and development times will change the effect, Figure 7-8.

Figure 7-7. *Example of photo silhouette and original photo. (Photo by Diana Fifer)*

Figure 7-8. *Example of same photo with three different silhouettes.*

POSTERIZATION

The natural extension of the photo sil-houette is posterization. Posterization covers two techniques: tone posteriza-tion and color posterization. These two techniques can be combined to form a toned color posterization, Figure 7-9.

Figure 7-9. Toned posterization.

A tone posterization uses the same technique as a photo silhouette, but adds one or more exposures using a screen unit. Follow this procedure:

1. Place an appropriate full-range, continuous tone photo on the copy board. Remember that some details will be lost, so choose a photo carefully.
2. Place a sheet of ortho film on the camera back.
3. Close the camera back and give a short exposure, about that of an average line exposure.
4. Open the camera back and cover the sheet of film with a screen tint. Generally use an average—about 50%—screen.
5. Close the camera back and expose the film again for a longer time than you did in step 3.
6. Remove the film and process it. The result is a three-tone posterization. The three tones are white, gray, and black.

Multiple exposures can be made using different percentages of screen tints for a posterization with up to six tones. Remember to rotate each screen to avoid a moiré pattern. Standard angles for screen exposures are 45, 75, 90 and 105 degrees, Figure 7-10.

Figure 7-10. *Standard screen angles for color work.*

A multicolor posterization, figure 7-11 uses separate sheets of film for eac color to be printed. Follow this proce dure:

1. Place a full-range, continuous tone copy on the copyboard.
2. Place film on the camera back
3. Close the camera back and ex pose the film as for an average line exposure.
4. Develop the sheet of film.
5. After processing the film, deter mine whether the negative i carrying too much or not enough detail, or if it is just right.
6. When you have made this de termination, go back to the cam era and place another sheet c film on the camera back.
7. Expose this second film for longer or shorter time than the first sheet of film.
8. Process the second sheet c film.
9. If these two sheets of film ar now carrying enough detail or you are stopping at two colors you may quit with these tw negatives. If you want more neg atives, return to the camera an expose another sheet of film fc a different amount of time.
10. Generally, when printing multi color posterization, the darkes negative will print the darkes color; the middle negative wi print the lightest color and th lightest negative will print th medium color.

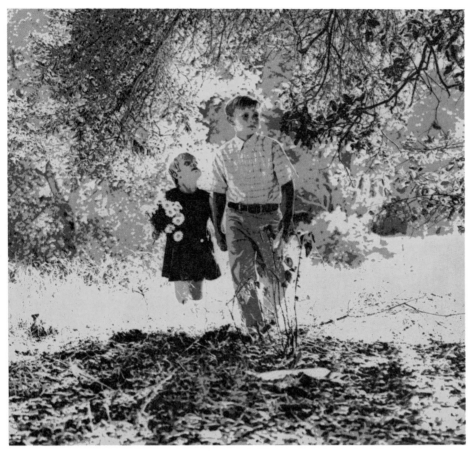

Figure 7-11. *A 4-color posterization. (Gardner Fulmer)*

SPECIAL EFFECT SCREENS

Special effects are often achieved by using special screens. These screens are manufactured with varied dot patterns or shapes. Some resemble wood grain; others resemble steel etchings or pebble grain. See Figure 7-12.

To use a special effect screen:
1. Select a continuous tone copy and place it on the camera copyboard.
2. Put a sheet of ortho film on the camera back.
3. Cover the film with the special effect screen.
4. Expose the film.
5. Open the camera back and give an appropriate flash exposure.
6. Process the film. Remove it from the developer when the desired effect is reached.

Special effect screens provide a variety of effects, Figure 7-13. Screens can produce a photo with strong ghosting or with very high contrast. Sometimes they are used to attract attention to a particular part of a photograph. Screens are also used to provide a ghost-like background photo. All these effects can be achieved with one screen by varying only the exposure. For a very ghosty simply choose the proper angle screen

kind of photo, a long flash exposure is given. To get high contrast, almost no flash exposure is used but the main exposure is extended, Figure 7-13.

Generally, special effects screens are not calibrated as standard halftone screens are. Instead the camera operator tries a series of shots with the special

Figure 7-12. *Various special effect screen patterns. (Caprock Developments, Inc.)*

Figure 7-13. *Series of special effect screened negatives, light to dark.*

effects screen, varying both main and flash exposures. From these samples he or she can determine the kind of exposure needed. Often the operator cannot determine the effect wanted or the dot or ghosting pattern needed, until several experimental shots are made.

DUOTONES

A duotone is one of the most complicated special effects in graphic arts photography. Duotones are usually made for two color printing. A true duotone is made from two negatives set at different angles and printed in two colors. Almost any camera operator who can make halftones can also shoot duotones.

Effective and pleasing color in duotone reproduction depends on screen angles. Halftone screens placed with dots parallel to the edge of a page are obvious to the eye and are not desirable. Even worse is a moiré pattern produced when screens are placed at improper angles, Figure 7-14.

For two-color work, 45° and 75° screen angles are used. Printers have found that the strong color should be placed at an angle that will make it least apparent.

The stronger color, usually black, is placed at 45 degrees; the lighter color screen is set at 75 degress.

There are several ways to set the screen angle for fine results. One method requires leaving the copy fixed on the copyboard while rotating the screen on the back of the camera. Marking the vacuum back on the camera will make it easier to handle the screen. Kodak markets a template or guide for cutting a square screen so that it can be rotated easily on the camera back, Figure 7-15.

Another way to set the screen angle is by rotating the copy. Here both the copy and the copyboard are marked to indicate the angle of rotation. The screen is always mounted in the same place on the back of the camera. Sometimes pins are used to hold the screen in place.

A third method uses contact screens with pre-angled rulings. In this case, you

Figure 7-14. *Moiré halftone. (Santa Fe Railway)*

Figure 7-15. *Template or guide for cutting screen. (Eastman Kodak Co.)*

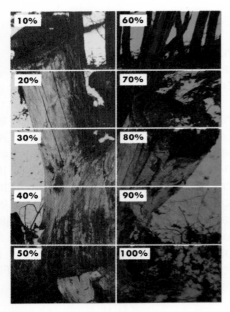

10%	60%
20%	70%
30%	80%
40%	90%
50%	100%

Figure 7-16. *Example of flat tint from 10-100% tint.*

from a set. It is good practice to include a gray scale whenever you shoot duotones. This practice provides the camera operator with good control factors and insures accuracy in reproduction of tones as they appear on the original copy.

The simplest form of duotone, sometimes called a *fake duotone,* is a flat tint laid under a halftone. When the flats are stripped and prepared for the platemaker, the artist or designer indicates to the platemaker where the screen tint should be placed. In addition the percent of color tint is noted. Remember, this is not a true duotone but rather an underprint. See Figure 7-16. The stripper must maintain the proper angle to avoid a moiré effect.

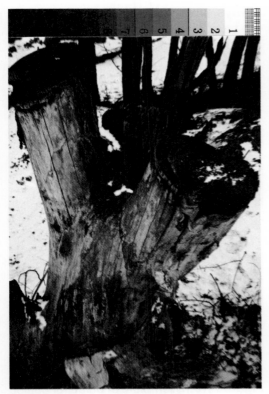

Figure 7-17. *Low key duotone.*

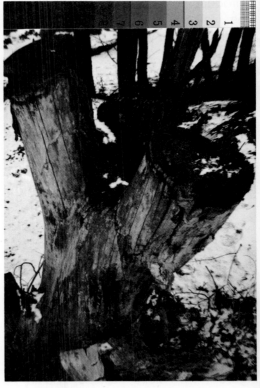

Figure 7-18. *Full range duotone.*

An unlimited number of combinations can be used in making true duotones. Tonal scales can be varied radically for the color or for the black negative. Figures 7-17 through 7-20 will demonstrate some of the more common characteristics.

Figure 7-17 shows a low key color. In this process, a short range color printer is combined with a full range black and white printer. This is a good method for creating certain moods. The light rendition of color adds depth to the picture. It is especially effective for portraits. Low key color is cleaner and a little more brilliant than other methods of duotone.

Figure 7-18 illustrates a full-range duotone. Here both the black printer and the color printer are normal, full-range negatives. This technique subdues color and lends depth and richness to the reproduction.

Figure 7-19, high key color, has a normal color halftone and a shortened scale on the black halftone. This type of duotone tends to create realism in the subject.

A duo-black, Figure 7-20, is not a color duotone. It is made from two separate halftones, both printing black. One is a normal range halftone printed at 45 degrees. The other printer is made much thinner (plugged in the highlights) and carries detail in the shadows and midtones. When overprinted, it adds much more depth to the shadows of the picture.

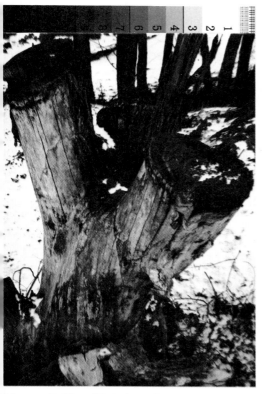

Figure 7-19. High key duotone.

Figure 7-20. Duotone black.

TYPES OF DUOTONES	PRINTER	SCREEN ANGLE	HIGHLIGHT DOT*	SHADOW DOT*
FULL RANGE	BLACK	45°	90	10
	COLOR	75°	90	10
HIGH KEY	BLACK	45°	PLUG	10
	COLOR	75°	90	10
LOW KEY	BLACK	45°	90	10
	COLOR	75°	PLUG	10
DUO BLACK	BLACK	45°	90	10
	BLACK	75°	PLUG	10

*GIVEN FOR PRESSES THAT HAVE END POINTS OF 10% to 90%

Figure 7-21. Duotone chart.

The chart in Figure 7-21 summarizes various methods of creating duotones and gives halftone dot requirements.

Perhaps the ultimate duotones are those made by color separation from full color originals. Briefly, this technique

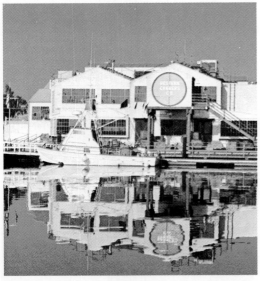

Figure 7-22. Duochrome. (Photo by Bill Dunlap)

uses two color separation filters (green, blue, or red) to separate out two of the colors from the original color copy. These separations are then used to print in corresponding colors. The result is often referred to as a *duochrome,* Figure 7-22.

COLOR SEPARATION

The most complex halftone procedure is color separation. To print a full color piece as the eye sees it, each color must be filtered out. Additive primary filters are used. They break white light into the primary colors, red, green, and blue. When added together, these three colors have the potential of creating any color visible to the eye, Figure 7-23.

When you place a red filter over a camera lens, you will get a negative record of all the red light reflected from the original. The result is a red filter separation negative in which the clear areas are a true record of the other two additive primary colors (blue and green).

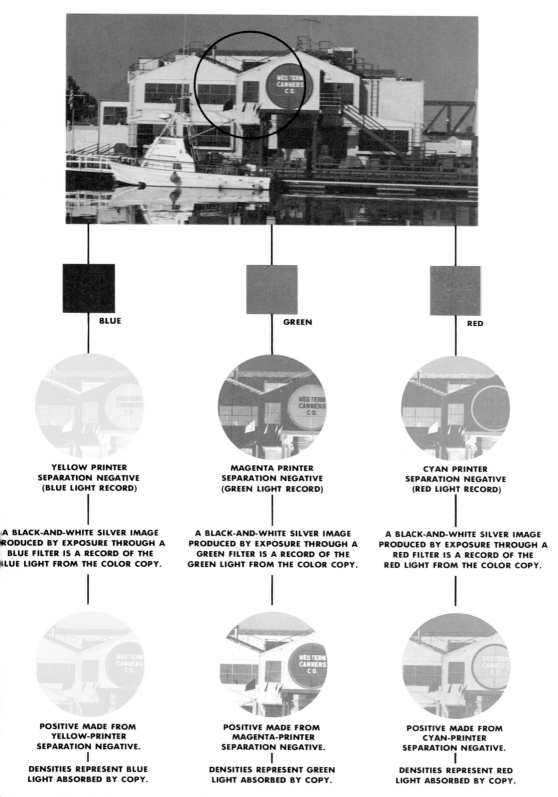

BLUE

GREEN

RED

**YELLOW PRINTER
SEPARATION NEGATIVE
(BLUE LIGHT RECORD)**

**MAGENTA PRINTER
SEPARATION NEGATIVE
(GREEN LIGHT RECORD)**

**CYAN PRINTER
SEPARATION NEGATIVE
(RED LIGHT RECORD)**

**A BLACK-AND-WHITE SILVER IMAGE
PRODUCED BY EXPOSURE THROUGH A
BLUE FILTER IS A RECORD OF THE
BLUE LIGHT FROM THE COLOR COPY.**

**A BLACK-AND-WHITE SILVER IMAGE
PRODUCED BY EXPOSURE THROUGH A
GREEN FILTER IS A RECORD OF THE
GREEN LIGHT FROM THE COLOR COPY.**

**A BLACK-AND-WHITE SILVER IMAGE
PRODUCED BY EXPOSURE THROUGH A
RED FILTER IS A RECORD OF THE
RED LIGHT FROM THE COLOR COPY.**

**POSITIVE MADE FROM
YELLOW-PRINTER
SEPARATION NEGATIVE.**

**POSITIVE MADE FROM
MAGENTA-PRINTER
SEPARATION NEGATIVE.**

**POSITIVE MADE FROM
CYAN-PRINTER
SEPARATION NEGATIVE.**

**DENSITIES REPRESENT BLUE
LIGHT ABSORBED BY COPY.**

**DENSITIES REPRESENT GREEN
LIGHT ABSORBED BY COPY.**

**DENSITIES REPRESENT RED
LIGHT ABSORBED BY COPY.**

Figure 7-23. Color separation. (Photo by Bill Dunlap)

Figure 7-24. Top, *overlapping color printers.* Bottom left, *three-color photo made from* amateur color separations. Bottom right, *color corrected four-color photo made with profes-* sional separations.

When blue and green light are mixed, a color called *cyan* results. Therefore, the record made with a red filter is the cyan printer to be used on the printing press.

In the same way, a green filter will yield a printer that records the additive primary colors red and blue. When red and blue lights are mixed, magenta results. Thus, using a green filter, a magenta printer is made.

The blue filter works in the same way to produce a negative record of all the blue in the subject. The clear areas left record the red and green colors, which, when mixed, form yellow. This negative then becomes the yellow printer.

The three colors cyan, magenta, and yellow are called the subtractive primary colors because each represents the two additive primaries left after one primary has been subtracted from white light. Cyan, magenta, and yellow are the colors of process inks and used for process color reproduction.

Theoretically, when the three printers are combined and printed, Figure 7-24, a faithful color reproduction should result. Unfortunately that does not happen. It is impossible to produce inks that are 100% pure color. Magenta and cyan, however, are less pure and print as if they are contaminated with the other two subtractive primaries. In order to compensate for these ink deficiencies, a process called color correction is used.

For color correction, certain areas are masked (covered) to hold back color. Masking may be done photographically or electronically as with an electronic scanner, Figure 7-25. Dot etching is another method of color correction. Dot etching manually reduces the sizes of dots in areas where colors overlap.

The simplest method of color separation is called direct screening. Separation halftones are made directly from the original copy with masking. A second method, indirect color separation, allows more freedom in making separa-

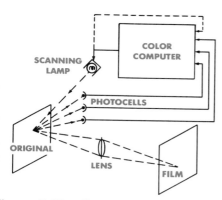

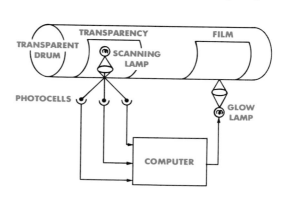

Figure 7-25. *Color scanner.*

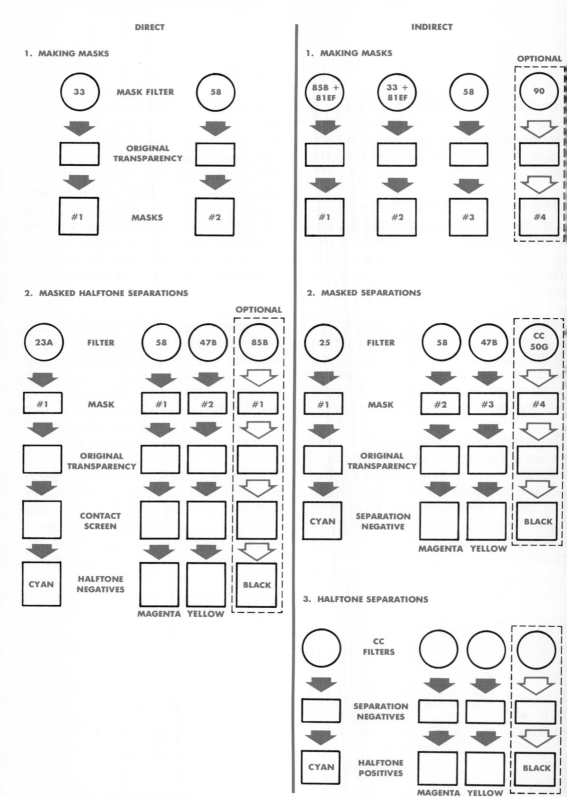

Figure 7-26. *Direct and indirect color separation diagram.*

ons but also requires more sheets of film. A typical color separation from an original copy may use as many as 16 sheets of film, and sometimes more. You can see this is a complex operation, Figure 7-26.

Another factor to be considered when you print in full color is the positioning of each screen at a precise angle to prevent a moiré. A 90° angle setup can only include three 30° angles. Therefore only three colors can be printed without creating a moiré. If a fourth color is needed, it must be set at an angle that produces only a slight moiré. Usually this moiré is printed in yellow so it is least obvious. The angles used for color separation are 45 degrees for black, 75 degrees for magenta, 90 degrees for yellow, and 105 degrees for cyan, Figure 7-27.

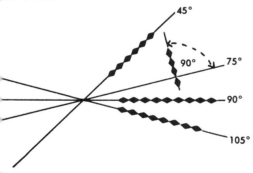

Figure 7-27. *Screen angles for color separation.*

Precise standards must be maintained when making color separations. An error as small as one-tenth of a degree between screen angles or a slight difference in registration between colors can cause a moiré in areas where three or four colors overprint.

One of the easiest ways to simplify color separation is to eliminate the masking. Normally, masking will correct the defi-

ciencies of process inks. We can also compensate to some extent for these ink deficiencies by shifting the printers slightly. Another way to simplify color separation is to eliminate the black printer. A third way is direct screening from original copy.

All three of these methods are used in the techniques of color separation described here. For this simplified method of color separation, the following materials and equipment are needed:

- A process camera with a filter holder and lighting system, quartz-iodine, pulsed xenon, carbon arc, or other lamps, suitable for color work
- A set of pre-angled gray screens or a single gray screen capable of screen angles of 45, 75, and 105 degrees
- A standard set of color separation filters: #29 red, #58 green, and #47B blue
- A normal temperature-controlled sink with a tray. Note that the more precise you are in development, the greater the success with this method.
- A calibrated gray scale ranging from about zero to 1.80 density
- Register pins attached to the camera back
- Kodalith MP (machine processed) pan film #2558. This film, designed for machine processing, can also be processed in trays at lower temperatures. Its high speed and superior color characteristics, make this film ideal for color separation work. This film makes direct screen separation simple.
- Kodalith MP developer, in two parts, A and B. To prepare this developer thoroughly MIX THOR-

OUGHLY four ounces of Part A with twelve ounces of water. To this solution add four ounces of Part B and *MIX VERY WELL.*

- Standard stop bath and fixer to stop development and clear the film.

Calibrate for each color printer, using a gray scale and the appropriate filter. Only one flash test is needed. From this information, calculate the correct exposure as if you were figuring halftone exposures. Proceed with the color separation:

1. Set up the process camera as you would for shooting a halftone. Instead of black and white continuous tone copy, use a color photograph or other color copy. Include a calibrated gray scale to determine whether or not the separations are in correct balance.
2. Prepare the camera as you would for normal halftone copy. Use some method of registration such as pins, Figure 7-28 (Round pins and a two-hole paper punch work well.) Turn out the lights. Punch the MP film and place it on the camera back.

Figure 7-28. *Pin registration system.*

3. Cover the film with the norma gray contact screen at a screen angle of 45 degrees. This will be the cyan printer, which is made first.
4. Close the camera back and insert a #29 red filter in front o the camera lens.
5. Use a halftone exposure, calculated from calibrations made with the filters. The exposures will vary, depending on the type of lighting system used. A pulsed xenon lamp, being a more balanced light, will require a shorter exposure time than other types of light.
6. When the exposure is complete flash the sheet of film using a bullet-type safelight with a 1.00 to 3.5 neutral density filter. Use this safelight in place of the flashing light in normal halftone work. Calculate the exposure the same way you would calculate a normal halftone flash exposure. This exposure will lengthen the screen range making it possible to cover the entire copy density.
7. Develop the film with MP developer for the standard two and a half minutes at 68° F. Because it is more sensitive than standard ortho film, MP film requires a shorter exposure time. It is important to immerse in developer as quickly as possible.
8. The magenta separation and the yellow separation are essentially the same as the cyan separation. For the magenta separation, use a #58 green filter and a 105° contact screen For the yellow separation, use a #47B blue filter and a 75° gray

contact screen. Refer to a Kodak direct screen color separation computer, Figure 7-29, to determine the dot size. Note that the magenta and yellow separation negatives are keyed to the cyan separation negative, Figure 7-30.

9. After the separations are complete, make a color key proof to check the color balance. Remember, the color will not be an exact copy of the original, but it should be close, Figure 7-24.

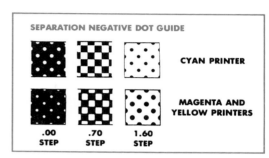

Figure 7-30. *Separation negative dot guide.*

There are many other methods of color separation, but they all use the same basic principles. If you can accomplish this simplified method of color separation, you will find it easier to understand the more advanced methods.

Figure 7-29. *Color separation computer.*

discussion questions

1. What is the difference between tone posterization and color posterization?
2. What is a fake duotone? Describe how to make a fake duotone.
3. Explain the difference between high key, full range, and low key duotones.
4. Why would a duo-black halftone be used?
5. What is a duochrome? When would it be used?
6. What color filters are used to make a three-color separation?
7. Light is made up of what three colors?
8. What is a moiré pattern?

Chapter 8

stripping
and
platemaking

equipment
stripping
platemaking

When the photo conversion is complete, the negatives are assembled into a unit called a *flat.* The flat is then used to *burn* or expose a printing plate. In this chapter you will learn the basic principles of stripping or making a flat. You will also learn how to take this flat and, on a machine called a *platemaker,* burn a plate for reproduction on the offset press.

EQUIPMENT

The most important piece of equipment for stripping a flat is a light table, Figure 8-1. A light table is basically a piece of frosted glass with a light shining from below the glass. A light table enables the stripper to see the placement of the negatives on the goldenrod sheet. Goldenrod is an 80-lb., double-coated sheet of paper. It allows light from the light table to penetrate but holds back the light from the plate burner. Other tools and supplies required for stripping are:

- red lithographer's tape
- special stripping knife, X-acto knife, or razor blade
- T-square made of steel
- metal triangle
- scissors
- scribing tools
- opaque and opaquing brush
- other tools as needed.

Figure 8-1. *Light table. (NuArc Company, Inc.)*

Equipment necessary for making a plate includes:

- a platemaker with a strong light source to expose a plate
- a developing area, either a flat work surface or a developing sink.

Chemicals needed will depend on the type of plate you are working with. You will also need either a sponge or a special developing pad for certain kinds of plates.

STRIPPING

Different techniques may be used for stripping. The important thing to remember is that the end results depend on the negatives being assembled on the goldenrod sheet in the proper position. Many lithographers use the following method:

1. Place a goldenrod sheet on the light table with the head of the sheet either at the top or toward the left.

2. Line up the masking sheet with the T-square. Some masking sheets, particularly for small presses, come gridded (with guidelines already drawn on them). Larger presses require the stripper to mark gripper margins, center lines, and other necessary guidelines. The following information is based on the use of gridded goldenrod sheets.

3. Tape the goldenrod sheet down along the top edge only, Figure 8-2.

4. Locate the paper area to be printed on the masking sheet and mark the exact position of the image. The image area must not extend into the gripper margin of the masking sheet because this area will not print when the plate is burned.

5. Carefully slide the negative, emulsion side down, under the masking sheet. Emulsion side down means that type copy will appear correctly; it will be right reading. On halftones you can determine the emulsion side of the negative by observing the texture of the surface. On most negatives the emulsion side will have a slightly flat or dull finish. On some halftones, however, this is not true. If scratched on the emulsion side, a mark will show. You will have to scratch the negative in a non-image or non-printing area to determine the emulsion side.

Figure 8-2.
Goldenrod taped to light table.

127

6. Place the negative in the proper position in the area marked on the goldenrod sheet. Align the negative with a T-square and triangle or follow the gridded lines on the goldenrod sheet, Figure 8-3.

FOOTBALL-SHAPED HOLES

Figure 8-4. *Cut football-shaped holes in goldenrod.*

TAPE

Figure 8-5. *Tape over holes to hold negative in place.*

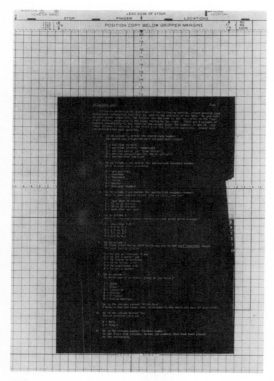

Figure 8-3. *Negative in proper position under goldenrod for taping.*

7. Once the negative is aligned, hold the negative and goldenrod sheet down with one hand, and with the other hand cut football-shaped holes in non-image areas, Figure 8-4. Be careful not to cut through the negative. Apply red lithographer's tape over the holes, Figure 8-5, to hold the negative and goldenrod together.

SAFETY NOTE: Always be careful when using sharp cutting tools such as a stripping knife.

8. Remove the tape from the top edge of the masking sheet. Turn over the negative and masking sheet together, making sure not to separate the two.

9. Tape each of the four corners of the negative to the masking sheet with lithographer's tape. Keep the tape at least ¼ inch from the image area.

10. Once the negative is secured, turn the flat over so the golden-rod sheet is on top. Cut away the masking sheet over the image area. The opening is called a *window,* Figure 8-6. Use enough pressure to cut only the goldenrod sheet; do not cut through the negative. Inspect the flat to make sure the entire image area is open. Do not worry about the area still covered; it will not transfer to the printing plate.

Figure 8-6. *Window cut in goldenrod.*

11. Paint out all of the unwanted clear areas with opaquing fluid, Figure 8-7. Opaquing is normally done on the base side of the film because the opaquing solution contains some water which could swell the emulsion. Almost all negatives have pinholes caused by dust on the film either in manufacturing or in the darkroom. If these pinholes are not opaqued, they will appear on the printing plate and print on the finished copy. Errors made in opaquing can be removed with a damp rag.

12. After opaquing, clean the brush in water and tightly stopper the bottle of fluid.

Figure 8-7. *Opaquing negative.*

Figure 8-8.
Scribing lines on negative.

The flat is now ready for platemaking. At this point scribing may be done or register marks may be included. Scribing means adding lines to an already developed negative by removing emulsion with a sharp instrument. For straight, even lines, a T-square or triangle is usually used, Figure 8-8.

Sometimes when printing more than one color or superimposing letters over a halftone, it may be necessary to make two flats. Both flats, then, must be stripped in the same position. This is called *register.* To insure proper registration, the flats are usually punched before assembly of the negatives. Register pins are then used on the stripping table to insure correct placement of both

flats, Figure 8-9. You may also use fine, little register marks (target lines) to insure proper placement of the flats, Figure 8-10.

Figure 8-9. *Register pins on stripping table.*

Figure 8-10. *Register marks. (Eastman Kodak Co.)*

When you assemble a flat that has both line and halftone negatives on it, you normally strip up the line negative first.

Then the halftone negative is placed in a window previously prepared and photographed, Figure 8-11.

Figure 8-11. *Line and halftone negative. (Eastman Kodak Co.)*

PLATEMAKING

After the flat has been prepared, an offset plate is made from it for the press. Many different types of presensitized plates can be used for this operation. Most school shops use a negative-acting additive plate, which will be discussed here. Most of these plates are either metal or foil types. Other offset plates will be described later in this chapter.

The negative-acting additive plate is exposed in a platemaker, Figure 8-12.

Figure 8-12. Platemaker. (NuArc Company, Inc.)

This platemaker is usually a vacuum frame to hold the negative and plate in very tight contact and a source of high-intensity light. Because the light on a platemaker is so strong, it can damage your eyes.

SAFETY NOTE: Do not stare at an unshielded plateburner light.

To make a negative-acting additive offset plate:

1. Open the vacuum frame and check the glass for dirt or other foreign material. Clean if necessary.
2. Place an unexposed plate, presensitized side up, on the vacuum-frame bed.
3. Position the flat, emulsion side down. Adjust the top and side edges so that the flat and the plate are in proper alignment, Figure 8-13.
4. Close the vacuum frame carefully so as not to move the flat and the plate.
5. Turn on the vacuum pump. Check to see that the flat and plate are in proper alignment and that the pump has reached maximum vacuum.
6. Set the timer and expose the plate. The exposure time depends on the type of plate, the type of light source, and the distance between lamp and plate. Check plate manufacturer's recommendations for exposure of a given plate. During exposure, light passes through

REGISTER PINS

*Figure 8-13.
Negative in position
over plate for exposing.
Note register pins
taped to vacuum frame.*

the clear areas of the negative and causes a chemical change in the plate coating.

Note: When using a double-sided plate, expose both sides of the plate before developing.

7. After exposure, turn off the vacuum, open the vacuum frame, and remove the plate.
8. Place the plate on a clean, flat surface, either a developing sink or a flat table top.
9. Pour a small amount of process gum onto the plate. Rub it lightly with a sponge or soft pad, Figure 8-14. The process gum removes the unhardened plate coating. Move the sponge or pad in a figure eight motion across the plate, making sure

Figure 8-14. Pour a small amount of process gum onto the plate.

Figure 8-15. *Move the sponge in a figure eight motion across the plate. Be sure the process gum covers the entire plate.*

Figure 8-17. *Developer will adhere to image areas, clearly showing what was exposed.*

Figure 8-16. *When emulsion is removed by the gum pour a small amount of developer on the plate. Again use figure eight motion.*

Figure 8-18. *Wash with water. Apply a small amount of process gum and buff the plate with cheesecloth.*

you cover the whole plate, Figure 8-15. Do not allow the plate to dry.

10. Once all the unwanted emulsion has been removed, pour a very small amount of developer on the plate, Figure 8-16. With light pressure and a circular or figure eight motion apply the developer. Again be sure you cover the whole plate surface, Figure 8-17. If the second side has been exposed, develop it in the same manner as the first side.

11. Wash or wipe the plate with clean water to remove all the excess developer.

12. Apply a small amount of process gum to buff the plate. Buff it dry with a cheesecloth or similar material, Figure 8-18. The process gum will protect the non-image area of the plate from oxidation and from fingerprints. When you use two separate flats to burn the same side of the plate, remember to expose all the flats before you process.

There are four categories of other pre-sensitized offset plates that may be used in a shop. A negative-acting plate may be additive, as just described, or subtractive.

The whole surface of a subtractive plate has been coated by the manufacturer with a lacquer emulsion. The image is then hardened on the plate and the developer removes the emulsion from all non-image areas.

Instead of negatives, positives can also be used to make plates. These plates are desensitized where light strikes and will not take the developing lacquer in these areas. Positive-acting plates come in additive and in subtractive forms. With additive plates, the developing lacquer is added to the image area; with subtractive plates the whole plate is covered with the lacquer emulsion. Developing then removes lacquer in the areas struck by light.

Some plates are made directly on the camera. They are called *camera direct plates* and are made of metal, paper, or plastic. To make a camera direct plate, place the copy on the camera board so the image is projected through the camera lens to light-sensitive material. The image can be enlarged or reduced with the copy camera lens. Expose and process the plate. If it is not to go directly to the press, store the plate according to the manufacturer's recommendations.

discussion questions

1. What is the most important piece of equipment for stripping?
2. Briefly explain the process of stripping a line negative.
3. Why are the negatives stripped *under* the goldenrod sheet?
4. Why are negatives opaqued?
5. What type of plates do most school shops use?
6. Why is the plate coated with process gum as the last operation?
7. What type of plate is made directly on the camera?

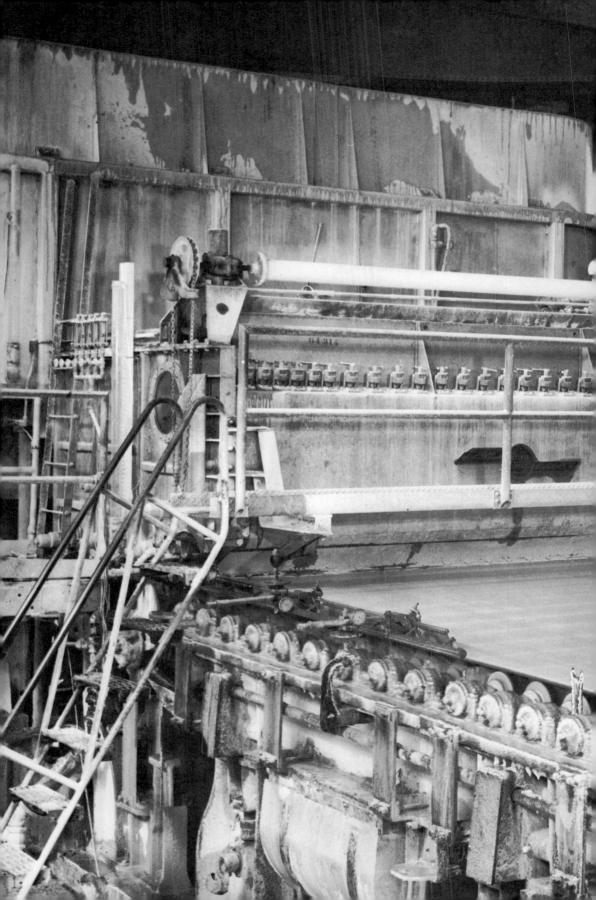

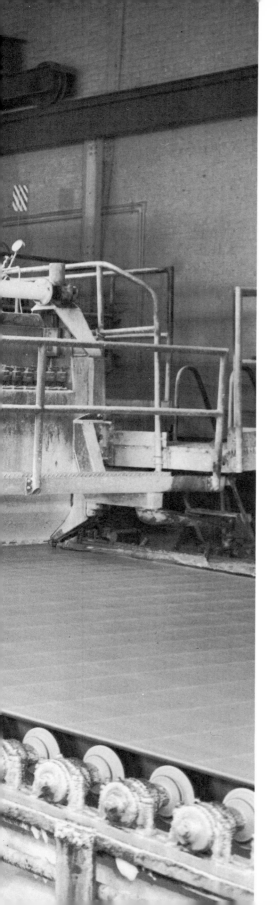

Chapter 9

ink
and
paper
in
lithography

ink for offset

paper in offset

F

ine quality printing can be accomplished only by using the correct combination of paper and ink. Today inks are specially formulated for the paper to be printed and the process to be used for printing. Only offset inks made especially for lithographic presses should be used on an offset press.

INK FOR OFFSET

Manufacture of Ink

Ink manufacturers must first determine their formula. Then they mix together the pigment and the vehicle in a large mixer, Figure 9-1, similar to a commercial mixer used for making bread dough. Pigment is gradually added to the vehicle in the mixer until the two are thoroughly blended. Fine printing requires the pigment to be completely mixed and dispersed throughout the vehicle. This is usually done by grinding the ink in an ink mill.

An ink mill has three to five hardened steel rollers, which are accurately machined and highly polished. These rollers rotate at different speeds and clearance between them is also adjustable. As the ink passes through the mill, Figure 9-2, the pigment is dispersed

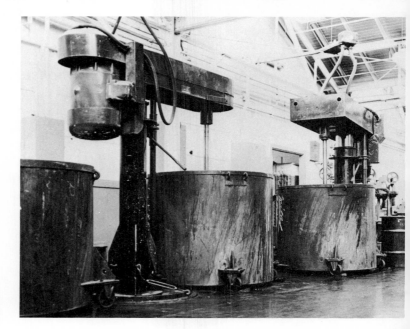

Figure 9-1. Large mixers are used for mixing the vehicle, the pigment and the drier.

guns. Ink is also available in one- and five-pound cans, Figure 9-3, or even in barrels or tank trucks.

Figure 9-3. *Various containers in which ink may be purchased.*

Ingredients of Ink

The ingredients of ink are similar to those of paint:

- vehicles
- pigments
- driers or modifiers.

Vehicles. The *vehicle* is the fluid part of the ink. It carries the *pigment* or color to the paper and holds it there. The most common type of vehicle is heat-treated linseed oil, sometimes called litho varnish. Today alkalyd resin oils are more commonly used. They provide higher gloss and more resistance to rubbing off of ink on hands or clothes.

Pigments. Pigments are the solid coloring matter of inks. Pigments are available in thousands of colors as well as black and white; they are the visible part of the ink. They also determine many of the characteristics of a particular type of ink. For example, pigments help determine opacity, transparency, and resistance to light, heat and chemicals. They also determine whether a particular ink will bleed in water, oil, alcohol, or grease. Because of all these variables, the pigment will determine to a consid-

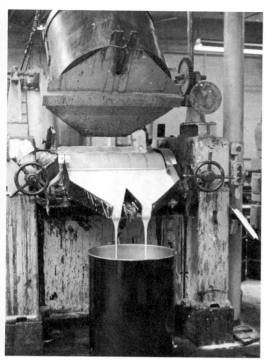

Figure 9-2. *Ink mill in operation. The pigment is dispersed throughout the vehicle by the shearing action of this machine.*

throughout the vehicle by the shearing action of the rollers. This shearing generates heat. To lower the temperature, the centers of the rollers are hollow and are water-cooled.

Most inks are run through the mill several times. Expensive inks, like offset inks, are ground much more than inexpensive inks such as newspaper inks.

Ink manufacturers are constantly looking for better ways of dispersing pigment in the vehicle. They are experimenting with methods like ultrasonic dispersion and kinetic energy.

Once the ink is ground to the desired fineness, it is packaged. Some ink is packaged in tubes which may be used with applicators similar to caulking

erable extent how a particular ink can be used. It will determine, for example, whether or not a particular ink may be used for offset printing or if it may be used to print food or soap wrappers.

There are two categories of pigments:
- inorganic
- organic.

Inorganic pigments come mostly from mineral sources. They include chrome yellows and oranges, iron blues, and cadmium reds. The yellow and red mineral colors are opaque and permanent.

Organic pigments are used more often than inorganic pigments. They are usually by-products of the petroleum industry. Organic pigments are made in all colors from lithol reds to alkali blues and violets.

Other special pigments in use include silver and gold powders, metallic inks, and fluorescent pigments that cause the ink to *fluoresce* or appear brighter than usual when exposed to light.

Driers. The drier in ink acts as a catalyst to speed up the oxidation of the vehicle. Most driers are manganese or cobalt compounds. The manufacturer generally mixes in the proper amount of drier for a particular ink. Not enough drier will cause the ink to dry very slowly or not at all. Too much drier will cause the ink to dry on the press. Because the drier, the vehicle, and the pigment all combine to influence the drying of a particular ink, the manufacturer determines the proper amount of the right type of drier.

Special modifiers are also available to speed up the drying of ink. Heat-set inks use heat to vaporize the vehicle as the paper passes through a heating chamber. Moisture-set inks dry when exposed to steam or a fine mist of water. Ultraviolet inks dry by exposure to ultraviolet light or to sunlight.

Ink Mixing

Although it is always best to purchase the desired color or ink from the manufacturer, occasionally a printing job will require a special color ink that is not available in the shop. Special colors can usually be made in the pressroom by carefully mixing correct proportions of other pigments.

To mix ink you will need a glass plate and two or three ink knives. It is best to mix the ink on a glass plate because ink will not penetrate the glass and it may be easily cleaned when finished. If no glass plate is available, a piece of press tympan paper is acceptable.

When you mix ink, start with the lightest color. Add the next color or colors *sparingly* until you reach the desired color. Use only clean knives and glass so you will not contaminate your color. Mix the colors until they are thoroughly blended, Figure 9-4. Test the color by spreading a small amount of ink in a thin film on a sheet of white paper.

Figure 9-4. *Mixing ink using a glass plate. Note the dark color is mixed into the light color.*

Ink Handling

Ink is available in containers of various types and sizes. A small job shop or a school will probably purchase ink in one-pound cans or in tubes. Some companies are now packaging ink in tubes that are used with a special dispenser that resembles a caulking gun. This is probably an economical way to pur-

chase small quantities of ink because it does not dry out as rapidly as in cans.

If you use one-pound cans always remember to replace the lids tightly to prevent oxidation of the unused ink. When you open a new can of ink, it is a good idea to apply a thin film of oil to the inside of the lid to prevent it from sticking to the can. Always replace the paper covering on the ink before replacing the lid to prevent oxidizing and formation of a skin on the top of the ink. Keep the ink level in the can; *don't dig down.* To do so increases the surface area exposed to air and causes waste.

Printing Ink Terms

To use or order ink you should know some of the terms used to describe properties of ink.

Viscosity. The resistance of a fluid to flow is called its *viscosity.* If ink has a low viscosity it flows readily. If it is heavy-bodied and does not flow readily, it has a high viscosity. Offset printing inks usually have a high viscosity.

Tack. Cohesion between particles of an ink is called *tack.* It is really a measure of the stickiness or adhesiveness of ink. A tacky ink does not break apart easily.

Opacity. The covering or hiding power of an ink is its *opacity.* An opaque ink will cover another color completely.

Transparency. The ability of an ink to let another color show through is called its *transparency.* A transparent ink will not cover another color.

Fastness. The resistance of an ink to fading or color change is called its *fastness.* A color fast ink will keep its color even though exposed to ultraviolet light, such as the sun, for long periods of time.

PAPER IN OFFSET

Paper and paper products are the most commonly used materials for printing. Good quality paper will improve the appearance of the job as well as prevent printing problems.

Manufacture of Paper

Paper making is a complex process. It begins with wood or rags that must be converted to pulp. Several kinds of pulp are used today.

The most common pulp is made from logs and is called chemical wood pulp. To help conserve natural resources, paper may also be made from recycled waste paper.

All wood contains cellulose fibers bonded together by lignin. Wood may also contain sugars, gums, resins, and salts. To make paper, the cellulose fibers must be separated from these other materials. Then the fibers are arranged in new patterns.

Logs, Figure 9-5, are generally used to make wood pulp. A chipper cuts the logs

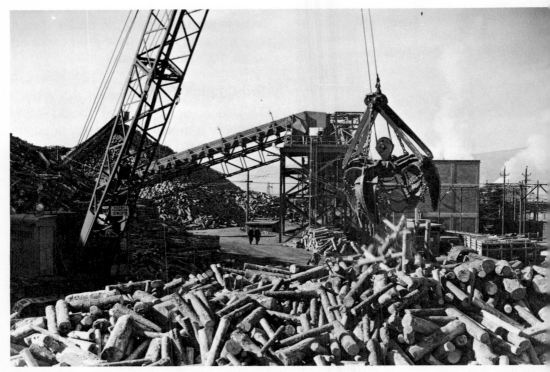

Figure 9-5. *Pulpwood stacked in piles waiting to be made into pulp. (The Brown Co.)*

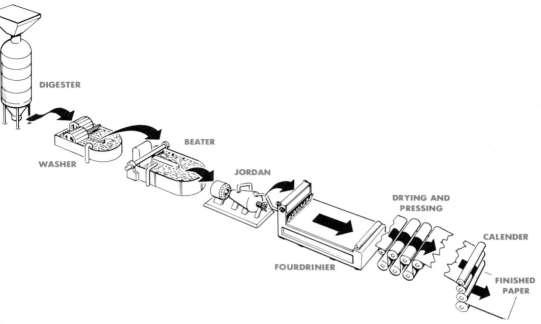

Figure 9-6. *Drawing showing the entire process of paper making.*

nto small chips which are then con-
veyed to a large pressure cooker called
a *digester.* (Figure 9-6 outlines the en-
ire chemical papermaking process.)
From the digester the pulp moves to a
washer where the pulp is washed with

clean water. The washed pulp then
flows to the beater, Figure 9-7. The
beater determines many of the qualities
the finished paper will have. Color dyes
may be added here.

*Figure 9-7. After
washing, the fibers are
twisted and frayed in
the beater. Dyes and
other ingredients are
added in the beater.
(Crown Zellerbach)*

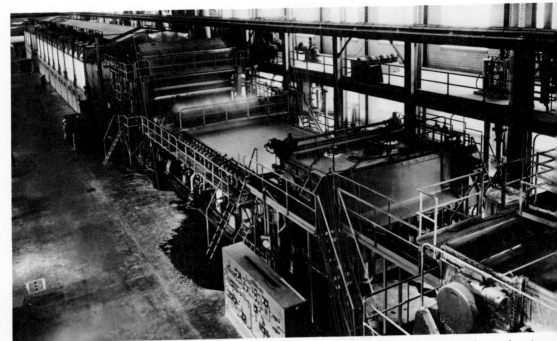

Figure 9-8. *Wet end of the paper machine. The water and fiber mixture is flowed onto a screen where much of the water shakes out of the fibers. From the screen the wet paper is fed into a long dryer section which removes most of the water. (Consolidated Papers. Inc.)*

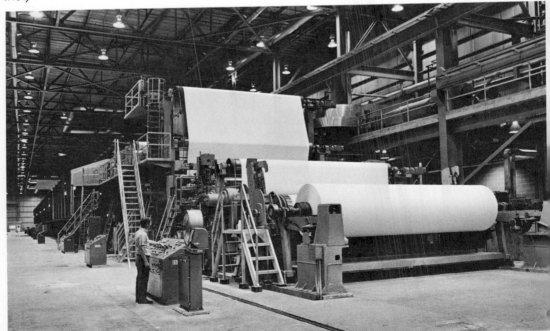

Figure 9-9. *Winding the finished paper onto large rolls at the dry end of a paper machine. From here the paper is rewound onto smaller rolls or cut into sheets to be sent to distributors. (International Paper Co.)*

The pulp then moves to a Jordan where the fibers are cut to a uniform length. The pulp then moves to a papermaking machine, Figure 9-8, which is one of the largest machines in any industry. It is sometimes over a city block long.

The finished paper is wound onto rolls, Figure 9-9. Later the rolls are rewound, trimmed and slit. Some rolls are cut into sheets for printers.

Paper Terms

For fine offset printing, the offset press operator must be familiar with certain terms and characteristics of paper.

Piece. A *piece* is an individual sheet of press-size paper. Large sheets of paper are usually cut into press-size pieces.

Sheet. Paper is purchased in full-sized sheets. Their size depends on the kind of paper and the size that is desired. A job-sized piece of paper is also called a sheet when it is ready to be run through the press. The terms *piece* and *sheet* are often used interchangeably.

Package. A package is a number of sheets packed together for sale. Index bristol, for example, is usually wrapped 100 sheets to a package. Bond or book paper, on the other hand, usually contains 500 sheets in a package.

Ream. A *ream* is 500 sheets of paper. It is the amount often wrapped in a package.

Felt Side and Wire Side. The two sides of paper have slight differences. One side is next to the felt drying blanket when made on the Fourdrinier; this is called the *felt side*. It is the better side to print on. Paper packages are often

marked with an arrow indicating which is the felt side.

The *wire side* is the side next to the wire screen on the paper machine. If you look at the sheet from the right angle, you can see the screen pattern. When you print on only one side of the sheet, use the felt side.

Paper Weights and Sizes

Paper is sold by the pound, hundredweight (100 lb), or by the ton (2000 lb). Some paper companies are now pricing paper by the number of sheets (per 100 or per 1000) as well as by weight.

Paper pricing depends on the kind of paper, its quality, and on economic conditions. Newsprint is one of the most inexpensive papers. Cotton content bond sells for about 5 to 6 times the cost of newsprint.

There is a standard system of weights and measurements to help in the pricing of paper. The standards from which the measurements are made are:
- basic unit (number of sheets)
- basic size
- basic weight.

Basic Unit. Originally the basic unit was the ream, 500 sheets. Today many papers are still packaged in 500 sheets, but most paper companies are now using 1000 sheets as the basic unit. Paper calculations are much easier based on 1000 sheets because decimals may then be used.

Basic Size. The basic size is the specific size from which weight measurements are made. Paper may be ordered from the mill in almost any size if a large enough quantity is wanted. Certain

sizes are usually standard for each kind of paper. They are stocked by most paper distributors. Each paper classification has a specific size from which its weight measurements are made. The most common size for bond and ledger papers is 17 × 22 inches, for example. From this size, four pieces of 8½ × 11 inch stationery can be cut. The basic size for book papers is 25 × 38 inches and the basic size for cover paper is 20 × 26 inches. All kinds of paper have their own individual basic size.

Basic Weight. Originally basic weight was the weight of one ream (500 sheets) of a particular paper. For example, 25 × 38–70 (basic 70) meant that 500 sheets (25 × 38) of this particular book paper weighed 70 pounds. A basic 80 cover paper would weigh 80 pounds per 500 sheets. Likewise, 500 sheets of a bond paper 17 × 22–20 would weigh 20 pounds.

Today, however, most basic weights are based on the weight of 1000 sheets. This system is indicated by the letter M representing 1000 sheets. Thus 25 × 38–140M is equivalent to 25 × 38–70. One thousand sheets weigh 140 pounds while 500 sheets weigh 70 pounds.

Paper may be made in any weight from 20 to 150 pounds. However, to eliminate confusion, paper mills have selected certain standard weights for each kind of paper. Book papers, for example, are usually made in weights of 50, 60, 65, 70, 80, 90, and 100. Some book papers are available in all weights; others are available in only a few.

Paper is often made in sizes other than the basic size. For non-basic sheets an equivalent weight is given. You may want to use 70-pound book paper in 35 × 45 size; the weight of one ream is 116 pounds. The paper would be listed as 35 × 45–116 or 35 × 45–232M. It is still the same paper and weight as 25 × 38–70.

Other Paper Characteristics

In addition to size and weight, other characteristics must be considered in the selection of paper. They include color, strength, stretch, and opacity. Colors, even white papers, vary from mill to mill. If you are trying to match a color, it is best to order from the company that produced the original.

Papers also vary in strength depending on how the fibers are intermingled. This is important for web-fed presses. All paper will stretch a certain amount. This is more important in finer printing.

Paper opacity is related to the thickness of the sheet and the fillers that have been added when the paper was made. A titanium compound is often added to increase opacity. If the stock is to be printed on both sides, high opacity is important.

Metric Measurements

The metric measurements most significant in the graphic arts are
- length
- area
- volume
- temperature.

Linear measurements based on the metric system are used for paper and film.

The graphic arts uses three ISO paper series:

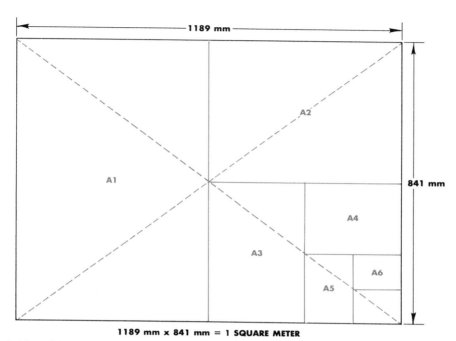

1189 mm x 841 mm = 1 SQUARE METER

Figure 9-10. *Chart showing ISO A size paper.*

- the A-series, for general printed matter including letterheads (Figure 9-10)
- the B-series, mainly for patterns
- the C-series, for envelopes meant to be used with A-sized paper.

The A-series is intended for general use. The largest size AO has an area of one square meter. The ratio of the sides is based on the proportion $1 : \sqrt{2}$ (1:1.414). The A size is 841×1189 millimeters. Smaller sizes in the series are obtained by dividing the larger sides by two. The A1 size is 594×841 millimeters. With this system, the standard $8\frac{1}{2} \times 11$ inch letterhead sheet becomes the A4 size (210×297 mm), Figure 9-11.

Paper is now sold by pounds per ream. The weight per unit area is expressed

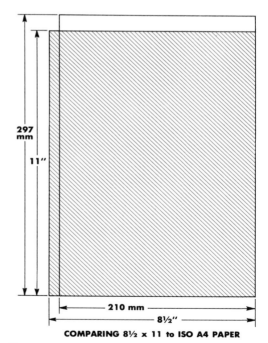

COMPARING 8½ x 11 to ISO A4 PAPER

Figure 9-11. *Comparison of the popular 8½ × 11 inch paper with the A4 paper of comparable size.*

as the basis weight. This is simply the weight, in pounds, of 500 or 1000 sheets of a specific size paper. The metric system refers to grams per square meter (g/m^2). The metric system also measures paper thickness in millimeters instead of in thousandths of an inch.

Calculating and Using Paper

As you plan a printing job, it is important to consider the kind, size, and cost of the stock that will be printed. To avoid needless waste, you will need to plan an original layout that can be cut economically from standard size sheets.

You should also consider the grain of the paper. If the job involves any folding, the direction of grain is important because the paper will fold more easily with the grain. Grain is also important because it will affect the direction of paper curl. To test for the direction of grain, moisten a piece of the stock. It will curl perpendicular to (against) the direction of the grain. Paper also tears more easily and straighter with the grain than across it. Tearing is especially useful in determining direction of grain in bristol or cover paper.

Moisture content of paper stock is also important. When paper reaches the end

of a Fourdrinier machine it contains four to six percent moisture. After that, the moisture varies due to atmospheric conditions. When paper absorbs moisture, it expands across the grain more than with the grain. When paper loses moisture, it shrinks more across the grain than with the grain. Moisture content of paper depends upon where it is stored or processed. Consequently, pressrooms require temperature and humidity controls, particularly where close color register printing is done. If the paper shrinks or expands during the color printing process, registration will be inaccurate and the work will not be clear and sharp.

Estimating Paper

When estimating the amount of paper stock for a printing job, you must first know the number of finished copies required. Next you must know the size of the available press or printing form. Now compute the number of copies that can be cut from a standard size sheet. An 8½ × 11 inch letterhead would probably be cut from 17 × 22 inch bond paper. Use the common method of dividing and cancelling:

$$\frac{\overset{2}{\cancel{17}} \times \overset{2}{\cancel{22}}}{\cancel{8\frac{1}{2}} \times \cancel{11}} = 4 \text{ pieces}$$

From each sheet of 17 × 22 inch bond paper, four pieces of 8½ × 11 can be cut. In this example the size of the needed pieces divided evenly into the size of the sheet. Often this does not happen.

Sometimes it is necessary to try dividing in both directions to determine which way the most efficient cut would be produced.

If a booklet, 9 × 12 is to be printed from 25 × 38 book paper, the calculations are:

$$\frac{\overset{2+\quad 3+}{\cancel{25} \times \cancel{38}}}{\cancel{9} \times \cancel{12}} = 6 \text{ pieces}$$

Turn the paper the other way:

$$\frac{\overset{2+\quad 4+}{\cancel{25} \times \cancel{38}}}{\cancel{12} \times \cancel{9}} = 8 \text{ pieces}$$

is more economical, then, to cut the stock with the 12-inch side along the 25-inch dimension. Always try both directions to determine which will give you more pieces.

After you have calculated the number of pieces from each sheet, you can figure the total number of sheets needed for the job. To do this, divide the number of finished copies required by the number of pieces obtained from each sheet. For example, if 500 letterheads are needed, and you will get four 8½ × 11 pieces from a standard 7 × 22 sheet:

```
        125
  4) 500
        4
       10
        8
       20
       20
```

Thus 125 sheets of 17 × 22 inch paper would be needed for 500 letterheads, 8½ × 11 inches.

It is best to allow some extra paper for spoilage. Spoilage occurs when setting guides, adjusting ink, and feeding the press. Each additional operation, such as folding, stapling, and trimming, increases the number of extra sheets needed. A good allowance for 500 letterheads is usually about 10 percent. Thus for 500 good copies about 550 pieces of stock will be needed. As the number of copies required increases, the percentage of spoilage allowance decreases. For 10,000 copies, 3 or 4 percent is all the spoilage allowance necessary.

Cutting Stock

Once you have estimated the number of sheets, the stock must be cut. There are two basic paper cutters:

- the hand-lever cutter
- the power paper cutter.

The knife on a power paper cutter, Figure 9-12, is brought down hydraulically or mechanically when an operator pulls the levers or pushes the buttons. Power cutters usually have two separate controls, a distance apart, which must be operated simultaneously. This is a safety device to keep the operator's hands far from the cutting knife.

To cut paper, set the back gage with the handwheel. Place the paper on the cutter and jog it against the back gage and the side of the cutter until the stack is even. Place a piece of chipboard on top of the stock to protect it from indentations from the clamp. Tighten the clamp to hold the paper in position for cutting.

SAFETY NOTE: The cutting blade of a paper cutter is extremely sharp and powerful. Be alert around the paper

Figure 9-12. *Typical power paper cutter. Notice the operator must use both hands to operate the machine.*

cutter and keep your mind on your work. Keep your hands away from the cutter except when moving the stock. Try to avoid paper cuts. The edge of a sheet of paper is sharp enough to produce a cut that may not be serious but is painful.

discussion questions

1. Why should you use only inks manufactured for lithography on an offset press?
2. What are the three ingredients of all inks?
3. Why should the darker color ink always be mixed into the lighter color when mixing inks?
4. Briefly explain the process of paper making.
5. Briefly explain *basic unit, basic size,* and *basic weight.*

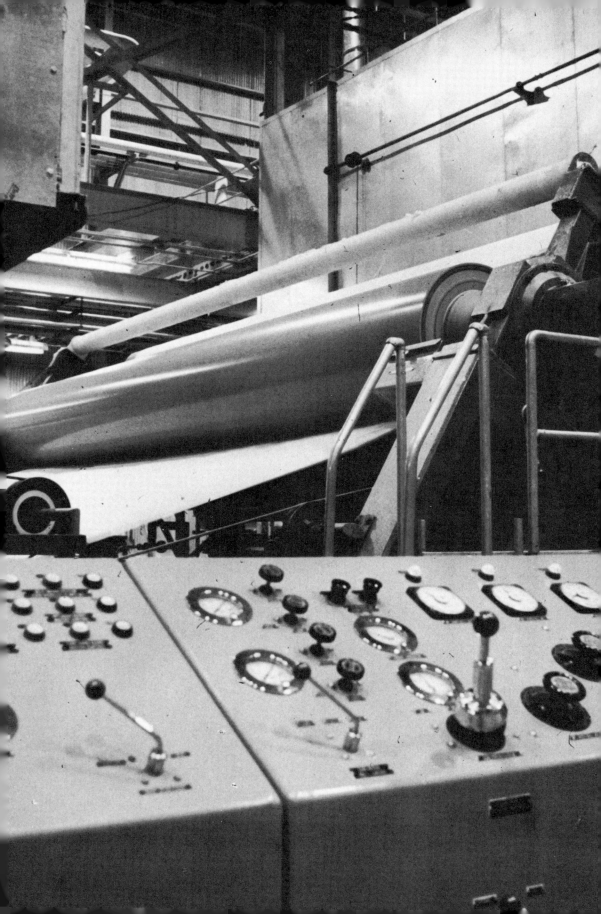

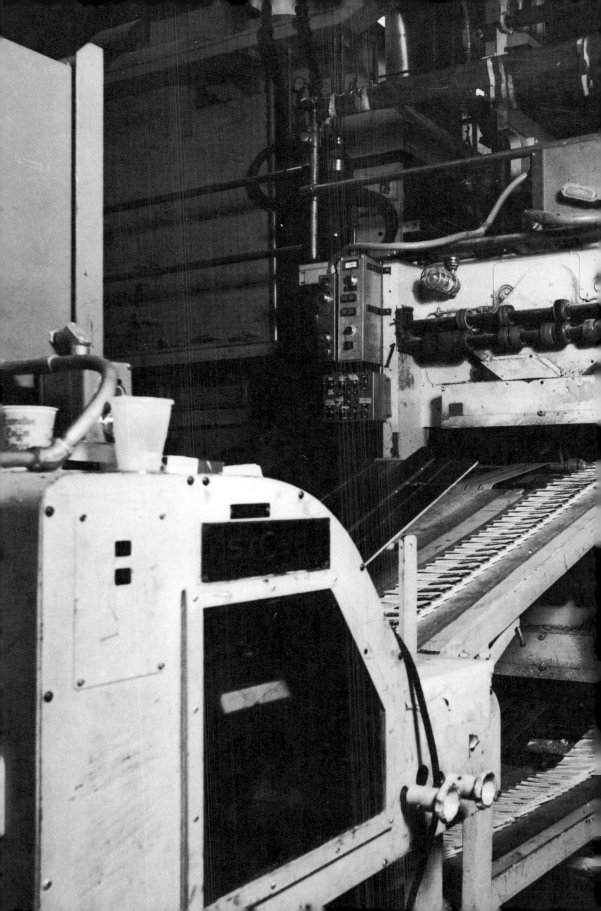

Chapter 10

offset
presswork

feeder system
dampening system
inking system
printing system
paper delivery system

To the beginning printer, the offset press is a large and complex piece of equipment. This chapter will use a systems approach in explaining the various parts of a press. When you have completed this chapter you will better understand each part. Chapter 11 then will explain how to set up and operate an offset press.

Based on the size of the printed sheet offset presses are classified as either printing presses or offset duplicators. The smaller offset presses were first popular in office reproduction work and were called duplicators. Because they had only a few inking rollers, they could not print large screened or solid image areas. Modern offset duplicators are capable of producing quality lithographic printing and in this chapter will be considered as small offset presses. Figure 10-1.

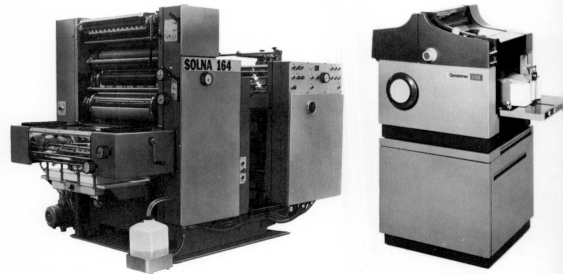

Figure 10-1. *A large offset press (Solna Corp.) and a small office duplicator. (Gestetner Corp.)*

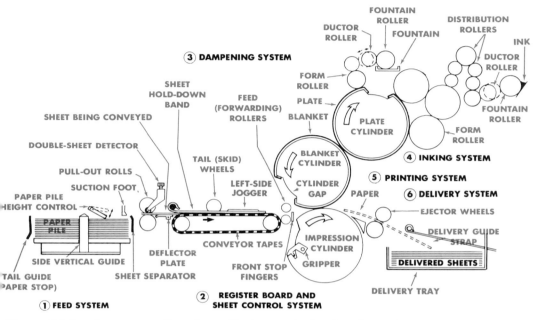

Figure 10-2. *A cross section of an offset press indicating the various systems.*

Medium and larger printing units contain more inking rollers and can successfully print areas of all sizes and densities.

All offset presses have certain systems in common, Figure 10-2. A sheet of paper moving through an offset press will pass through the following systems:

- feeder system, which picks up the sheet of paper and feeds it into the press
- registration and sheet control system, where the sheet of paper is moved so that it will be inserted into the printing unit at a precise time in a precise position
- the dampening unit, which applies water to the offset plate
- the inking system, that applies ink in a thin film to the plate
- the printing system, made up of three, or sometimes two, cylinders which do the actual printing
- the delivery system, where the paper leaves the press printed and ready to dry.

FEEDER SYSTEM

Paper feeding units are either sheet-fed or roll-fed. Roll feeding is normally used with large, complex offset presses. A roll-fed press uses large, continuous rolls or webs of paper.

As a beginner, you will be dealing almost exclusively with sheet-fed units. Smaller, less expensive presses will have a friction feed pickup, which consists of one or two rubber rollers that feed one sheet at a time into the press, Figure 10-3.

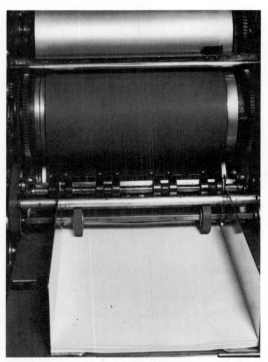

Figure 10-3. *Friction feed rollers rotate at the correct time, feeding a sheet of paper into the printing system.*

Sheet-fed systems may also use an air and vacuum pickup, which has two or more air blowers at the side, front or rear of the paper stack. The air stream raises the top sheet from the stack so it

can be picked up by one or more suction feet that lift it and send it into the press, Figure 10-4.

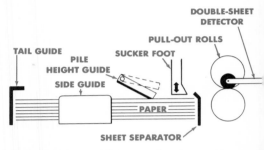

Figure 10-4. *Vacuum feeder cross section with major parts labeled.*

One type of air and vacuum system is the successive sheet feeding unit. In this system, the top sheet is separated from the paper stack and advanced to the feed board table, tapes, or ramp, depending on the feeder design. The next sheet is not separated from the pile until the tail end of the first sheet has cleared the advancing mechanism. Thus a distinct space and time interval exists between sheets. The sheet must travel forward at about the same speed as the press operates since one full sheet at a time is advanced to the registering and/or insertion device. Because the sheets move so rapidly, special attention must be given to holding down the sheet and keeping it moving at press speed without damage to the sheet. The sucessive sheet feeding system is used primarily with small presses.

Another air and vacuum system, the stream feeding type, sends a continuous flow of sheets to the forwarding mechanism. As one sheet is advanced, the next sheet is separated and advanced, usually from the back end of the paper pile, Figure 10-5. Several sheets are moving forward all the time with

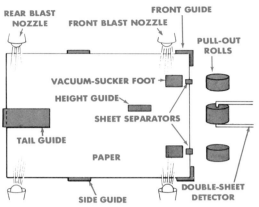

Figure 10-6. *Common parts of the vacuum feeder (top view) with major parts labeled.*

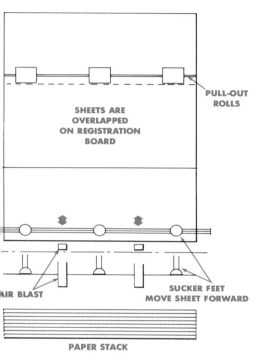

Figure 10-5. *Cross section of a typical stream feeder system with major parts labeled.*

some part of their length overlapping. The speed of forwarding is much slower in the stream feeder than on the successive sheet feeders. The slower travel of the sheet on stream feeders makes it easier to control the sheet. Another important advantage of stream feeders is that, because they overlap, the first sheets help control the sheets that follow. Stream feeders are usually found on large sheet-fed presses.

Common components of the paper feeding unit, Figure 10-6, include:

- paper pile guides at the front, side, and tail of the paper stack
- two or more flexible sheet separators, often called "cat whiskers" or

"stripper fingers," that control the front edge of the top sheet while it is being lifted by the air blast

- a pile height guide that automatically raises or lowers the paper stack to keep the top sheet in pickup position
- one or more pull-out rolls that guide the sheet onto the feed board or directly into the printing unit (if the press does not have a conveyor or feed board)
- a double sheet detector or eliminator to prevent more than one sheet being fed into the press at a time. It is usually positioned on the same shaft as the pull-out rolls. On some presses, the double sheet eliminator is a jam type, meaning that multiple sheets will jam up and stop feeding into the press.

Paper Conveyor or Register Board

Most offset presses, except the A. B. Dick, Ryobe, and MGD 20- and 22-inch presses, have a paper conveyor or register board. The register board, Fig-

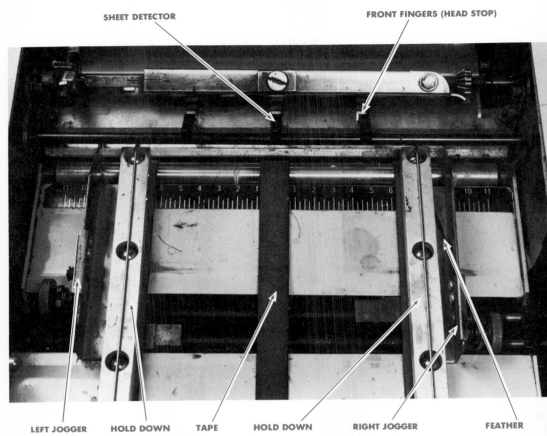

SHEET DETECTOR FRONT FINGERS (HEAD STOP)

LEFT JOGGER HOLD DOWN TAPE HOLD DOWN RIGHT JOGGER FEATHER

Figure 10-7. *A typical register system with major parts labeled.*

ure 10-7, consists of a set of conveyor tapes, with one or more metal hold-down bands, to convey the sheet from the feeder unit to the printing unit. It also has a set of front stop fingers or head stops to stop the sheet while a set of side guides jogs the sheet into side register. *Jogging* means moving the sheet into position. The front stop fingers then move away to permit the sheet to be taken into the impression cylinder grippers.

On some presses, a feed roller contacts the sheet and pushes it into the impression cylinder grippers. On other presses, the grippers actually take hold of the sheet in the stop position and

move it into the impression cylinder. While the sheet is stopped by the front fingers, a set of tail skid wheels can be positioned manually at the back end of the sheet to improve the register control.

Side guides are used to set the lateral or side margins. Most presses have a left jogger guide that moves back and forth to guide the sheet. On some presses either or both side guides can also be used as jogger guides.

The side guides, along with the front stop fingers, provide a three-point register system that sends each sheet into the impression grippers in identical po-

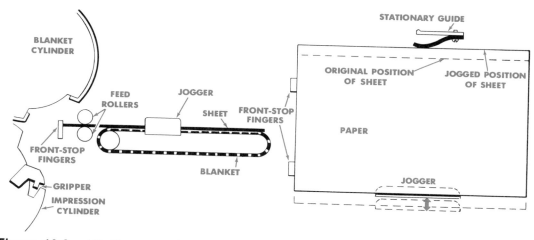

Figure 10-8. (A) *Cross section of a register system with a sheet of paper momentarily stopped and ready to be jogged into correct position.* (B) *Top view of register system with the jogger moving the sheet into correct position against the feather.*

sition, Figure 10-8. Some presses also permit a slight angular and vertical copy adjustment at the front stop fingers to compensate for plates where the copy is not exactly squared on the plate.

On presses without a paper conveyor or feed board, the paper is delivered directly into the impression cylinder grippers from the suction feed with one side pile guide being used as a paper register guide.

DAMPENING SYSTEM

Both the dampening and inking systems use many rollers, each of which is named according to its function, Figure 10-9. At the fountain or reservoir is a fountain roller which distributes the amount of ink or water needed. Next is a ductor roller that rotates and moves back and forth between the fountain roller and the next roller, which is either an oscillator or a distributor roller. As it rotates, the oscillator also moves from side to side of the ductor roller. A distributor roller does not move from side to side but evens out the film of ink or water around the rollers.

Each system has a different number of oscillator or distributor rollers. The final roller is the form roller which applies an even film of ink or water to the plate. Form rollers are the only rollers that actually contact the plate.

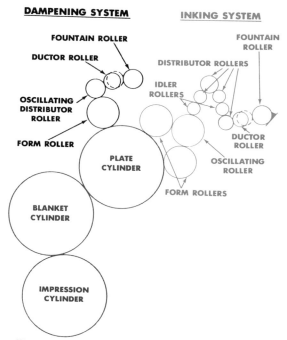

Figure 10-9. *Cross section of the inking and dampening system of a typical small offset press (Multilith).*

There are many types of dampening systems in use on offset presses. Among these, two types are commonly used on small and medium presses:

- the conventional system of separate dampener form rollers that contact the plate
- the integrated system that provides a water-base fountain solution on top of ink rollers, using the ink roller system to carry both fountain solution and ink to the plate.

The conventional system, Figure 10-10, includes a water fountain that holds a controlled ph or acid fountain solution. It also has a revolving roller that feeds or meters the fountain solution to the ductor roller. As the ductor roller rocks back and forth, it alternately contacts the fountain roller and an oscillator or distributor roller.

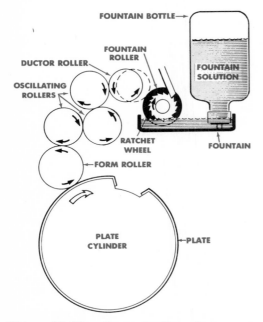

Figure 10-10. *Cross section of a conventional dampening system.*

The conventional dampening system includes:

- a water fountain that holds a controlled ph or acid fountain solution
- a fountain roller that feeds or meters the fountain solution to the ductor roller
- a ductor roller which rocks back and forth alternately contacting the fountain roller and an oscillator or distributor roller
- one or more oscillator rollers that contact the form roller
- a form roller that contacts the plate directly.

Usually the ductor and form rollers are covered with special cloth covering called *molatin* or cellulose-based paper. The fountain and oscillator rollers are usually metal. But rollers will vary in different models.

A conventional dampening system is found on Davidson, Hamada and ATF Chief presses, Figure 10-11.

The integrated dampening system, Figure 10-12, consists of:

- a water fountain roller
- a metal or rubber ductor roller
- a rubber oscillator or distributor roller
- ink distributors
- form rollers

One problem that is common with integrated dampening systems is roller stripping. Roller stripping occurs when ink will not adhere to rollers dampened just prior to inking. To prevent roller stripping, ink must be distributed on all the ink rollers before the fountain solution is added.

On a few integrated dampening systems (particularly on MGD presses), the fountain rollers and distributor rollers must be kept free from ink. Otherwise the fountain solution will not adhere, Figure 10-13.

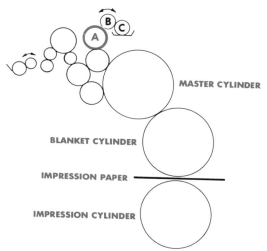

Figure 10-13. *The MGD 20 and 22 integrated dampening system. When in operation only A should have a coating of ink.*

INKING SYSTEM

Inking rollers for offset presses are generally made of synthetic rubber and can be washed with several types of solvents. Commercial blanket wash solutions and mineral spirits are recommended. Inking rollers can also be cleaned with a special soap or lye solution. Rollers can be buffed with steel wool and a polishing compound commonly called pumice and can be reground when necessary to give a new roller surface.

Ink is kept in a fountain, which is simply a steel blade held against the ink fountain roller by a series of adjustable screws. As the fountain roller revolves it carries a thin layer of ink on its surface and contacts the ductor roller. The duc-

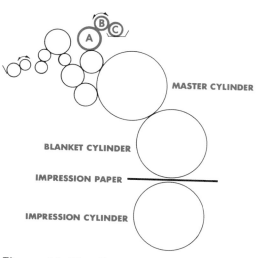

DUCTOR ROLLER FOUNTAIN BOTTLE FOUNTAIN ROLLER

OSCILLATING DISTRIBUTOR PLATE CYLINDER
FORM ROLLER

Figure 10-11. *The conventional dampening system as found on the ATF Chief 15 press.*

MASTER CYLINDER
BLANKET CYLINDER
IMPRESSION PAPER
IMPRESSION CYLINDER

Figure 10-12. *The A. B. Dick integrated dampening system. When in operation, all three rollers, A, B, and C, in the dampening system have a coating of ink.*

tor roller rocks back and forth to make alternating contacts with the fountain roller and the distributor roller. The distributor is in constant contact with several idler and oscillator rollers, some of which are also moving back and forth. These distributor and oscillator rollers spread ink evenly on the form rollers, Figure 10-14.

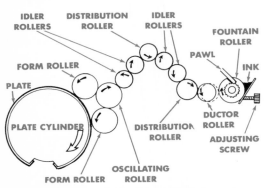

Figure 10-14. Inking system found on small offset presses.

The form rollers contact the moistened plate and ink the image before it is transferred to the blanket cylinder. Inking capabilities of the press are increased by increasing the number of ink rollers, by adding an oscillating movement to the rollers, and by varying the diameter of rollers to help fill the depleted ink areas. The more rollers in the inking system, the more the ink is broken down and the better it will transfer to the plate and then to the blanket.

PRINTING SYSTEM

The printing unit consists of two or more cylinders, Figure 10-15. The most common uses three cylinders and includes:

- a plate cylinder with head and tail clamps that can sometimes be adjusted from side to side to provide an angular adjustment

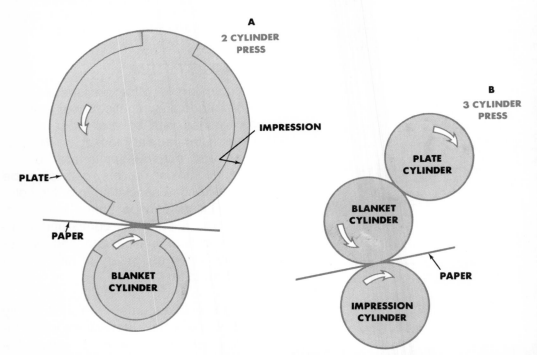

Figure 10-15. (A) *The three cylinder printing system is found on A. B. Dick, Multilith, ATF Chief and Hamada star presses.* (B) *The two cylinder printing system is found on the Davidson press.*

- a printing cylinder, covered with a rubber blanket, that receives the inked image from the plate and transfers it to the copy paper
- an impression cylinder with grippers to carry the paper during the contact with the blanket cylinder.

The plate cylinder holds the plate during printing. The head and tail clamps at the top and bottom of the cylinder are made to fit straight, serrated, slotted, or pinbar plates. Usually your press manual will describe the kind of plates designed for your press. Some presses can be changed to accept more than one type of plate. The clamps are either spring-loaded for quickly changing short run plates or are screwed down for tighter cylinder contact. The clamps are often adjustable for straightening the image angle, Figure 10-16.

Plate cylinders have either a steel or chrome finish. Steel cylinders are somewhat ink receptive and tend to rust. If rusted, special care must be taken when you use two-sided plates. A properly maintained cylinder should not rust. If it has rusted, clean the cylinder with solvent, rub with very light emery cloth, and treat to prevent further rusting. Clean chrome cylinders with solvent after each run and polish periodically with chrome cleaner to prevent rust.

TIGHTENING ADJUSTMENT ANGULAR ADJUSTMENT

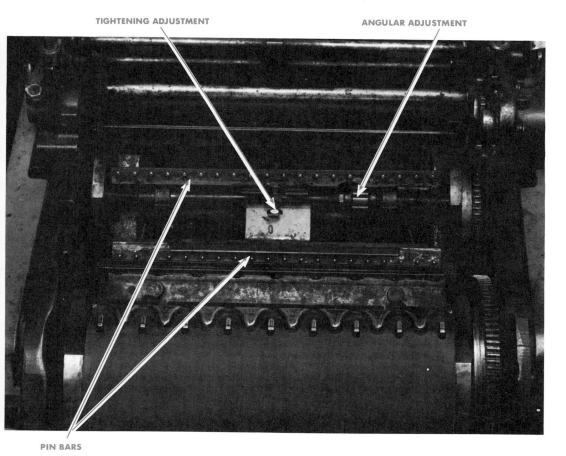

PIN BARS

Figure 10-16. Plates can be angled or moved from side to side on some presses.

Some plate cylinders are undercut to allow for printing plates of varying thicknesses and may require packing material to bring the plate to printing height, Figure 10-17. Follow the press manufacturer's instructions for packing. The Heidelberg offset press is an example of one press requiring packing.

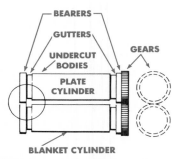

Figure 10-17. *An undercut plate cylinder requires packing under the plate to bring it up to bearer height.*

The printing contact between plate and rubber blanket cylinder should not exceed about three thousandths of an inch packing or squeeze. In addition to the angular adjustment possible with the head and tail plate clamps, most offset presses control the vertical placement of copy. This is done by an adjustable plate cylinder that can be unlocked and revolved to a new position indicated on a dial on the drive side of the plate cylinder. This operation changes the blanket position and moves the copy up or down on the copy paper. After adjusting, retighten the plate cylinder and wash the old image off the blanket, Figure 10-18. It is not always necessary to wash off the old inked image. Some presses like the A.B. Dick or the Ryobe always keep the plate and blanket in the same relative position to each other. So as the

Figure 10-18. *Vertical adjustment of the printed image is made by unlocking and revolving the plate cylinder.*

Figure 10-19. *The offset blanket is attached to the blanket cylinder at either end.*

impression cylinder revolves, the image always contacts the same spot on the blanket.

The blanket cylinder is covered with a fabric-backed rubber blanket snugly fastened to the cylinder by head and tail clamps, Figure 10-19. Because the blanket does the final printing, the final quality of the printed work depends largely upon the condition and adjustment of the blanket. Sometimes the blanket cylinder is undercut (like the plate cylinder) and requires additional underpacking to bring it to the correct printing height. In all cases follow the manufacturer's instructions for packing. Rubber blankets must be kept clean. Powder them with a prepared blanket dusting powder made primarily of talc and use them in rotation with other blankets to prolong their useful life. A blan-

ket clamped to the printing cylinder should fit evenly and snugly with the clamp pressure applied evenly from both ends. Some presses require that the blanket be unfastened at one end for overnight storage and retightened before printing the next day. When you use a new blanket, it usually requires a run-in period to allow it to stretch and be tightened so there will be no slippage during the actual printing operation.

In order to get maximum life from the blanket, clean it with special blanket wash that evaporates rapidly and will not harm rubber. Use a soft cloth for cleaning the blanket and rub with an even pressure. After you have cleaned it, wipe the blanket dry with a clean, soft cloth. Blankets with a built-up coating of ink and repellent solution are glazed and must be cleaned with a commercial

glaze-removing solution or rubbed with pumice and blanket wash.

Most presses have a multiple-sheet detector to prevent a buildup of paper that would smash the blanket. All presses have impression adjustments to avoid undue pressure and wear on the blanket and plate.

Low places in a blanket which will not transfer image lines may be raised by pasting tissue or onion skin paper under the area with pressroom paste. Another way to remedy low spots is to fold the blanket at the low spot and roll it between your thumb and index finger. You may also apply a dab of commercial blanket raising solution to the area. Usually, though, when a blanket is smashed or has a low spot, replace the blanket as soon as possible.

Before you install a new blanket, clean and polish the metal blanket cylinder removing ink, rust, and other foreign matter. Center the blanket clamping devices and attach the leading edge of the blanket to the head clamp. Rotate the blanket cylinder with one hand while holding the blanket smoothly on the cylinder with the other. Attach the bottom to the tail clamp, Figure 10-20.

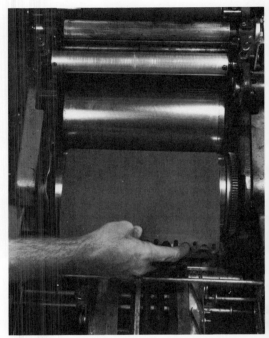

Figure 10-20. *To replace an offset blanket, attach the head and revolve the cylinder with the handwheel while holding onto the blanket.*

Check that the blanket is straight. Tighten each screw equally from both ends, but do not stretch the blanket unnecessarily. After you have cleaned the blanket and adjusted the cylinder pressure, check the new blanket for stretch and tighten as necessary. Run either a short job or about 100 impressions or run scrap paper through the press to break in the blanket.

Finally, the impression cylinder receives the copy paper from the register unit and brings it into contact with the blanket cylinder, Figure 10-21. The impres-

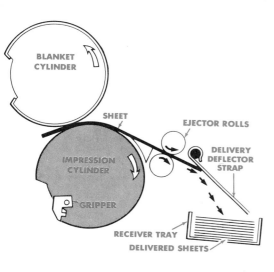

Figure 10-21. *Impression cylinder grippers have moved the sheet into the printing unit and have released it into the delivery system.*

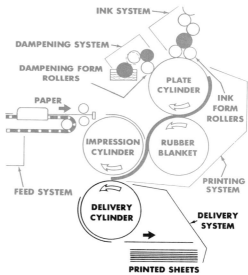

Figure 10-22. *The four-cylinder press has a separate delivery cylinder in the delivery system.*

sion cylinder then delivers the paper into a tray or to the grippers of the chain delivery unit. On some presses the paper is delivered to a delivery cylinder, Figure 10-22.

On some presses the impression cylinder can be moved closer to or farther from the blanket cylinder, Figure 10-23, thus controlling the impression. While making this adjustment, place a sample of the stock to be printed between the two cylinders.

Some other presses have a self-compensating device to hold the copy paper to the blanket cylinder by spring pres-

Figure 10-23. *To compensate for various paper thicknesses, the impression cylinder can be moved closer or farther away from the blanket cylinder. This is the adjustment on a multilith press.*

167

sure. On such presses an approximate impression adjustment will suffice to accommodate a range of paper thicknesses.

Impression cylinders have either a steel or a chrome finish. Steel cylinders again are somewhat sensitive to ink and will allow ink to build up from misfeeds or printed stacks of sheets not quite dry. Steel cylinders will also rust in time and should be periodically cleaned and smoothed with pumice. Most presses are equipped with steel impression cylinders. Chrome cylinders, on the other hand, reduce setoff transfers from the impression cylinders. However, they still should be periodically cleaned and polished with chrome cleaner.

PAPER DELIVERY SYSTEM

The paper delivery system receives the printed copies from the impression cylinder and stacks them on the tray or platform. There are two types of delivery systems:

- the simple tray or chute delivery system
- the chain delivery system.

A simple tray delivery system uses ejector rings and wheels to guide the printed sheet into the tray between two side guides and the paper stop. Proper setting of the rings and wheels is important. Generally set the wheels near the outside edges of the sheet and the rolls about ½ inch inside the wheels, Figure 10-24. The paper is delivered with the curl of the paper up. In some cases, the wheels may have to be placed inside the rings or above the rings for smooth and consistent sheet delivery.

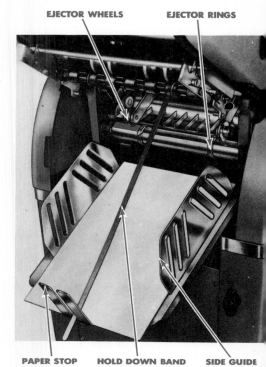

EJECTOR WHEELS EJECTOR RINGS

PAPER STOP HOLD DOWN BAND SIDE GUIDE

Figure 10-24. *The simplest delivery system is the tray or chute delivery system. (AM International, Inc.)*

A chain delivery unit picks up the printed sheet with a set of delivery grippers and conveys it to a flat platform between two side guides and a paper stop, Figure 10-25. Chain delivery provides better con-

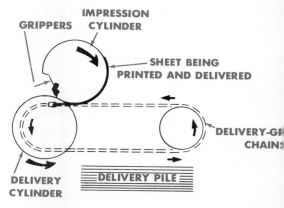

IMPRESSION
GRIPPERS CYLINDER

SHEET BEING
PRINTED AND DELIVERED

DELIVERY-GR
CHAINS

DELIVERY
CYLINDER

DELIVERY PILE

Figure 10-25. *Cross section of a chain delivery system.*

trol of the delivered sheets and a larger variety of papers can be printed at faster press speeds. Most chain delivery units have an additional jogger side guide and a receiving stock platform to permit neat stacking of printed copies.

Most paper delivery systems also include a piece of metallic tinsel grounded to the frame of the press to help eliminate static electricity from the printed sheets. An anti-offset spray may also be installed in the delivery unit to prevent the image from setting off on the backside of printed sheets, and it permits sheets to be stacked in larger piles.

You have now been introduced to the basic systems of an offset press. In the next chapter you will learn how to adjust each of these systems in preparation for printing.

discussion questions

1. What is the difference between duplicators and offset presses?
2. Describe how a sheet feeder works.
3. What is the purpose of the register system on an offset press?
4. What is the difference between the integrated dampening system and the conventional dampening system?
5. Why do inking and dampening systems have oscillating rollers?
6. What are form rollers? What makes them different from other rollers on the press?
7. Why is it important to have many ink rollers?
8. What are the advantages of the two, three, and four cylinder presses?
9. Describe how to care for an offset blanket.
10. How can a smashed blanket be repaired?
11. What is *set-off?*

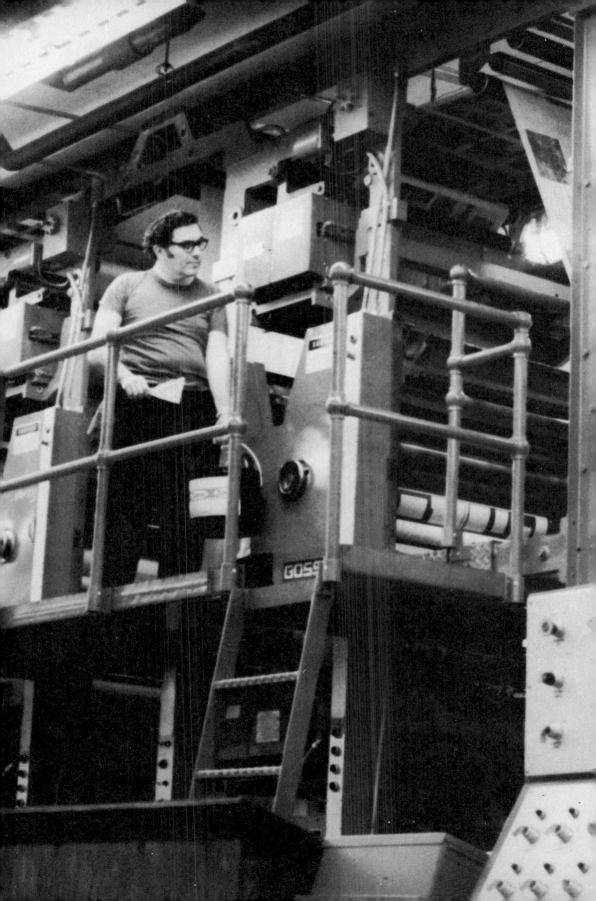

Chapter 11

offset
press
setup
procedures

Setting up an offset press for a printing job is a complicated process. In this chapter you will learn how to set up each system so a successful press run will result.

In industry, press operators usually set up the ink and water system before loading the paper onto the feeding section. An experienced press operator generally runs the same press day after day with small variations in paper size and thickness. Therefore the feeder is already set up and little, if any, time is needed for feeder and delivery setup.

Beginners, however, must usually set up for a great variety of paper sizes and weights. Therefore, it is best to set up the paper feed and delivery units before the inking or dampening systems. This will help prevent the ink and water systems from going out of balance when the press operator turns on the press to check and remedy problems with the feeder and delivery systems.

SETTING UP THE FEEDER SYSTEM

Refer to Figure 11-1 to identify the various parts of the feeder system. The

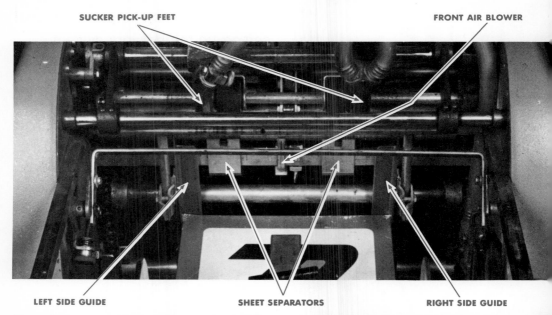

SUCKER PICK-UP FEET · FRONT AIR BLOWER · LEFT SIDE GUIDE · SHEET SEPARATORS · RIGHT SIDE GUIDE

Figure 11-1. The major parts of the feed system are left side guide, right side guide, sheet separators, sucker pick-up feet, and front air blower.

feeder system is set up in the following manner:

1. Lower the feed table.
2. Fold a sheet of stock to be run in quarters lengthwise.
3. Unfold the sheet and lay it on the feedboard to serve as a set-up guide, Figure 11-2.

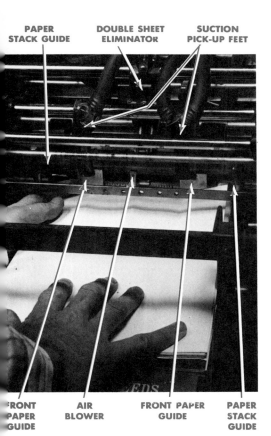

PAPER STACK GUIDE DOUBLE SHEET ELIMINATOR SUCTION PICK-UP FEET

FRONT PAPER GUIDE AIR BLOWER FRONT PAPER GUIDE PAPER STACK GUIDE

Figure 11-2. To set up the feeder, fold a sheet of paper into quarters lengthwise and use the folds as guides.

4. Set the left paper-stack guide to the mark on the feed board for the width of the sheet to be run. If there are no markings, align the center crease of the paper with the center mark of the press. Then move the left side guide up to the stock.

5. When the left side guide is set, move the right side guide ⅛ inch from the right edge of the sheet.
6. Set the front paper guide so that the stripper fingers line up on the two side creases of the guide sheet.
7. Loosen the suction pickup foot (or feet). If one foot is used, position it on the center crease of the paper. If two feet are used, set them over the outer two creases of the paper. Tighten the thumb screws that hold these feet in position.
8. Move the air blower so the air blast will strike the center of the sheet. (Note: A. B. Dick presses do not have this type of feeder and do not require this setup.)
9. Set the double-sheet eliminator. Tear a strip of the stock about ten to twelve inches long and one to two inches wide. Fold the strip so about two inches is a single thickness and the rest is doubled over. Turn the press handwheel to check the press for jams or problems. Start the press and insert the single side of the strip into the pull-out rollers. The double-sheet deflector plate should be closed. If it is open, the double-sheet detector has been activated and needs

to be adjusted. Turn the double-sheet detector screw until the plate stays closed, Figure 11-3.

DOUBLE SHEET DETECTOR ADJUSTMENT SCREW

DEFLECTOR PLATE

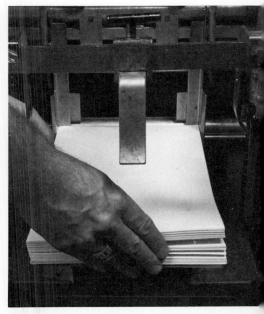

PULL-OUT ROLLS

Figure 11-3. Set the double sheet detector by inserting alternately single and double thicknesses of the stock to be run. Adjust the thumbscrew until the deflector plate stays closed with one sheet thickness and opens with two sheet thickness.

Next insert the doubled part of the trial strip. The deflector plate should open. If it does not, adjust the screw until the plate opens. Check again with a single thickness to make sure one sheet alone will not trip the deflector plate but two sheets will. (Some presses, such as the A. B. Dick, do not have double-sheet detectors.)

10. Fan and jog the paper to insure even feeding. Then load the paper onto the paper platform, Figure 11-4.

Figure 11-4. Fan paper and load evenly onto the feed board.

11. Carefully set the back side guide extensions about one inch from the back of the paper stack and against the paper. Make sure not to misalign the stack.

12. Set the paper back guide at the center of the stack, Figure 11-5.

Figure 11-5. Back guides are set after the stock is loaded on the feed board.

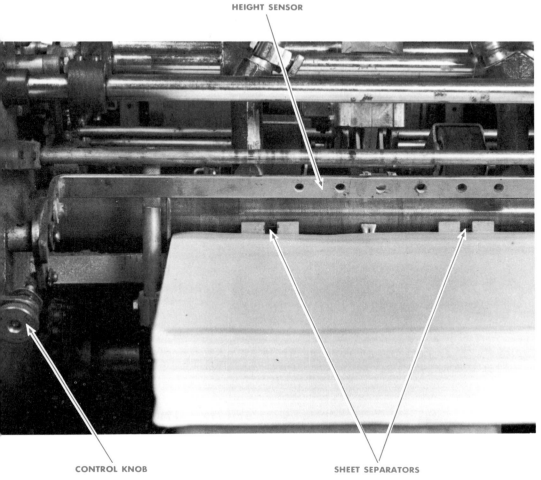

HEIGHT SENSOR

CONTROL KNOB

SHEET SEPARATORS

Figure 11-6. *Paper in feed section raised to the approximate feed height of ¼ " from sheet separators.*

13. Lower the feed table a few inches and turn on the press. Vacuum and air switch should be off. Engage the paper platform elevator. The paper stack should rise to about ¼ inch below the sheet separators, Figure 11-6. If it does not, adjust the elevator control knob so that the stack will stop about ¼ inch below the separators. The control knob is usually labeled RAISE and LOWER. Each time you reset the elevator control knob you must lower the feed table in order to get an accurate indication of how high the stack will rise.

14. If the side air blast is adjustable, aim it towards the opposite side of the paper sheet about two-thirds of the way from the front of the sheet. The second hole of the blower tube should be at the

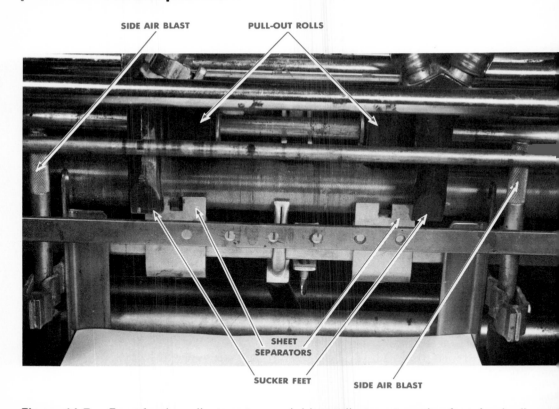

SIDE AIR BLAST PULL-OUT ROLLS

SHEET
SEPARATORS

SUCKER FEET SIDE AIR BLAST

Figure 11-7. *Front feeder adjustments are air blast adjustment, sucker feet, feed rolls, and sheet separators.*

top of the sheet when the sheet is ¼ inch below the sheet separators, Figure 11-7.

15. Turn on the air and vacuum switch and check to see how the paper is floated up by the air blast. It should float almost to the sheet separators without vibration. If the sheet is vibrating, cut back the air. If the sheet is not high enough, increase the air blast.

16. Adjust the vacuum so that it will draw the floating sheet to the feeder feet but will not pick up more than one sheet.

17. Adjust the pull-out wheels to uniform pressure so the paper sheets move squarely from the feeder onto the register board.

SETTING THE REGISTER FEED BOARD

Not all presses require setting the register feed board. The A. B. Dick, for example, does not. To set the register feed board, Figure 11-8, follow this procedure:

1. Move the joggers and side guides out of the way of the incoming paper.

2. With the press running, set the tapes, hold-down bands and skid rolls so the sheet will move smoothly down the register board.

3. Turn on the vacuum and air switch and feed control (if the press is so equipped) and cycle the press to pick up the paper

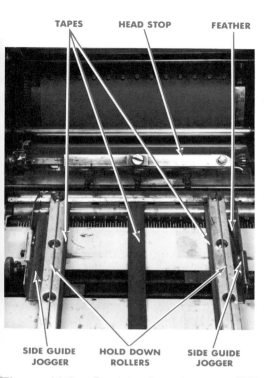

TAPES HEAD STOP FEATHER

SIDE GUIDE JOGGER HOLD DOWN ROLLERS SIDE GUIDE JOGGER

Figure 11-8. Register board on an ATF Chief showing the joggers, forward tapes, hold down rollers, front finger stops, and feather.

and move it onto the feed register board. On some presses the paper can be fed without turning on the press. When the paper touches the head stops, turn off the press.

4. Adjust the sheet jogger to center the sheet on the press. The jogger should move the sheet about ¼ to ½ inch.

5. The feather is a piece of spring steel used to prevent the sheet from bouncing against the side guide. Adjust the side guide so that the jogged sheet will contact the feather but move it no more than ¹⁄₁₆ inch.

6. On presses with adjustable head stops, set the head stop at center position.

7. Adjust two skid wheels to just touch the rear of the paper sheet on the feed tapes.

8. On presses with adjustable feed rolls, check the pressure. The feed rolls should propel the sheet forward to the grippers and impression cylinder. Timing should be such that the sheet will be buckled slightly to insure positive movement into the grippers. Uneven pressure from side to side must be adjusted by turning the feed roll adjusting screw on the feed roll housing. Pressure on both sides of the feed rolls should be even so the paper will be fed evenly and smoothly.

To set the feed roll pressure, tear a sheet of paper into several one-inch strips. Place one strip of paper under each feed roll. As you pull the strips toward the end of the press, you should feel a slight drag. Adjust the rolls if necessary, Figure 11-9.

Figure 11-9. To adjust feed rolls on some presses insert two strips of paper and adjust pressure until both strips pull out with equal firm drag.

177

How to Adjust

Blanket cylinder to impression cylinder

Improper pressure adjustments may result in poor quality copy. If you run a heavier than normal stock, it will be necessary for you to readjust your blanket cylinder-to-impression cylinder adjustments. To do this follow the steps outlined below. In addition to the adjustments mentioned below, improper blanket cylinder-to-impression cylinder pressure adjustments may result in smashed blankets and poor quality copy.

ATF CHIEF 15

Loosen locking screw (A) and turn the impression adjusting screw (B) toward you until the print obtained is very light. Then turn the adjusting screw (B) back, away from you, until the desired impression on the paper is obtained. Retighten the locking screw (A).

ADDRESSOGRAPH-MULTILITH 1250

Loosen clamp screw (A) and turn micrometer adjusting screw (B) clockwise to decrease pressure and counterclockwise to increase pressure. Tighten clamp screw.

DAVIDSON DUALITH 500

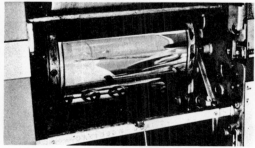

This adjustment is accomplished on the Davidson Dualith 500 by underpacking the impression segment with packing sheets under the metal drawsheet—refer to owners manual for specifics.

A. B. DICK 360

Insert Allen wrench into the control dial opening and turn the dial to the lower numbers to increase pressure and to the higher numbers to decrease pressure.

Figure 11-10. *Adjusting the blanket cylinder to impression cylinder. (3M Co.)*

9. Leave the sheet of paper between the side guides and turn the handwheel until the paper moves between the blanket and impression cylinders. Adjust the impression cylinder pressure to the thickness of the sheet. This adjustment device is located in different places depending upon the press, Figure 11-10. On Multilith presses, for example, it is just below the handwheel behind a small round plate.

SETTING UP THE DELIVERY SYSTEM

When the feed system and the register feed board are prepared, the delivery system may be set up:

1. Continue turning the sheet through the press until the leading edge extends into the delivery section of the press. On presses with a tray delivery, Figure 11-11, set the delivery rings to the outer edges of the sheet and the delivery rolls about 1/2 inch inside the rings. Set the delivery tray side guides to the edges of the sheet. If the press has a side jogger guide, set it while in its innermost position.

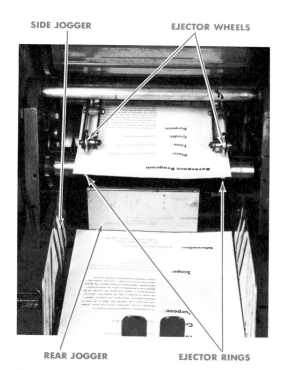

SIDE JOGGER — EJECTOR WHEELS — REAR JOGGER — EJECTOR RINGS

Figure 11-11. *The chute delivery system requires adjustment of the ejector wheels, ejector rings, side jogger, and rear jogger.*

2. Continue turning the press until the sheet is in the delivery section. Set the front and tail stops to the sheet length. If either stop jogs, set it while it is in its innermost position. If the press has a

179

chain delivery, Figure 11-12, turn the sheet until the delivery gripper is about to release the sheet. Set all side, front, and tail delivery guides to the dimensions of the sheet. Be sure all jogging guides are at their innermost position. On presses that have a receding stacker, set the receding stacker control to lower the delivery platform slowly as the printed sheets are delivered to it.

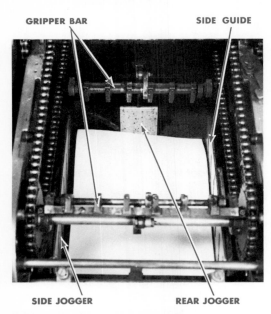

GRIPPER BAR SIDE GUIDE

SIDE JOGGER REAR JOGGER

Figure 11-12. *The chain delivery system requires adjustment of side guides, side jogger, and rear jogger. Generally the gripper bars do not need adjustment.*

3. Finally, check the entire system. Start the press, turn on the air and vacuum switch, and allow the paper to feed into the delivery section. Let 20 to 25 sheets of paper feed through the system. The sheets should move smoothly and consistently onto the registration board with each sheet uniformly centered and transferred to the printing system. The delivery system should remove each sheet and stack a perfect pile on the delivery table. Adjust any system not handling the sheet correctly. Fine adjustments may be made after the printing unit has been set and the first proof sheets come through the press.

SETTING UP THE DAMPENING SYSTEM

Attach a dry, used plate (similar to the one you will be using) to the plate cylinder for the purpose of checking the dampening system, the inking system, and the printing system. Set up the dampening system in this way:

1. Inspect the dampening rollers and fountain. Clean them if necessary.
2. Replace any missing rollers.
3. Fill the fountain bottle with fountain solution prepared for the type of plate you are going to run. Place the bottle in the fountain holder.
4. Do not over-saturate. Dampening rollers should be damp, not wet.
5. Check the pressure between the dampener roller and the plate cylinder, Figure 11-13. Adjust if necessary.

How to Adjust

Dampener rollers to plate cylinder

It is important to have equal pressure at all points between the dampening roller and the plate cylinder. After mounting a plate on the plate cylinder, place two 1-inch wide strips of paper (or two .005 3M Dampening Gauges) between the roller and plate. With the roller in an "on" position, slowly pull on the strips. You should feel a uniform, firm pull on both strips. An unequal pull on the paper strips means the roller is not parallel with the plate cylinder. If the pull is too heavy or if the strips pull too easily, overall pressure between the roller and plate cylinder must be adjusted. Adjustment instructions are described below.

ATF CHIEF 15

Loosen locking nut (A). Then turn the dampener form roller adjusting screw (B) clockwise if the test strip is too tight or counterclockwise if too loose. Tighten the locking nut (A) and repeat the paper test to be sure that the proper amount of adjustment has been made.

DAVIDSON DUALITH 500

Loosen lock nuts (A) and turn screws (B) counterclockwise until the bottom of the screws (B) do not touch the round metal banking stud directly under the Dampening form roll brackets. Next, loosen lock nuts (C) and turn the adjusting screws (D) until the springs (E) exert an even pressure slightly more than is normally needed for running. Tighten lock nuts (C).

*Adjust dampening form roller to metal vibrator roller before adjusting to plate.

ADDRESSOGRAPH-MULTILITH 1250

Loosen set screw (A) in the form roller knob and with a screwdriver, turn eccentric shaft (B) counterclockwise until a fairly strong pull can be felt as the strips are withdrawn. Tighten set screw (A) to lock the adjustment.

A. B. DICK 360

The dampening roller does not contact the master cylinder, but there should be a 1/64" gap between the aquamatic oscillator and the aquamatic ductor roller. After turning the handwheel until the ductor operating levers have travelled as far as they can toward the oscillator roller, adjust the eccentric screws so there is a 1/64" gap across the entire length. This adjustment must be rechecked and adjusted whenever ink form roller pressure adjustments are made.

Figure 11-13. *Adjusting the dampening roller to plate cylinder. (3M Co.)*

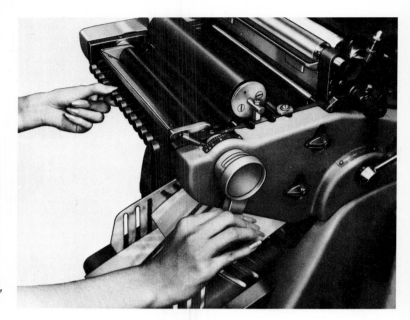

Figure 11-14.
To adjust the flow of ink from the ink fountain, turn the thumbscrews at the rear of the fountain. (AM International, Inc.)

SETTING UP THE INKING SYSTEM

To set up the inking system:

1. Check the ink rollers. Be sure they are clean and free from glaze. The rollers should have a dull, flat appearance.
2. Lock the fountain in position and fill it with enough ink to complete the press run.
3. Turn the ink fountain roller and inspect the film of ink on it. Adjust the fountain screws to obtain a thin, even film of ink over the whole roller surface, Figure 11-14.
4. Start the press to feed ink onto the rollers. All of the rollers should have a thin film of ink. The inking system should make a soft, hissing sound.
5. Stop the press and ink feed.
6. Check the pressure between the ink form roller and the plate cylinder by lowering the ink form rollers onto the plate, Figure 11-15. You should have uniform

parallel bands of ink across the plate when the ink form rollers are raised. The width of the ink bands will vary with each press. Adjust if necessary.

SETTING UP THE PRINTING UNIT

The last system to be set up is the printing unit. Follow this procedure:

1. Check the blanket and replace it, if necessary. Clean the blanket with the proper blanket wash.
2. Check the pressure between the plate cylinder and the blanket cylinder by inking the plate solid and then putting the press on impression. Take the press off impression. A single uniform band of ink should be transferred to the blanket. Adjust if needed. See Figure 11-16.
3. Remove the old plate. Clean this plate and the blanket and impression cylinders.

How to Adjust

Ink form rollers to plate cylinder

It is important to have your machine properly adjusted. When performing the ink form roller check, you will see uniform parallel bands of ink. Irregular bands indicate either uneven settings or worn rollers. Adjustments for various machines are described below.

ATF CHIEF 15

Loosen ink form roller lock screw (A) on the side requiring adjustment. Then turn the ink form roller adjusting screw (B) clockwise to decrease the width of the stripe or counterclockwise to increase the width of the stripe. Tighten lockscrew.

ADDRESSOGRAPH-MULTILITH 1250

Loosen set screw (A) in the form roller knob, and with a screwdriver turn eccentric shaft (B) counterclockwise to increase width of bead or clockwise to decrease width of bead. Tighten set screw (A) to lock the adjustment.

DAVIDSON DUALITH 500

Loosen lock nuts (A) in the form roll brackets and turn the adjusting screw (B) clockwise to decrease pressure and counterclockwise to increase the pressure. Tighten the lock nuts (A) and recheck the pressure until both form roll marks are exactly 1/8" wide.

*Adjust ink form roller to vibrator roller before adjusting to plate.

A. B. DICK 360

Loosen lock screws (A) both sides and adjust screws (B) as necessary. Turn screw (B) on operator side of machine in clockwise direction. Turn screw (B) on the non-operator side of the machine in a counterclockwise direction to increase width of bead line. Tighten lock screws.

Figure 11-15. *Adjusting ink form rollers to plate cylinder. (3M Co.)*

How to Adjust

Plate cylinder to blanket cylinder

After you have performed the ink band checks and adjustments, turn the duplicator on and ink up the rest of the plate. To make your plate-to-blanket check, the entire plate must be covered, not just the image area. You do this by not dropping the dampener rollers. Turn the duplicator off and then gently lower the plate cylinder to the blanket and raise it immediately. Rotate the blanket cylinder by the handwheel and inspect your ink band. Again, it should be a uniform parallel band. If not, you will have to make the adjustments described below. Remember, your instructor will assist you and all of these adjustments are shown in the instruction manual supplied with your duplicator.

ATF CHIEF 15

Loosen the Locking Screw (A) and turn the Plate-to-Blanket Impression Adjusting Screw (B) clockwise to increase the width of the stripe or counterclockwise to decrease. Retighten locking screw (A).

ADDRESSOGRAPH-MULTILITH 1250

Loosen lock bolt (A) Move single lever control (B) to left to increase pressure; move lever to right to decrease pressure. Tighten lock bolt (A).

DAVIDSON DUALITH 500

Loosen the two allen screws (A) in the blanket latch. Then loosen the lock nut (B) and turn the hex-headed screw (C) clockwise to increase pressure and counterclockwise to decrease pressure. Tighten the lock nut (B) and the two allen screws (A) and recheck for correct pressure.

A. B. DICK 360

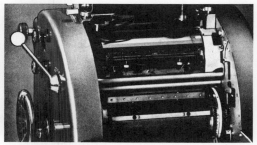

This adjustment should be made by your instructor or the A. B. Dick service representative.

Figure 11-16. *Adjusting plate cylinder to the blanket cylinder. (3M Co.)*

RUNNING THE JOB

You now have the various systems, Figure 11-17, in adjustment for running the job. Proceed in this manner:

1. Install the plate to be run. Remove the protective gum arabic with a damp, cotton pad.

2. Check the dampening system again for moisture. Remember the rollers should be damp, not wet.

3. Start the press and engage the dampening form rollers, if your press is so equipped. After a few press revolutions, engage the ink form rollers.

4. Turn on the vacuum and blower control and/or the feeder control. Feed a couple sheets through the press.

5. Shut down the press in this sequence:
 a. Turn off feeder and/or vacuum blower control.
 b. Raise plate cylinder from the blanket cylinder (if applicable).
 c. Raise ink form rollers.
 d. Raise dampener form rollers.
 e. Turn off press motor.

6. Check the quality of the printed sheet and the position of the image. Here are some of the problems you may encounter and some suggested remedies:
 - *Ink Spot on the Plate.* Remove ink spots from non-image areas of the plate with a clean, soft eraser dipped in fountain solution or dilute stopout solution or use a fine hone.

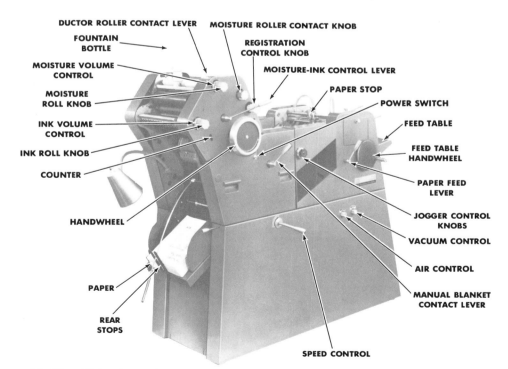

Figure 11-17. *Side view of an ATF Chief Press with operating controls labeled. Similar controls can be found on most small offset presses.*

● *Scumming or Tinting in the Non-image Areas, Figure 11-18.* This problem may be caused by incorrect pressure setting of the dampener form rollers to the plate or by too much ink in the inking system. Adjust the rollers and decrease the flow of ink to the system. Scumming or tinting may also be caused by a dampening system that is too dry. Check moisture. Another cause may be the pH factor or the acidity of the fountain solution. Check with pH paper and adjust.

BACKGROUND DIRTY—SCUMMING
Too much ink ● Not enough moisture ● Dirty dampener roll covers ● Dampener covers tied too tightly on ends.

Figure 11-18. *Scumming and its causes. (3M Co.)*

● *Non-Uniformity of Ink Coverage, Figure 11-19.* The printed image should have a solid, dense color, evenly inked across the sheet. Adjust ink flow with the fountain ratchet control. Adjust ink consistency with the individual ink fountain adjusting screws.

UNEVEN PRINTING
Incorrect ink distribution ● Glazed rollers ● Incorrect dampener form roller parallel pressure ● Poor paper (surface of paper) ● Incorrect ink form roller parallel pressure ● Incorrect plate-to-blanket parallel pressure ● Incorrect impression-to-blanket parallel pressure ● Dirty impression cylinder.

Figure 11-19. *Uneven printing and its causes. (3M Co.)*

● *Overall Ink Too Dark or Too Light or Spotty, Figure 11-20.* This is the result of incorrect balance of ink and fountain solution with impression pressure. It is best to set up the press with a minimum amount of fountain solution and ink. Then run the press with the dampening system set at the minimum necessary to obtain a clean sheet. Match the ink setting to it. Check the quality of the print with a magnifying glass to determine the amount and distribution of ink and the degree of impression. Too many pinholes may result if the impression is too light. If the copy is gray, there may be too much fountain solution or too little ink. But always check for too much before you look for too little. If the image lines are ragged, there may be too much ink or too heavy an impression. Form roller pressure or glazed rollers may also be at fault.

COPY TOO DARK
Too much ink ● Too much impression-to-blanket pressure ● Not enough plate-to-blanket pressure ● Too many revolutions on blanket without paper going through (build up on blanket).

WEAK SPOTS (SPOTTY COPY)
Incorrect plate-to-blanket pressure ● Incorrect impression-to-blanket pressure ● Low spots in blanket ● Tacky ink ● Tacky blanket ● Dirty impression cylinder ● "Blind" image on plate caused by dried gum or too strong fountain solution.

GRAY, WASHED OUT?
Not enough ink ● Too much moisture ● Wrong color of ink ● Incorrect dampener form roller pressure ● Incorrect plate-to-blanket pressure ● Incorrect impression-to-blanket pressure.

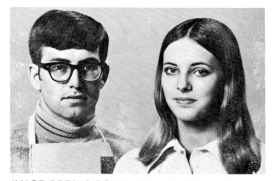

IMAGE BREAKS DOWN WHILE PLATE IS RUNNING
Too much dampener form roller pressure ● Too much ink form roller pressure ● Too much plate-to-blanket pressure ● Fountain solution too strong ● End play in form rollers.

GRAY, WASHED OUT PLUS DIRTY BACKGROUND
Glazed ink rollers ● Glazed blanket ● Too much ink form roller pressure ● Too much dampener form roller pressure.

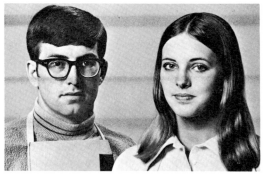

STREAKING
Incorrect ink form roller pressure ● Incorrect dampener form roller pressure ● Incorrect plate-to-blanket pressure ● Incorrect impression-to-blanket pressure ● Improper ink ● Loose blanket.

Figure 11-20. Incorrect ink coverage. (3M Co.)

- *Vertical Copy Placement.* Top and bottom margins are generally adjusted by releasing the plate cylinder and moving it up or down according to a scale on the drive side of the cylinder, Figure 11-21. Tighten the plate cylinder in the new position. Clean the image off the blanket.

Figure 11-22. *To achieve horizontal adjustment, move the side guide left or right as needed.*

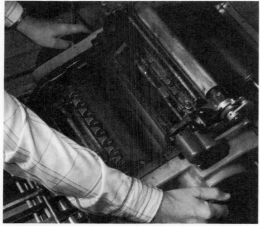

Figure 11-21. *To adjust for vertical placement on the printed sheet, unlock the plate cylinder and rotate it to a new position.*

- *Angular Copy Placement.* To straighten a tilted image on the plate, most offset presses have adjustable head and tail plate clamps that can be moved short distances to one side or the other, Figure 11-23. Some presses, like the ATF Chief, have movable front stop fingers to

- *Horizontal Copy Placement.* On most offset presses with a conveyor table register board, the side margin copy is adjusted by moving the jogger and stationary side guides in the correct direction, Figure 11-22. On presses, like the A. B. Dick, without a conveyor table or register board, the paper is jogged against a side guide and the paper feeder unit. It is then moved directly into the impression cylinder grippers by the suction feed. On these presses lateral adjustments are made by moving the paper stock from side to side.

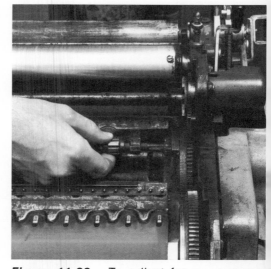

Figure 11-23. *To adjust for an unsquare image on multilith type presses, cock the plate by adjusting the head plate clamp.*

adjust angular placement of copy on the printed page, Figure 11-24.

Figure 11-24 *To adjust for an unsquare image on ATF Chief type presses adjust the front finger stops.*

- *Miscellaneous Problems.* Other problems that may occur are paper curling in the delivery, Figure 11-25; paper nicked on the edge, Figure 11-26; paper wrinkling, Figure 11-27; and double or blurred image, Figure 11-28. These problems are caused by improper settings of pressure, moisture, tightness, etc.

Figure 11-25. *Paper curling in the delivery is caused by too much moisture or curl in the paper. (3M Co.)*

Figure 11-26. *Paper nicking on the edge is caused by paper stop fingers being too high, feed rollers not being set properly, or paper hitting the back stop in the receiver too hard. (3M Co.)*

Figure 11-27. *Wrinkling paper is caused by too much moisture, damp paper, too much pressure between blanket and impression cylinder, or the register board not being set properly. (3M Co.)*

Figure 11-28. *Double image (blurred copy) is caused by a loose blanket, too much ink and fountain solution, not enough plate-to-blanket pressure, a loose plate, or incorrect impression-to-blanket pressure. (3M Co.)*

7. When position and copy quality are acceptable, set the counter to zero and print the required number of copies. Continue to inspect copies while the press is running to make sure that ink and water remain in balance. Check also the register during the press run to make sure that every copy is exactly in the same position on the printed page. This is extremely important in multicolor and process color printing.
8. When the job is run, turn off the paper feed and raise the plate cylinder, the ink rollers and the dampener rollers in that order. Stop the press. Remove printed copies from the delivery and stack them carefully on a rack or table.

 Run a few sheets of scrap paper through the press with the ink and dampening systems shut off. This will remove ink remaining on the plate and blanket.
9. Remove the plate. If it is to be stored, apply a thin coat of gum arabic and buff it dry with a small piece of cheese cloth.

CLEANING THE OFFSET PRESS

Clean the various systems of the offset press in this sequence:
1. First clean the dampening system.
 a. Remove the fountain solution from the fountain and discard it. Next time the press is used, mix a new solution.
 b. Inspect all dampener rollers and clean them if they are dirty. Remove ink with plate cleaner on metal rollers or with soap and water on covered rollers. Your instructor may recommend some other non-greasy cleaner to use.
 c. Remove the dampener form roller or lock it in the UP position so it will not contact the plate cylinder.

2. Next clean the inking system:
 a. Remove and clean the ink fountain. Use an ink knife or scrap cardboard to remove most of the ink from the fountain.
 b. Clean the ink fountain roller with a rag saturated with solvent.
 c. Attach a cleanup sheet (blotter paper) to the plate cylinder, Figure 11-29 or, if your press has one, mount a scraper cleanup device.

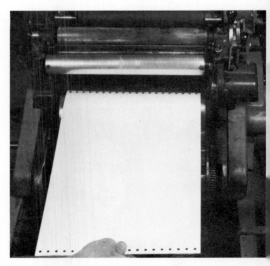

Figure 11-29. *To clean the ink off the inking rollers with a blotter, mount the blotter in the same way you would mount a plate.*

d. Turn on the press and apply an appropriate amount of solvent across the largest ink roller.

e. If you are using a blotter, drop the ink rollers. If you are using a scraper cleanup device, tighten the blade against the distributor roller to remove the ink.

f. Add solvent as necessary to remove ink from the inking system.

g. When using blotters, you must change them when they become saturated with ink and solvent. Normally about three blotters are needed to clean a small press.

h. Continue cleaning until the ink system is free from all ink. It is usually necessary to finish cleaning by hand, especially at the roller ends.

3. Clean the plate blanket and impression cylinder with a rag saturated with blanket wash, Figure 11-30.

Figure 11-30. After all the rollers are clean, clean the cylinders with a solvent-soaked rag.

4. Clean off any ink or dirt found on the rest of the press.

5. Lubricate and cover the press as your instructor recommends.

discussion questions

1. How is lateral or horizontal adjustment made on most offset presses?
2. How is vertical adjustment made on most offset presses?
3. How can the press operator compensate for a plate that is made not square?
4. When a plate scums, what should be checked?
5. If the finished copy is gray, what should be checked?
6. What is the procedure for cleaning the dampening system on an offset press?
7. What types of clean-up systems are used to clean the ink off the inking system of an offset press?
8. What is the procedure for cleaning the inking system of an offset press?

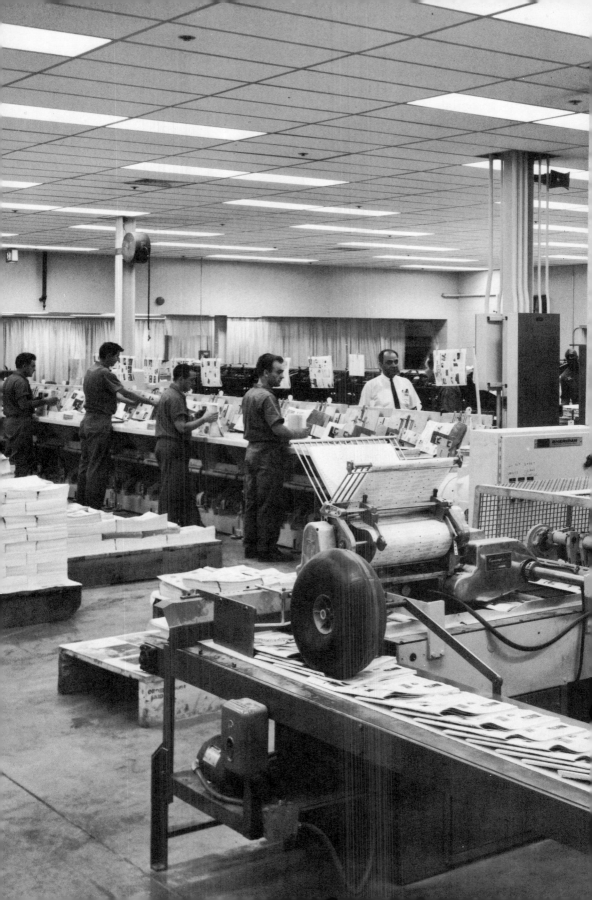

Chapter 12

finishing
operations

folding
collating
gathering
binding
packaging

As printed products come from the press, they usually require further operations to prepare them for use. These operations include:

- folding
- collating
- binding
- packaging.

These are the final steps before the printed job is delivered to the customer. In this chapter you will learn how to perform various finishing operations. The material in this chapter will explain only those operations used in the school shop.

Each printed sheet may require one or more folds, depending on the number of images on the sheet and the intended use. In book manufacture, several pages are printed on both sides of large sheets. Each sheet is then folded several times to make up a *signature*, Figure 12-1.

Paper is folded in either parallel folds or in right angle folds, Figure 12-2. Parallel folds are made by folding the paper so that each fold runs parallel to the others. Right angle folds have one fold running at cross angles to the others.

Figure 12-1. *Single sheet of paper folded and trimmed to make a signature.*

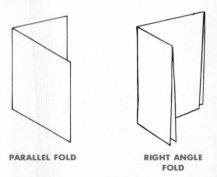

PARALLEL FOLD RIGHT ANGLE FOLD

Figure 12-2. *A parallel and a right-angle fold.*

Certain folds, Figure 12-3, are commonly used in the graphic arts:

- single fold
- letter fold
- accordion fold
- panel fold
- french fold.

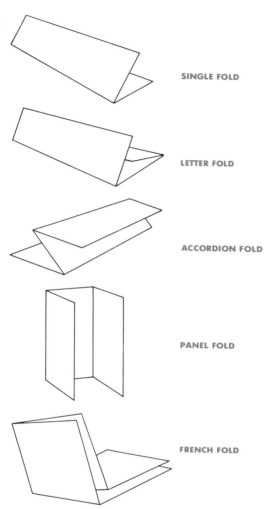

SINGLE FOLD

LETTER FOLD

ACCORDION FOLD

PANEL FOLD

FRENCH FOLD

Figure 12-3. *Various types of folds in common use.*

As the end of the paper strikes a stop, the paper buckles and is forced between a pair of rotating rollers which crease the paper.

Folders are available in many sizes, ranging from a small table top model, Figure 12-4, to a large floor model,

Figure 12-4. *Common table top buckle folder.*

Types of Folders

Folding machines are classified as:
- knife folders
- buckle folders.

A knife folder has a blade which pushes the paper between a pair of rotating rollers. The rollers grip and crease the paper forming a fold. Paper is placed in a folder in much the same way it is placed in a printing press.

A buckle folder uses a fold plate to make the fold. Paper is fed into the fold plate.

Figure 12-5. *A large folder which can make several parallel or right angle folds in a sheet of paper.* *(Baumfolder Corp.)*

Figure 12-5. Large folders can make several folds in a single sheet of paper as it passes through the machine.

COLLATING

Often before printed pages can be used, they must be assembled in their proper sequence. *Collating* is the process of arranging individual sheets in the proper order. Collating may be done by hand or by machine. When collating by hand, an individual takes one sheet from each pile and stacks the sheets in order. Hand collating is slow and tedious so collating machines have been developed to assist the operator or to do the job automatically.

One small collator in wide use is the A. B. Dick table top collator, Figure 12-6. Two to eight pages may be placed in the machine. Feed rollers then push out the

pages to where a person can grasp and stack them for further processing.

Figure 12-6. *A small table-top collator.*

Figure 12-7. *An automatic collator.*

Some collators can collate completely automatically, Figure 12-7.

GATHERING

Gathering means the assembling of signatures in the proper sequence to form a book or pamphlet. Gathering may be done by hand or automatically.

In manual gathering, stacks of signatures are placed in proper order around a table. The operator walks along assembling the signatures one by one in proper order. Some places use revolving tables. As the operator remains in one place, the table revolves slowly. The operator picks up the signatures and assembles them. Several gatherers may work at the revolving table at one time. When thousands of signatures must be gathered, fully automatic equipment is used, Figure 12-8. Often the

Figure 12-8. *An automatic gathering machine.*

Figure 12-9. *A stapler attached to the gathering machine fastens the signatures together automatically as they pass through the machine.*

gathering machine and the stapling and trimming machine are combined into one machine, Figure 12-9.

BINDING

Binding is usually the last operation before packaging for the customer. Binding is fastening the gathered or collated sheets together. There are many methods of binding depending upon the product and its intended use.

Binding includes sewing and hard covering (such as this book), plastic ring binding, metal ring binding, side stitching, saddle stitching, spiral wire binding and other less common or special forms of binding. This chapter cannot give detailed instructions on binding. It will only attempt to illustrate some of the methods commonly used in school and small to medium sized job shops.

Drilling Paper. When the printed product is to be fastened in a ring binder or a

loose leaf notebook, holes must be made in the paper for the rings. These holes are usually made with a paper drill. Most binderies use an electric hollow paper drill, Figure 12-10.

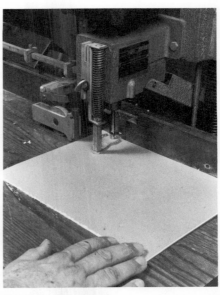

Figure 12-10. *Electrically driven power paper drill.*

The rotating drill is forced through the stack of paper with a foot treadle. Most paper drills have a back gage to control the distance from the edge of the paper to the hole. They also have an adjustable side guide to control the distance between holes.

Power paper drills have interchangeable hollow drills which can be placed in the machine. Drill sizes vary from 1/8 to 1/16 inch in diameter. The most common size is 1/4 inch.

SAFETY NOTE: Paper drills revolve at extremely fast speeds. Be careful of loose clothing and hair and remove all jewelry. Only one person at a time should operate the drill.

Loose Leaf Binding

Loose leaf binding is probably most familiar to students. This method permits the addition or removal of pages as the rings may be opened or closed. Ring binders, Figure 12-11, may have two or three rings. Drilled paper is placed in the binder and the rings are snapped shut.

Figure 12-11. Common ring binder.

Saddle Stitching

In the saddle stitching method of binding, folded sheets or signatures are fastened with wire staples through the center fold, Figure 12-12. The stitching is done by opening the pages of signatures and laying the signature on the

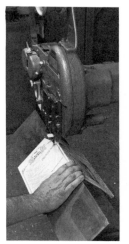

STAPLES

Figure 12-12. Saddle stitching.

saddle of the stitcher. The stitcher then places a staple through the fold, Figure 12-13. Saddle stitching is used for short brochures or booklets which contain less than 60 sheets in stack. Saddle stitched material will lie flat when opened for reading.

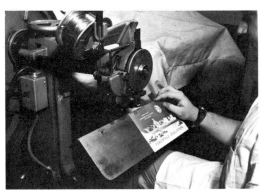

Figure 12-13. Printed matter in position to be saddle stitched.

Side Stitching

Side stitching is used for binding single sheets together with wire staples. The staple passes through the material in the left-hand margin, Figure 12-14. Materials that are side stitched will not lie flat as will saddle stitched material.

Figure 12-15. Applying padding compound to a note pad. Note: two thin coats are better than one thin coat.

sheet. Two thin coats of adhesive are better than one thick coat. After drying, the three edges may be trimmed to make a neat pad of material.

Plastic Binding

Plastic binding, sometimes called plastic mechanical binding, is another way of fastening single sheets together so they will lie flat when opened. With this method, closely spaced holes are punched in a few sheets at a time with a special punch, Figure 12-16. After the

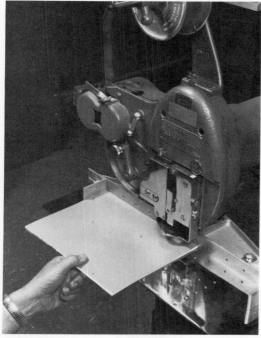

Figure 12-14. Side stitching a booklet. Note the staple is about 1/2 to 3/4 inch in from the margin.

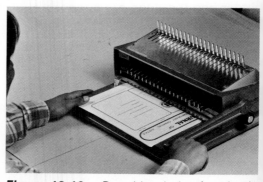

Figure 12-16. Punching holes for plastic binding.

Adhesive Binding

Adhesive binding, sometimes called padding, fastens single sheets of paper together with a rubber-like adhesive, Figure 12-15. This method is used for binding notepads, forms and tablets so that single pages may be removed easily for us.

The pages must be jogged evenly. They are then placed in a clamp to hold them tightly together. Adhesive is brushed on from the center toward the edges of the

pages are punched, they are placed in the plastic binder by using a special machine which spreads the tongues of the binder, Figure 12-17. Plastic binders are available in a variety of colors and in

Figure 12-18. *Counting and wrapping printed catalogs.*

Figure 12-17. *Placing sheets on the plastic binder strip after it has been opened on the special binding machine.*

sizes ranging from 3/16 inch to more than two inches in diameter.

PACKAGING

Many printed products require packaging before they are delivered to the customer, Figure 12-18. It will be necessary to first count the items. Many printed products are packed 50, 100, 500, or 1000 to a package. Printed material may be counted, wrapped in paper, and then sealed with tape. A popular packaging method used today is called *shrink wrapping.*

Shrink wrapping seals the product in a plastic bag, Figure 12-19. The package

Figure 12-19. *Placing printed products in a plastic bag for shrink wrapping.*

Figure 12-20. *Oven which shrinks plastic around printed matter.*

is then sent through an oven, Figure 12-20. Heat causes the plastic to shrink and seals the product tightly.

The product has now been designed, prepared, printed, finished, and packaged ready for delivery to the customer.

discussion questions

1. After the product is printed, what other operation may be necessary before it is delivered to the customer?
2. What are the most common folds used in the graphic arts?
3. What is the difference between collating and gathering?
4. What is the difference between side stitching and saddle stitching? When is each used?
5. What is the last operation before a printed job is delivered?

GLOSSARY

A

acetic acid: Acid used in photographic stop bath.

actinic light: Light in the blue region of the visible spectrum which exerts the greatest photographic action.

activate: To make active—set in motion.

agitate: To move into action—to stir.

air brush: A tool for spraying colors by means of compressed air. Used for shading original art and retouching.

alkaline: A mixture which contains alkali. Alkaline solutions will neutralize acid solutions.

aluminum plate: Plate made of aluminum used for offset printing.

antihalation backing: A coating on the back surface of film to absorb the light which reaches the back surface and prevents reflection back into the film.

aperture: The opening in a lens which permits the passage of light.

aperture setting: See f/number.

apochromatic lens: Lens corrected for aberrations.

arc lamp: Light source made from carbon electrodes between which an arc is formed when electricity is applied.

auto screen film: Film which contains a built-in screen for making halftone negatives.

B

back up: Printing on the reverse side of the sheet.

balance: Placing images on a page so that the page looks balanced.

base: Transparent support for film emulsion.

basic density range (BDR): The range of tones a halftone screen can reproduce with the main exposure.

basic weight: The weight of 500 sheets of paper of a standard size.

baumé: A measure of the density of liquids used in chemical solutions.

bearers: Steel rings at the end of the plate and blanket cylinders.

bellows: The center section of the camera that connects the lensboard and the back.

bellows-extension: Total bellows length necessary for focusing at close subject distances.

blanket: A rubber coated fabric which covers the blanket cylinder and transfers the image from the plate to the paper.

blanket cylinder: The roller on an offset press which holds the blanket.

bleed: An illustration which extends to one or more edges of a trimmed page.

blind: An image or plate that will not take ink.

blowup: A photographic enlargement.

glossary

blue sensitive: Applied to film and plates that are sensitive primarily to blue and ultraviolet light.

bond: A kind of paper made either from rags or wood pulp. Used for letterheads.

book paper: Paper used for printing books.

brayer: A hard ink roller used to ink letterpress forms.

bristol board: A kind of cardboard.

buckle: Paper that is raised in the middle by pressure on both sides of the sheet.

bumping: Manipulating contact exposures to increase or decrease dot sizes.

burning in: exposing a photographic print to more light in one spot.

C

camera: A device to transfer original copy to a light sensitive film.

camera back: The back of the camera which holds the photographic film.

camera extension: The distance between the lens and the film.

caption: Descriptive matter placed, above, beneath or near an illustration.

catching up: Scumming—non-image area of a plate becoming receptive to ink.

cellulose fiber: Main ingredient of paper.

chain delivery: A delivery system utilizing a chain and grippers to deliver the sheet.

chalking: The tendency of dry ink to rub off.

chokes: Contact process by which letters, solids or other shapes are made thinner without otherwise altering their shape.

chroma: The purity of a color.

chute delivery: Paper is stripped from the blanket cylinder and drops into a receiving tray.

clip art: Books of illustrations which may be cut out and used in layouts.

coating: The film of light-sensitive material covering a sheet of film or plate.

cold type: Type matter produced by one of several methods on paper or film without the use of metal type.

collating: Gathering in sequence pages of a book or other printed material.

color (additive): The principal colors of light (red, green and blue).

color blind film: Film sensitive to the blue end of the color spectrum.

color correction: Any method of correcting color photographs, color prints, color transparencies, or color separations to compensate for incorrect renditions of the colors.

color filter: Colored gelatin or glass used on a camera to absorb certain colors in color photography.

color proof: Color illustrations printed beforehand in the same inks and on the same paper as production run.

color separation: The process of separating colors from original artwork by means of filters and a halftone screen at different angles.

combination illustration: An illustration produced from both line and continuous tone copy.

composition: The assembling of words, lines and paragraphs of text for reproduction by printing.

compositor: A person who sets type.

contact print: A print made by exposing light-sensitive material in contact with a negative and then developing it.

contact screen: A halftone screen made on a film base. Used in direct contact with the film to obtain a halftone pattern.

continuous tone: Tone variations in a print or negative due to variations in density.

contrast: Term used to describe the separation of tones in a negative. *Also,* a device used to relieve monotony and provide variety.

copy: The material furnished for reproduction.

copyboard: The part of a camera which holds the copy to be photographed.

copyboard extension: The distance from the lens to the copyboard.

copy density range (CDR): Density range on the copy to be shot.

copy fitting: Estimating the amount of space that will be used by a particular size and style of type.

copy preparation: Preparing copy in pasteup form as a unit—called a mechanical.

crop: To trim a piece of camera copy to improve composition or make it fit into a particular sized space.

crop marks: The marks placed on a photograph or piece of copy to indicate where it is to be trimmed.

D

dampening rollers: Rollers that distribute fountain solution to the printing plates on an offset press.

darkfield illumination: A method for viewing halftone dots on film. View against a dark background with light coming from a side angle.

darkroom: A light-tight room where light-sensitive material, like film, is handled.

arkroom camera: A camera that has the camera ack in the darkroom and the rest of the camera in a ghted workroom.

ensitometer: An instrument for measuring the ensity of negatives or prints.

ensity: A numerical measure of the opaqueness of a hotographic image.

ensity range: The numerical difference between e maximum and minimum densities of a negative or ositive.

esensitize: To make insensitive or non-receptive to k.

eveloper: A chemical solution that makes photo nages visible.

etail: Individual, specific parts of an image.

iaphragm: Opening in the camera lens that controls e amount of light entering the camera.

irect color separation: Making color separations rough a halftone screen so that the separation nega- ves are obtained directly.

isplay type: Specifically designed large type used attract attention.

ot etching: Changing tone values of a halftone by hemically reducing the size of the halftone dots.

rier: A chemical compound added to ink to increase s drying speed.

rilling: Making holes in paper using a hollow drill.

ropout: Portion of a halftone highlight in which the ots have been removed to produce a clear white.

ry offset: Offset printing using a shallow-etched lief plate. The plate prints on the blanket, which then ansfers the image to the paper.

ry offset plate: Shallow-etched plate used for dry ffset printing.

ummy: A paste-up or designer's layout of a planned iece of printing to assist in the printing and binding perations.

uograph: A two-color reproduction which uses two ifferent halftone negatives made with two different creen angles. One color is dark the other is a tint or ue of the first.

uotone: Printing from two different halftone nega- ves at two different screen angles in two different olors.

uotype: Two-color printing using the same negative. he first color is dark, the second is light and is over- rinted.

uplicating: Reproduction process used in offices nd small printing plants. Includes small offset, elec- ostat, photocopy, etc.

E

electrostatic printing: A process of printing using a dry powder and electrostatic charges.

embossing: A raised image imparted to paper.

emulsion: The light-sensitive coating of photographic material, mainly silver salts suspended in gelatin.

enamel paper: Paper that is coated, usually with clay, to give it a glossy finish.

enlargement: A large picture made from a smaller negative.

etching: In offset platemaking, the non-image areas are etched to make them more receptive to water and less receptive to ink.

etch solution: The solution used for etching the offset plate.

exposure: The amount of light that is allowed to act on the photographic material. The act of exposing the material to light.

exposure computer: A device used to calculate main and flash exposure.

F

feeder: The part of a press that automatically feeds sheets of paper to the printing unit.

filling up: Openings in letters or halftones filling up with ink.

film: Light-sensitive material used to produce a nega- tive.

film holder: That portion of the camera that holds the film in position during exposure.

filter: Gelatin or glass placed between the subject and the film in order to reduce or eliminate light of certain colors.

filter factor: A number that indicates the amount of exposure increase necessary when using a filter.

fixing: The process of removing unexposed silver salts from a developed plate, film, or print.

flash exposure: The exposure given in halftone photography to strengthen the dots in the shadow areas.

flat: Negatives and/or positives properly assembled to a carrier sheet and ready for platemaking.

floppy disc: A storage medium similar to a record that is made of thin, flexible material. Used for storing information for a computer.

flow: A term used to indicate that ink follows the foun- tain and levels itself.

fluff: Separating the top few sheets of paper in the feeder by air.

glossary

fog: Tone or density on photographic material. Usually caused by the material being exposed to extraneous light.

font: A complete assortment of all the letters of one size and kind of type.

fountain: That part of a press that acts as a reservoir for ink or water.

fountain rollers: Rollers that deliver the fountain solution to the printing plate.

fountain solution: Slightly acid water left on the non-printing areas of a plate to repel ink.

f/value: Designates the diameter of the opening through which light passes for any lens.

f/stop: Numerical designation of the lens openings.

G

gallery camera: A camera that is outside the darkroom.

gamma: The numerical designation for the contrast of photographic material.

gathering: Pulling together the sections or signatures of a book in the proper sequence.

ghosting: Indistinct image patterns that appear in solids.

glaze: A hard, shining surface on press rollers or blanket.

glossy print: A photographic print having a shiny surface.

goldenrod: A coated paper used to prepare negative flats. The goldenrod prevents exposure of the non-printing areas.

grain: The direction of the fibers in a sheet of paper. The roughness of an offset plate.

gravure: Printing from a recessed or sunken surface.

gray scale: A strip of standard gray tones, ranging from white to black, placed alongside the original copy while photographing.

gripper margin: The amount of space used by the gripper as it carries the sheet.

grippers: Metal fingers on a press which carry the sheets while they are being printed.

ground glass: A sheet of glass with a grained surface used to view the copy on the copyboard for focusing.

guide: The fingers on a press that feed the paper into register.

gum arabic: A solution used to form a protective coating on an offset plate to prevent oxidation.

gumming: coating the offset plate with the gum solution.

H

hairline: The fine lines in a type face or an illustration.

halation: Blurring of a photographic image caused by light reflected from the back surface of the film.

halftone: A tone pattern composed of dots of uniform density, but varying in size to produce a picture.

halftone photography: The process by which halftone is produced.

halftone screen: The ruled device used to make continuous tones into halftones.

halo: The luminous circle around a halftone dot.

hard dot: Second or third generation contacted halftone where dots lack fringe.

harmony: The placing of various colors together in pleasing manner.

hickey: Small spot in the printing area resulting from dirt in the ink or on the plate or blanket.

highlight: The lightest portion of a picture. In a negative the areas of highest density since these are the lightest areas when printed.

hot type: Lines of type created from molten metal.

humidity: Moisture content of the air.

hydrophilic: An affinity for water—the non-printing areas of an offset plate.

hypo: Fixing agent for films and photo papers.

I

illustration: Any form of picture, art, drawing, etc.

impression: The squeeze created on the paper by the printed image.

impression cylinder: The cylinder of a press which presses the paper into contact with the blanket.

ink: The pigment with vehicle used to print an image.

ink fountain: The part of the press that holds the ink.

ink rollers: The cylinders that carry the ink from the fountain to the plate.

J-K

jacket: The paper covering of a book.

jog: To straighten the sheets of paper and make the edges all even.

justification: Spacing inserted between words in a line so the line will fill a predetermined space.

key plate: The plate used as a guide for registration in color printing.

kill: Instructions to destroy the form or negative which is no longer needed.

darkroom camera: A camera that has the camera back in the darkroom and the rest of the camera in a lighted workroom.

densitometer: An instrument for measuring the density of negatives or prints.

density: A numerical measure of the opaqueness of a photographic image.

density range: The numerical difference between the maximum and minimum densities of a negative or positive.

desensitize: To make insensitive or non-receptive to ink.

developer: A chemical solution that makes photo images visible.

detail: Individual, specific parts of an image.

diaphragm: Opening in the camera lens that controls the amount of light entering the camera.

direct color separation: Making color separations through a halftone screen so that the separation negatives are obtained directly.

display type: Specifically designed large type used to attract attention.

dot etching: Changing tone values of a halftone by chemically reducing the size of the halftone dots.

drier: A chemical compound added to ink to increase its drying speed.

drilling: Making holes in paper using a hollow drill.

dropout: Portion of a halftone highlight in which the dots have been removed to produce a clear white.

dry offset: Offset printing using a shallow-etched relief plate. The plate prints on the blanket, which then transfers the image to the paper.

dry offset plate: Shallow-etched plate used for dry offset printing.

dummy: A paste-up or designer's layout of a planned piece of printing to assist in the printing and binding operations.

duograph: A two-color reproduction which uses two different halftone negatives made with two different screen angles. One color is dark the other is a tint or hue of the first.

duotone: Printing from two different halftone negatives at two different screen angles in two different colors.

duotype: Two-color printing using the same negative. The first color is dark, the second is light and is overprinted.

duplicating: Reproduction process used in offices and small printing plants. Includes small offset, electrostat, photocopy, etc.

E

electrostatic printing: A process of printing using a dry powder and electrostatic charges.

embossing: A raised image imparted to paper.

emulsion: The light-sensitive coating of photographic material, mainly silver salts suspended in gelatin.

enamel paper: Paper that is coated, usually with clay, to give it a glossy finish.

enlargement: A large picture made from a smaller negative.

etching: In offset platemaking, the non-image areas are etched to make them more receptive to water and less receptive to ink.

etch solution: The solution used for etching the offset plate.

exposure: The amount of light that is allowed to act on the photographic material. The act of exposing the material to light.

exposure computer: A device used to calculate main and flash exposure.

F

feeder: The part of a press that automatically feeds sheets of paper to the printing unit.

filling up: Openings in letters or halftones filling up with ink.

film: Light-sensitive material used to produce a negative.

film holder: That portion of the camera that holds the film in position during exposure.

filter: Gelatin or glass placed between the subject and the film in order to reduce or eliminate light of certain colors.

filter factor: A number that indicates the amount of exposure increase necessary when using a filter.

fixing: The process of removing unexposed silver salts from a developed plate, film, or print.

flash exposure: The exposure given in halftone photography to strengthen the dots in the shadow areas.

flat: Negatives and/or positives properly assembled to a carrier sheet and ready for platemaking.

floppy disc: A storage medium similar to a record that is made of thin, flexible material. Used for storing information for a computer.

flow: A term used to indicate that ink follows the fountain and levels itself.

fluff: Separating the top few sheets of paper in the feeder by air.

glossary

fog: Tone or density on photographic material. Usually caused by the material being exposed to extraneous light.

font: A complete assortment of all the letters of one size and kind of type.

fountain: That part of a press that acts as a reservoir for ink or water.

fountain rollers: Rollers that deliver the fountain solution to the printing plate.

fountain solution: Slightly acid water left on the non-printing areas of a plate to repel ink.

f/value: Designates the diameter of the opening through which light passes for any lens.

f/stop: Numerical designation of the lens openings.

G

gallery camera: A camera that is outside the darkroom.

gamma: The numerical designation for the contrast of photographic material.

gathering: Pulling together the sections or signatures of a book in the proper sequence.

ghosting: Indistinct image patterns that appear in solids.

glaze: A hard, shining surface on press rollers or blanket.

glossy print: A photographic print having a shiny surface.

goldenrod: A coated paper used to prepare negative flats. The goldenrod prevents exposure of the non-printing areas.

grain: The direction of the fibers in a sheet of paper. The roughness of an offset plate.

gravure: Printing from a recessed or sunken surface.

gray scale: A strip of standard gray tones, ranging from white to black, placed alongside the original copy while photographing.

gripper margin: The amount of space used by the gripper as it carries the sheet.

grippers: Metal fingers on a press which carry the sheets while they are being printed.

ground glass: A sheet of glass with a grained surface used to view the copy on the copyboard for focusing.

guide: The fingers on a press that feed the paper into register.

gum arabic: A solution used to form a protective coating on an offset plate to prevent oxidation.

gumming: coating the offset plate with the gum solution.

H

hairline: The fine lines in a type face or an illustration.

halation: Blurring of a photographic image caused by light reflected from the back surface of the film.

halftone: A tone pattern composed of dots of uniform density, but varying in size to produce a picture.

halftone photography: The process by which halftone is produced.

halftone screen: The ruled device used to make continuous tones into halftones.

halo: The luminous circle around a halftone dot.

hard dot: Second or third generation contacted halftone where dots lack fringe.

harmony: The placing of various colors together in a pleasing manner.

hickey: Small spot in the printing area resulting from dirt in the ink or on the plate or blanket.

highlight: The lightest portion of a picture. In a negative the areas of highest density since these are the lightest areas when printed.

hot type: Lines of type created from molten metal.

humidity: Moisture content of the air.

hydrophilic: An affinity for water—the non-printing areas of an offset plate.

hypo: Fixing agent for films and photo papers.

I

illustration: Any form of picture, art, drawing, etc.

impression: The squeeze created on the paper by the printed image.

impression cylinder: The cylinder of a press which presses the paper into contact with the blanket.

ink: The pigment with vehicle used to print an image.

ink fountain: The part of the press that holds the ink.

ink rollers: The cylinders that carry the ink from the fountain to the plate.

J-K

jacket: The paper covering of a book.

jog: To straighten the sheets of paper and make the edges all even.

justification: Spacing inserted between words in a line so the line will fill a predetermined space.

key plate: The plate used as a guide for registration in color printing.

kill: Instructions to destroy the form or negative which is no longer needed.

L

latent image: The invisible image recorded on sensitized surfaces during exposure. Becomes visible with development.

layout: The sequence of printed matter. Contains specifications for the printed job.

lead edge: The gripper edge of a sheet to be printed.

leaders: Dots spaced at intervals to lead the eye.

leading: Spacing between lines of printing.

legend: Explanation under an illustration.

lens: A device for focusing light rays.

lensboard: The part of a camera that holds the lens.

lens cap: A cap that fits over the lens to protect it when not in use.

letterpress: Printing from raised surfaces.

lift: A quantity of paper.

light: Source of illumination.

light angle: The angle the light source is placed in relation to the copy.

light face: One classification of type face.

line copy: Copy consisting of black and white areas without grays, as opposed to continuous tone copy. May be printed, written, drawn, or typewritten.

line drawing: See *line copy.*

line gage: A printer's ruler which measures in points, picas, and inches.

line negative: Negative copy that is shot without a halftone screen.

linen finish: Paper that has a finish similar to linen cloth.

line-up table: A lighted glass table.

lithography: Means "stone printing"—used less than metal or plastic plates.

live form: Printing form that is in use.

low spots: Areas that do not print because of damage to the blanket in that area.

M

machine composition: Hot type composition done mechanically such as on the Intertype.

machine finish (MF): A smooth paper used in printing.

magnetic printing: Printing with ink that can be magnetized. Used on bank checks.

make-ready: The process of getting the press ready for running a job.

mask: A photographic image mounted in register with a negative to modify certain tones or colors.

masking: One process of color correcting.

master: A paper plate used on small offset presses.

middletone: The tone in a reproduction between the highlights and the shadows.

moiré: An undesirable pattern created by multiple halftone screens closer than 30°.

molleton: A thick felt-like material used for covering dampening rollers.

monochromatic: Sensitive to only blue or ultraviolet light. Also, a color scheme using only one color with its tints and shades.

mottling: Ink that does not dry flat, some areas are shiny and some dull.

N

negative: An image obtained from an original where the tones are in reverse.

neutral density filter: A filter that reduces all colors of light uniformly.

nodal point: The point in a lens where the light rays converge.

non-offset gun: A device which sprays a fine powder onto each printed sheet to prevent ink transfer.

O

offset: The short term used to mean *offset-lithography.*

offset lithography: Printing from a plane surface onto a rubber blanket then onto a sheet of paper.

offset plate: A flat sheet of metal, paper or plastic used on an offset press to carry the image to the blanket.

offset press: The press used in offset printing.

opaque: Not permitting the passage of light. Also, the material used to block out holes in a negative.

opaquing: The process of applying opaque to a negative.

optical character recognizer (O.C.R.): A machine capable of scanning a page of typewritten material and automatically making a record on tape for a phototypesetting unit.

orthochromatic: Film sensitive to all colors but red.

overdevelop: Developing for too long a period of time.

overexposure: Excessive exposure of photo material.

overlay: A transparent sheet placed over the base artwork to permit the addition of another color or other notations.

glossary

overprinting: Printing over an area already printed— usually with a varnish or lacquer.

oxidation: Oxygen combining with another substance.

P

packing: Paper sheets placed under an offset plate or blanket.

padding: Gluing the ends of paper sheets to make a pad.

pamphlet: Printed work not having a stiff cover— usually side or saddle stitched.

panchromatic: Film that is sensitive to all colors.

paper plate: Offset plates made of specially treated paper.

paste-up: Assembling on one page the various elements of art, display, etc., for pages.

perfecting: A press that prints both sides of a sheet of paper at the same time.

photo composition: Placing of type images on light-sensitive paper or film.

photograph: Picture made by exposing sensitive paper to light through a negative.

photography: The art of making pictures by photographic means.

photo lettering: Also called *photo display,* is the setting of headlines or display text a letter at a time.

photolithography: See *offset lithography.*

phototype composing machine: A device for assembling images of type characters on photographic film or paper.

photo typesetting: Also called *text typesetting,* sets type a line at a time.

pH value: A scale used to express acidity or alkalinity. The scale ranges from 0-14. A pH of 7 is neutral, below 7 is acid, above 7 is alkaline.

pica: The standard unit of measurement in printing.

picking: The lifting of a portion of a paper surface during printing.

pigment: The substance which makes the color in ink.

piling: The caking of ink on a plate or blanket.

pinholes: Clear specks in a photographic image. Caused by dirt or dust.

planographic: Printing from plane flat surfaces neither raised nor sunken.

plate cylinder: The cylinder which holds the printing plate.

platemaking: Exposing and developing an offset plate.

point: A unit of measurement in graphic arts. 1 point equals about 1/72 inch.

positive: A photographic image which exactly corresponds to the original.

posterization: Printing process in photography in which the image gradation is limited to two or three tones of gray.

pre-etch: To clean and de-sensitize an offset plate.

presensitized plate: An offset plate that is purchased already sensitive to light.

press operator: Person who operates a press.

press proofs: Proofs made on a printing press.

pressure sensitive: Paper which has a quick sticking material on the back, protected by peel-off covering.

process: The general term for chemical treatment following exposure.

process plates: Printing from a series of plates. In four-color process printing, there are four different plates, one for each color.

progressive proofs: Proofs of color plates used as a guide for the pressman.

proofs: Sample of copy made of various stages of a production job.

proofreader: Person who reads and marks corrections on proof.

proofreader's marks: Signs and symbols used by proofreaders to mark errors.

proportional scale: A device for calculating width and depth

pulp: The raw material used to make paper.

pulsed-xenon arc: An electronic discharge through xenon gas usually in a glass tube.

Q

quadding: Spacing out the blank areas in type lines.

quartz-iodine: A tungsten lamp with iodine vapor which prevents tungsten from being deposited on the inside of the envelope.

R

ream: 500 sheets of paper

reduce: To make smaller photographically.

reducer: A chemical that reduces the density of a photographic image by removing silver.

register: Correct position of printed matter on the page or in the printing area.

register marks: Fine lines crossing at angles and placed at specified positions on the copy. Used for registering plates.

repro proof: A proof made to be photographed.

rescreening: Making a halftone from copy already screened.

retouching: Correcting a negative or plate.

reverse plate: A printing plate in which the white and black are reversed.

revise proof: Any proof pulled after the first proof has been read and corrected.

rhythm: Leads the reader's eye in the desired direction.

rollers: Inking and dampening cylinders on a press.

roller stripping: Rollers refusing to take ink.

rotogravure: Printing by the gravure process on a rotary press.

run: The number of impressions to be made for a particular job.

S

saddle stitch: To fasten sheets together by stitching through the fold of the sheet.

safelights: Colored lights used when processing photographic materials.

safety paper: Paper treated to protect it against forgery. Used for bank checks.

scaling: Calculating the percentage of reduction or enlargement of originals.

scratchboard: Specially treated paper with a black ink coating which can be scratched off to make an illustration.

screen angle: The angle at which halftone screens are made for multi-color printing.

screen ruling: The number of lines per inch on a halftone screen.

scum: Ink adhering to non-printing areas of an offset plate.

shadow: The darkest portion of a picture. In a negative, the low density areas are called the shadow areas.

side guide: A device on the press which places the sheet into position before printing.

side stitch: Fastening pages together by stitching along the edge of the sheet.

signature: A folded, printed sheet or part of a sheet which forms a section of multiple pages for a book.

silver salts: The light-sensitive material on photographic materials.

slur: Shadow dots and/or reverse letters filling up.

solid matter: Type composition that is not leaded.

split fountain: Dividing the ink fountain into sections to run different colors at the same time.

spreads: Contact process by which letters, solids, or other shapes are made fatter without otherwise altering their shape.

step and repeat: Printing the same image in register many times on the same plate.

stream feed: An automatic feeder which delivers overlapping sheets to the press.

stripper: The person who strips negatives or positives into a flat.

stripping: Arranging the negatives or positives on the goldenrod sheet in proper relationship to each other.

stripping table: A glass top light table.

suckers: Small rubber or metal feet used on press feeders to pick up sheets of paper.

supercalendered: Paper that has been made extra smooth by rolling between large steel rollers.

T

tack: Amount of pull in an offset ink.

temperature controlled sink: A sink that automatically keeps the chemicals and solutions at a preset temperature.

thermometer: A device for measuring temperature.

three-stop method: Making a halftone by three exposures: highlight, midtone, detail.

tinting: Discoloration of non-image areas on an offset plate.

tissue: A very thin paper, usually used to protect mechanicals and provide a place for writing directions to the printer.

tonal range: A graduation of tones, white to black.

tone value: The density of a negative at any specified point.

trailing edge: Bottom or back edge of the paper to be printed. Opposite of *leading edge.*

transpose: To change from one position to another.

U

ultraviolet: The light rays beyond the violet end of the visible spectrum.

underdevelop: Not allowing enough time in the developer.

underexpose: Insufficient exposure of photographic material.

underlay: A sheet or sheets of paper placed under the offset plate or blanket. See *packing.*

unity: A quality of design that holds the layout together.

glossary

V

vacuum back: The back of the process camera that holds the film by means of vacuum.

vacuum frame: A device for holding plate and negative tightly together during exposure.

varnish: One of the vehicles used in making ink. Also used for overprinting.

vehicle: The component of ink which carries the pigment to the paper.

veiling: The soft, fuzzy density that fills the small clear area between large dots on the original first generation halftones.

video display terminal (V.D.T.): Displaying type or symbols on a cathode ray tube.

vignette: A halftone which fades off gradually at the outer edge until it seems to blend into the paper.

W—X

water fountain: The reservoir that holds the water solution.

watermark: A faint design impressed into paper during manufacture.

web: A roll of printing paper.

web offset: An offset press that prints from a continuous roll of paper.

white space: That part of printed matter not covered with printing.

work and back: One form is backed up with a different form. The same gripper and side guide are used on the single sheet.

work and turn: Both sides of the sheet are printed with one form.

work and tumble: A double size sheet printed on both sides with one form.

wrong-reading image: An image that is backward relative to the original subject.

xerography: Electrostatic printing.

INDEX

index

Density guide, 93-96
Design, 17-19
 balance, 18-19
 color, 22-25
 contrast, 19-20
 proportion, 20-21
 rhythm, 19
 unity, 21-22
Designer, 3
Developer
 mixing, 70
 plate, 134, 135
Diagonal line method of scaling copy, 49-50
Direct screening, 119-120
Dot etching, 119
Dots, 91
Driers, ink, 140
Drilling paper, 198-199
Dry transfer letters, 36
Duo-black, 115-116
Duochrome, 116
Duotones, 113-116
 fake, 114
 full-range, 114, 115
 high key, 115
 low key, 114, 115

E

Editor, copy, 3
Emulsion of film, 68, 127
End points, halftone, 90-91
Engraving, 84-85
Enlarger problems, 106, 107
Enlarging copy, 49-50
Equipment, platemaking, 123
Estimating paper, 148, 149
Etching dot, 119
Exposure
 basic, 91
 basic flash, 92, 94
 basic main, 94
 bump, 99-101
 flash, 110, 105, 106
 main, 105, 106
Exposure, calculating halftone, 94-99
Exposure, calibrating halftone, 91-94
Exposure of line negative, 76

F

Fake duotone, 114
Feeder system of offset press, 154, 156-159, 172-176
Felt side, paper, 145
Film, 68-69
 handling, 69
 processing, 74-75
Film holder, process camera, 66-67
Filmotype, 39
Filters, 116, 118, 119
Finishing operations, 9-10, 194-202
First generation phototypesetter, 41
Fixer, 71
Flash exposure, 101, 105, 106
Flashtest, color separation, 122
Flat, 126
Flop negative, 78
Floppy disc phototypesetting, 44-45
Focusing controls, process camera, 66
Folder, 9-10, 195-196
Folding, 194-196
Formula for scaling copy, 50
Fotosetter, 40
Fourth generation phototypesetter, 42
f/stop, 66, 72
Full-range duotone, 114, 115

G

Gathering, 197-198
Goldenrod, 127
Graphic arts exposure computer, 94-99
Graphic designer, 3
Gray scale, *see* Sensitivity guide
Ground glass, process camera, 66-67
Guide
 density, 93, 96
 sensitivity, 72, 74-75, 79, 92, 107
Gutenberg, 32

H

Halftone end points, 90-91
Halftone exposure
 calculating, 94-99
 calibrating, 91-94
Halftone negative, 131
Halftone photography, 83-101
Halftone screen, 4, 6, 86
Handling ink, 141
Headliner, 39
High key duotone, 115
Highlight dots, 91
Hot type, 32-35

I

IBM Selectric Composer, 38, 39
Image generation, 33-45
Impact typesetting, 36-39
Impression cylinder, 166-168
Indirect screening, 119-121
Ink, 138-142
 color fastness of, 192
 handling, 141
 manufacturing, 11-12, 138-139
 mixing, 140-141
 opacity of, 142
 tack of, 141
 transparency of, 142
 viscosity of, 141
Ink driers, 140
Ink vehicles, 139
Inking problems, 186-187
Inking system of offset press, 154, 161-162, 182-183, 190-191
Ink mill, 138-139
Ink modifiers, 140
Ink pigments, 139-140
Inorganic pigments, 140
Integrated dampening system, 160-161
Intertype machines, 33-34
ISO paper series, 146-147

J-K

Jogging, 158
Justowriter composing machine, 37-39
Keylining, 54

L

Lacquer, 135
Lamps, process camera, 65
Laser system of setting type, 41
Lateral reverse negative, 78
Layout principles, 17-29
Lens diaphragm, 66
Lens, process camera, 66
Lettering pens, 36
Light for contact printing, 77
Light, process camera, 65
Light trap, 61
Line casting machines, 33-34
Line copy, 3, 50
Line negative, 70-76, 131
Line photography, 59-81

index